THE
CANYONS
of
GATEWAY

A photographic journey to a place in far western Colorado
where the planet opens up to tell its story

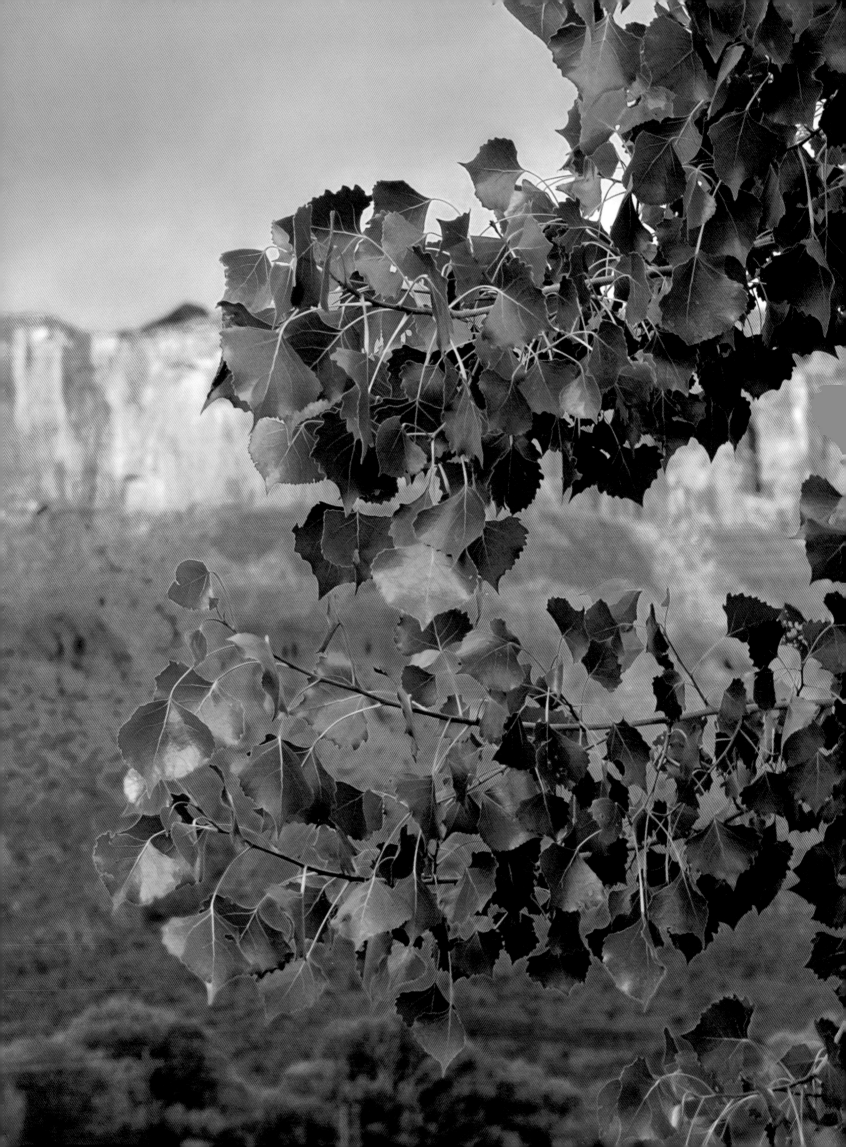

THE
CANYONS
of
GATEWAY

A photographic journey to a place in far western Colorado
where the planet opens up to tell its story

Photography and Preface by
John Hendricks

Introduction and Text by
Mary Judd

Design by
Carrie Hurlburt

Experius
Academy
Press

Experius Academy Press

Experius Academy Press
8484 Georgia Avenue, Suite 700
Silver Spring, MD 20910

ISBN 978-1-61658-081-0
Library of Congress Control Number: 2009939604

Photographs by John Hendricks made with a Nikon D2X digital camera.

Map illustration by Carrie Hurlburt
Chapter icon illustrations by Kenny Doss
Text and cover design by Carrie Hurlburt

Printed on Galerie Art Gloss 100# Text
Printed by Brilliant Studio, Exton, Pennsylvania
Bound by ACME Bookbinding, Boston, Massachusetts

FIRST EDITION

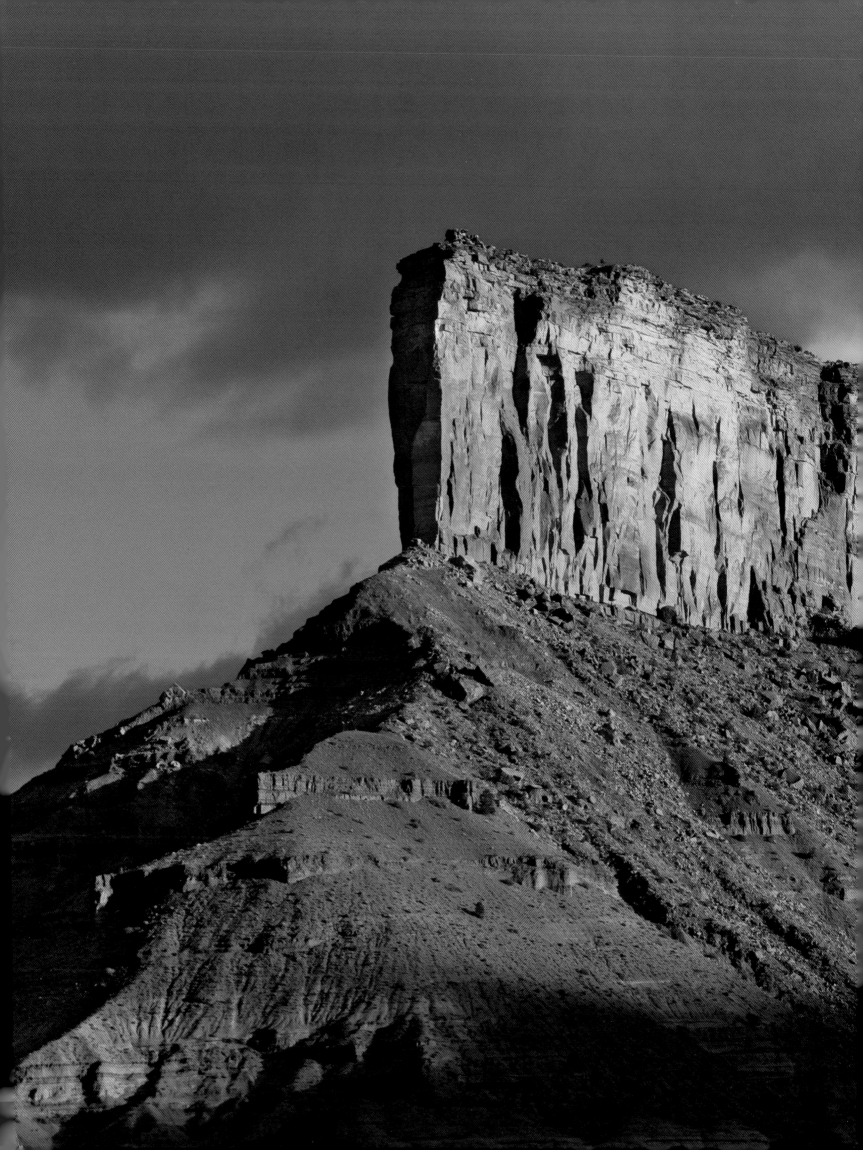

CONTENTS

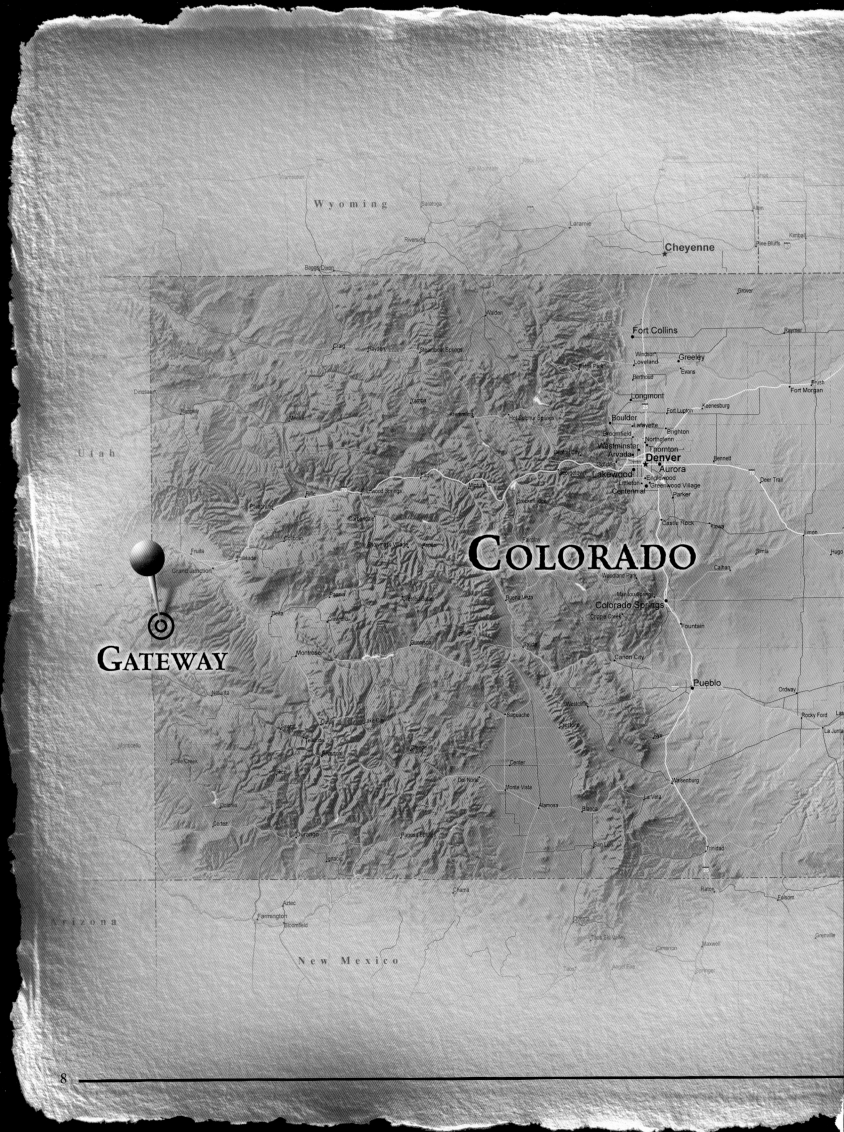

COLORADO

GATEWAY

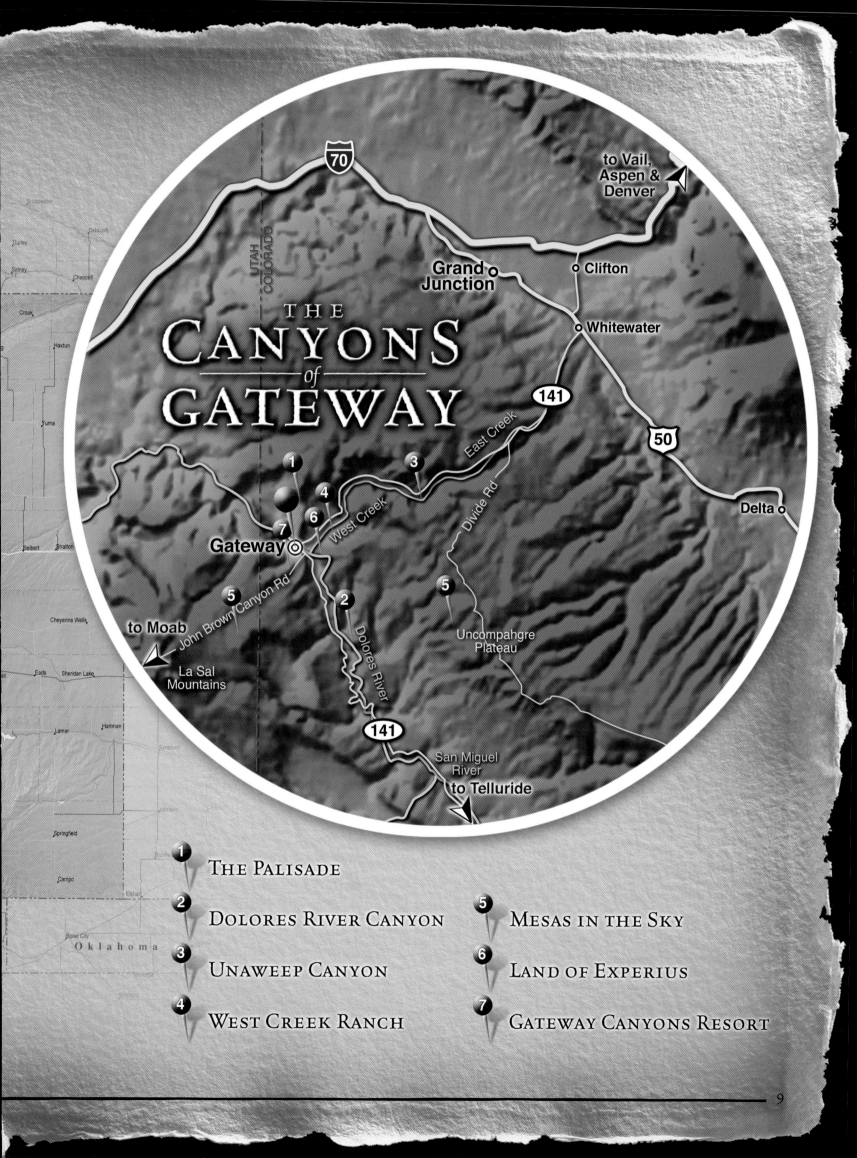

THE CANYONS of GATEWAY

1. THE PALISADE
2. DOLORES RIVER CANYON
3. UNAWEEP CANYON
4. WEST CREEK RANCH
5. MESAS IN THE SKY
6. LAND OF EXPERIUS
7. GATEWAY CANYONS RESORT

ENCOUNTER WITH THE CANYONS

by

John Hendricks

In a way, I began my journey to the canyons of Gateway when I was 5 years old. I was captivated by my father's old road maps of Colorado and Utah, which he collected on his own wanderings out West during the 1920s and 1930s. The oil company road maps, with their colorful illustrations portraying the joys of traveling the nation by car, worked their magic in 1957 on a little boy in the hills of West Virginia. I longed to see the marvelous places in my father's stories...majestic snow-covered Rockies, deep canyons cut by raging rivers, and desert vistas so wide that you could see for a hundred miles.

On many an evening after my dad came home from work, I jumped behind the wheel of his 1952 Plymouth Cranbrook and, armed with a Sinclair Oil map of Colorado or Utah, I set off on a great pretend drive to far off places with names like Provo, Grand Junction, Rifle, and Zion. Adding to the wonder of each journey were the illustrated dinosaurs on the old Sinclair Oil map covers that told me I was traveling to a mysterious world once ruled by the likes of Tyrannosaurus Rex. I also recall that the Great Salt Lake was always a must-see on these journeys that lasted until my mother called me in for dinner.

I never got to explore the West with my dad, who died in 1972, but he instilled in me a powerful curiosity about the planet and its wonders. There was a particular place out West that he mentioned as the most beautiful and grand...the canyon country southwest of Grand Junction, Colorado. I heard about this place several times as I was growing up, including a story my mother told of a train journey in 1945 when my family was returning to West Virginia from Portland, Oregon following my father's work in the shipyards during the war. I was not yet born but my older sister and brother, then toddlers, were along for the trip. When the train stopped in Grand Junction, my father tried his best to convince my mother to have the family stay a few days and consider living there. Previously, in the mid-1920s, my father and his older brother Robert explored the West by working ranches as they traveled from state to state over a three-year period of youthful adventure. Apparently, at one time they had worked on a ranch somewhere in the "grand and beautiful canyon country" southwest of Grand Junction, an experience that led to this eventual proposal for a family re-location to the area. However, my mother would have none of this talk as she longed to be with her friends and family in West Virginia. So, after that brief stop in Grand Junction, my mother, father and older brother and sister re-boarded the train and headed back East. My dad never returned to the place that had so captivated him as a young man.

Like so many others, I fell in love with the West on my first visit in 1974, just after I graduated from college. I toured the front range of Colorado from Pike's Peak north to the Rocky Mountain National Park, where I made an exhilarating and life-changing climb of Long's Peak. Beginning on that June day in 1974, I have relished every opportunity to explore and hike and ski the wondrous landscapes of Utah, Idaho, Colorado, Arizona and New Mexico.

In 1989, four years after I had started the Discovery Channel, I found myself in

Kenya around an evening campfire alongside the Mara River with the experienced members of a BBC natural history film crew, who were in the process of filming a joint documentary production between Discovery and the BBC. Knowing that the crew had traveled the world extensively, I asked them to identify the most dramatic landscape they each had witnessed. For some reason, I had expected the reply to be some exotic location in Nepal or New Zealand, but to a person they named "the American Southwest." It was a surprising but somehow reaffirming response that instantly met with warm confirmation in my own mind. There is really no place on earth possessing the grand contrast of landscapes that is so remarkably abundant in the American Southwest.

There comes a time when occasional visits do not fully satisfy the soul and so, for me and my family, a search for a place out West began in 1989 after my wife Maureen and I returned from Africa. We looked for a place where we could retreat, reflect, and enrich our lives amidst an unspoiled natural landscape. We began to spend time in the summers in Idaho and, in winter, we skied the Wasatch Mountains of Utah where our children, Elizabeth and Andrew, developed their own passions for the glories of the West. Maureen, a quilt artist and collector, began to spend more and more time in the early 1990s at quilt retreats and classes in Santa Fe. I accompanied her several times on her Santa Fe trips and together in April 1995 we discovered a ranch in northern New Mexico that seemed to be an ideal candidate for our long-awaited western family retreat. After meeting with a realtor in Santa Fe, we decided to pursue the available ranch property and I was scheduled to make one more visit prior to making an offer in late April, 1995. However, on the day before my trip to New Mexico, I stumbled across a real estate ad in the Wall Street Journal. The ad contained these words: "ranch for sale in the spectacular red rock canyon country southwest of Grand Junction, Colorado." Those words reached places deep inside me where a child lived, listening to his father's stories of a wondrous

land full of canyons too difficult to describe.

I changed my Santa Fe trip plans to include a stop in Grand Junction where I met the realtor who was representing the ranch seller. The realtor was also a pilot. After a sixteen minute flight in his yellow Cessna 185, we began to circle an area where magnificent red rock canyons converged at the confluence of West Creek and the Dolores River. As we descended into the canyons, a dirt landing strip appeared just ahead of the most stunning red rock landform I had ever seen. "It's called the Palisade," said the realtor pilot who banked toward the landing strip, smiling as he saw my jaw drop at my first sight of the Palisade in morning light.

Following my amazing introduction to the canyons of Gateway and visits shortly thereafter by my wife and children, we purchased the West Creek Ranch in the spring of 1995. Other large ranch tracts in the scenic region of western Mesa County, Colorado became available for sale over the following decade. Fearing purchase by developers for subdivision sales, we steadily acquired property to help conserve the pristine open space vistas and wildlife habitats outside of the little settlement of Gateway, which had been a thriving mining town in the 1950s and 1960s. After acquiring the large Sky Mesa Ranch which borders Utah, we placed over 4,000 acres in a permanent conservation easement with The Nature Conservancy largely to protect the unspoiled wildlife habitat of North Cotton-wood Canyon located deep within the ranch.

In 2001, I began to have meetings with officials of Mesa County who, like our family, desired to protect the scenic riches of this remarkable canyon country while also revitalizing the economic life of the Gateway community which had suffered from the loss of its mining economy. Included in our purchase of the Sky Mesa Ranch were lower

elevation parcels in Gateway that engineering studies showed to be the only viable sites for a desperately-needed new wastewater treatment facility for the residents of Gateway. Utilizing what we considered to be the best principles of "smart growth planning" to protect existing open space and natural ecosystems, the Board of County Commissioners of Mesa County and I entered into an agreement in 2003 containing seven beneficial objectives for revitalizing the Gateway community through the stimulation of a scenic and recreation-based economy. As part of the agreement, our family donated the land and construction funds for a new wastewater treatment plant to address failing local septic systems. We also dedicated land we owned within an approximate one-mile perimeter of the Gateway U.S. Post Office for future commercial development, keeping new residences and new economic activity confined to where it had historically been located, while preserving the surrounding open space and natural environment.

As part of the seven objectives cited in the 2003 agreement with Mesa County, we identified the potential development of an educational and recreational project that would attract visitors and thereby create a re-birth of jobs and economic life for the community. Following an investment in essential community services (the new sewer system, general store, fuel station, and lodging to stimulate tourism and outdoor recreation), our family began work on a unique educational attraction, the "Experius Academy," which debuts in 2010 at our Gateway Canyons Resort. Designed to provide opportunities for lifelong learning during one and two-week vacations, the Experius Academy will treat resort guests to stimulating and rewarding informal lectures and field trips to explore topics that include science and technology, world history, the arts, geology, astronomy, native American culture, and self-improvement. And, as you may have guessed, the Experius Academy will present a wealth of video treasures from The Discovery Channel in an intimate 56-seat HD Theater. The glorious red rock canyon country of Gateway is now the setting

for what we hope will be the world's most enriching vacation experience.

Along with my talented colleagues at Discovery Communications, I have devoted my career to helping share the wonders of the world with television viewers around the globe. In my leisure time, I have a passion for landscape photography. The canyons of Gateway have offered me an enormous treasure of photographic moments that have captivated and enchanted me for the last 14 years. This book offers me the first chance to share the exquisite wonder of an unspoiled canyon country that continually surprises and inspires me on every hike and road trip in the area. At some point, I hope that you will also have the opportunity to take a sunrise or sunset walk on these canyon floors or on the mesa tops above, armed with your own camera to permanently record some of life's most awe-inspiring moments.

John Hendricks
Gateway, Colorado
June 2009

INTRODUCTION

RETURN OF THE NATIVE
by
Mary Judd

Once upon a time, I was driving my ten-year-old nephew back to his home in Connecticut. One of the tricky turns had me a bit confused. Not my nephew. "I know this area like the back of my head!" he said.

When I was asked by John Hendricks to travel back to my home state of Colorado to help with research and educational programming for his new Experius Academy in Gateway Canyons, I felt the same assuredness that my nephew had shown years before. After all, I had been born in Colorado, lived there many years before moving to Texas and New York, and had returned many times since. This will be easy, I thought. All I have to do is use my travel writer's nose and educator's eye to capture the state's beauty and history. I honestly thought I knew my home state. Ha! (Here's where the back of *my* head comes in.)

Gateway, Colorado is located in an area of the state I had never explored, the deep, southwestern part, one hour south and west of Grand Junction, only a few curvy miles from the Utah border. Before arriving, I expected, as usual, to be charmed by Colorado's clear blue skies and those loyal Rocky Mountains laced with waterfalls and wildflowers, feisty streams and fresh air.

for what we hope will be the world's most enriching vacation experience.

Along with my talented colleagues at Discovery Communications, I have devoted my career to helping share the wonders of the world with television viewers around the globe. In my leisure time, I have a passion for landscape photography. The canyons of Gateway have offered me an enormous treasure of photographic moments that have captivated and enchanted me for the last 14 years. This book offers me the first chance to share the exquisite wonder of an unspoiled canyon country that continually surprises and inspires me on every hike and road trip in the area. At some point, I hope that you will also have the opportunity to take a sunrise or sunset walk on these canyon floors or on the mesa tops above, armed with your own camera to permanently record some of life's most awe-inspiring moments.

John Hendricks
Gateway, Colorado
June 2009

RETURN OF THE NATIVE
by
Mary Judd

Once upon a time, I was driving my ten-year-old nephew back to his home in Connecticut. One of the tricky turns had me a bit confused. Not my nephew. "I know this area like the back of my head!" he said.

When I was asked by John Hendricks to travel back to my home state of Colorado to help with research and educational programming for his new Experius Academy in Gateway Canyons, I felt the same assuredness that my nephew had shown years before. After all, I had been born in Colorado, lived there many years before moving to Texas and New York, and had returned many times since. This will be easy, I thought. All I have to do is use my travel writer's nose and educator's eye to capture the state's beauty and history. I honestly thought I knew my home state. Ha! (Here's where the back of *my* head comes in.)

Gateway, Colorado is located in an area of the state I had never explored, the deep, southwestern part, one hour south and west of Grand Junction, only a few curvy miles from the Utah border. Before arriving, I expected, as usual, to be charmed by Colorado's clear blue skies and those loyal Rocky Mountains laced with waterfalls and wildflowers, feisty streams and fresh air.

Instead, when we made the drive from Grand Junction through the canyons to Gateway I was almost mad. I couldn't believe what I had been missing. I was astonished. Where *are* we? What *is* this place? Questions roared through my head. Why haven't I *been* here before? And how many others like me have *no idea* this place exists? Within minutes, as we climbed higher and higher to reach the vast, deep canyons, my questions became less self-centered: Why are the Rockies so tall and this canyon so deep? How did this all form? Why did John Hendricks choose this place for his resort and the Experius Academy?

Anyone who knows John Hendricks knows that he loves questions. He is, after all, the man behind the world's greatest educational media empire – one that answers nearly any question we pose. Armed with facts, stories and his favorite camera, he led a small group of us around the thousands of acres he has come to know so well, and set out to preserve. We spent a week firing questions at him and he threw answers back, many with even more questions attached. Two things became immediately apparent. One, that this brilliant landscape was riddled with questions and adventures as old as time. And, two, that it was the perfect setting for an Academy aimed at exploring the "big questions."

For those of you who, like me, were not familiar with this incredible place, I've gathered some of my questions and snippets to share. John's photos pick up where the words leave off, beautifully capturing the historic essence that words cannot convey.

What *is* this place?

"… a place where the planet opens up to tell its story," says John.

We traveled from Grand Junction, as most visitors do, heading south and west along Colorado Scenic Highway 141 through Unaweep Canyon, the first canyon on our tour. (The Rocky Mountain peaks of my youth more than five hours to the east.) Here, the planet's story came through loud and clear, as if Mother Earth was saying, "Once upon a time…and another time…and another…" Layer upon layer of the Earth's history was visible right from the car window. "Here's my Precambrian layer," she said, "…formed more than 1.7 billion years ago."

I felt like I was driving through a textbook. (The best kind, with lots of photos.) My eyes traveled up each layer, through the ages of dinosaurs, ancient peoples and mining dreams come and gone, each period leaving abundant souvenirs.

This mesmerizing Unaweep Canyon was named by the Ute, and means "canyon with two mouths." It is the only canyon in the world where a nearly imperceptible divide acts like a mirror, sending two creeks off in opposite directions, each running out a different end. Its beauty is breathtaking. The heart of Unaweep's high canyon reveals a lush pasture floor, lined with towering walls that are topped with shrubby mesas. Streams pour over the canyon walls, some in cascading waterfalls and others carving gentle side canyons. John Hendricks points out Divide Road that heads off to the east. "It winds upward to the Uncompahgre Plateau where the land flattens into peaceful cattle grazing country located within a ponderosa pine forest," he says. Several of his favorite shots were taken there.

We travel further south, making our final descent down through Unaweep Canyon's ever-narrowing gray walls toward Gateway, the lowest town on Colorado's Western Slope, and still about twenty miles ahead. We're rewarded with a true visual delight as sun-bathed, expansive red canyons come into full view. And then we see it.

What is *that*?

Dominating the landscape like something from another planet is the red sandstone landform known as the "Palisade." From miles down the road, it commands our attention with its grand narrow "fin" cutting across the massive range. We're not surprised to learn that the area has been designated as the Palisade Wilderness Study Area and named an Outstanding Natural Area by the Bureau of Land Management.

Gazing up at the majestic landform, which looms large over the canyon floors of both the Dolores River and West Creek, again we're able to stare back into time. Eons of the earth's history are unlocked through great bands of colorful sedimentary layers, revealing the process of how our planet was formed.

The lessons begin...John directs us to look at the center, to the highest portion of the Palisade where the Earth's recent past is most clearly evidenced. The topmost Dakota and Burro sandstone layers contain remnants of the Cretaceous Period, which witnessed the great rise of the mammals. Underneath these top layers is the Morrison Shale and Sandstone layer, which marks the Jurassic Period and the long reign of the giant dinosaurs. A great band of light sandstone known as the Entrada layer lies below the Morrison and is remarkably smooth in appearance. The Entrada sandstone also forms the intriguing landscape of nearby Arches National Park. Below Entrada, and reaching further back through the ages, are the Navajo and Kayenta sandstone layers. Forming the sheer, vertical cliff walls of the Palisade below the Kayenta layer is the immense, dark red Wingate layer of sandstone that bore witness to the Triassic Period dating back more than 300 million years. Below the Wingate is the Chinle formation sandstone layer. Here in the ancient Triassic period the dinosaurs were small, delicate creatures and their tracks are present on fallen Chinle

formation rocks found in abundance along the canyon floors of the Gateway area.

Yes, dinosaurs right here, all over the place. (Note to self: Plan a family field trip soon.) What could possibly pull our eyes away? "Look over there," John says. Soaring above the western horizon we spy the 13,000-foot peaks of Utah's still snowy LaSal Mountains. One stunning landform after another, waiting to be further explored, admired...and photographed.

Who lives here?

In such an intriguing place, it's impossible not to wonder about those who live here, and those who came before. As we approach our destination in Gateway, we travel along West Creek, which emerges from Unaweep Canyon into a broad canyon floor ringed by the red Wingate cliffs of Tenderfoot Mesa on the south and the striking Palisade formation on the north. The creek, full from winter's melt, plays hide and seek with us as it winds through tall cottonwood trees and behind occasional boulders. We are only about three miles northeast of Gateway, near the western mouth of Unaweep Canyon when we reach West Creek Ranch, which contains the adobe-styled southwestern ranch residence of the Hendricks family along with a grass airfield, hangar, stables, and a guest house.

Having two large reservoirs fed by an irrigation ditch dug in 1901, West Creek Ranch features lush, green irrigated pastures which are home to American quarter horses, Arabians, Belgian draft horses, and American bison. The original log homestead remains intact on the ranch. It was constructed in the mid-1890s.

In ancient times, the land now occupied by West Creek Ranch was the site of an

Anasazi or Fremont village as evidenced by the presence of significant petroglyph rocks, one a potentially rare birthing rock. A hike along a high bluff overlooking the creek reveals rock art that is estimated to date between 100 A.D. and 700 A.D. Here, etchings of baby feet are found among other symbols. Another find reveals three shamans holding snakes to prove their magic and power. A possible source of inspiration for the Native American artists is the majestic three-fingered fin of rock, which stands at the opposite end of the Palisade range. Through the ancient "pictures," their stories and mysteries remain.

As we leave West Creek Ranch, we head up the road and close in on a collection of small buildings that make up the town of Gateway today -- a small diner...clusters of homes...a cheery school...a chapel by the Palisade...a library, the Post Office.

What is the history of Gateway?

The town of Gateway is nestled deep in the valley of these canyons, centered where West Creek meets the Dolores River, with the Palisade standing watch. It has long been called, "the most remote part of Colorado." Gold and copper were discovered in the 1870s, and the bulk of settlers arrived in the 1880s, lured by mining and ranching opportunities. The first school-house was built in 1904, with classes taught by a man named Joe Scharf. Electricity didn't reach Gateway until the early 1950s, shortly before Highway 141 was finally paved in 1958.

Many travelers had come long before the miners. Some, like the Anasazi, or "ancient peoples," left "pictures." Others, like the Spanish explorers, left names. The Dolores River was the first river in the state to be named by a white man of European descent, in this case, Juan Rivera, commissioned by the Spanish government in 1765 to investigate the

'unknown' territory. It is believed that when he came upon the winding, strong river he named it El Rio de Nuestra Señora de Dolores (The River of Our Lady of Sorrows). Two famed Franciscan friars, Father Silvestre Velez de Escalante and his superior, Francisco Domíngues, chronicled their expedition throughout the area in 1776 as they searched for a direct route from Santa Fe, New Mexico to Monterrey, California.

It was one hundred years after these expeditions that the Gateway area gained fame for its mineral riches. In the early 1870s bits of gold were discovered in the Dolores River gravel, yielding little more than thin, flaky pieces. Next, in 1875, copper was discovered, bringing more miners who set up Pearl and Copper City. Finally, in 1881, a yellow cake-like substance named Carnotite was discovered further south along the Dolores River. This mineral most significantly impacted the area, as Marie and Pierre Curie discovered that it contained radium, which they used in the treatment of cancer. Later, Carnotite was mined for its vanadium and uranium content. The uranium from these mines was used in the Manhattan Project in the 1950s, and later for nuclear power plants until the 1970s. As demand decreased, the mining ceased.

Ranchers have long been attracted to the area's abundant fertile pastures and protected valleys. Much of the land surrounding Gateway still provides rich grazing for a variety of cattle ranchers. Over the years, the vast canyons have served as prime hideouts for cattle rustlers, the last gang being rounded up as recently as the 1950s.

Taking it all in

With each new road taken, the majestic views only increased. We often found

ourselves humbled, and silent, lost in our own thoughts. From these "Mesas in the Sky" as John calls them, we felt the power of nature and were truly awed.

A short drive up Divide Road took us to thick ponderosa pine forests overlooking the high-desert landscape of the red canyon country below. Home to elk, black bears, mountain lions and numerous hidden creatures, these forests stood in stark contrast to the piñons and junipers that dot the canyon floors. Ponds, lakes, and reservoirs are spread across the plateau's mesa tops that in places stand above 9,000 feet, surrounding both Unaweep Canyon and the Dolores River Canyon.

Another photographer's dreamscape, Sky Mesa Ranch, is accessed via a spectacular 20-minute drive up John Brown Canyon Road from the Gateway Canyons Resort. The high ranch property is thick with ponderosa pines and aspen groves and has the Colorado-Utah border as its western fence line. The southern bluff of Sky Mesa Ranch overlooks the expansive Sinbad Valley formed through what geologists speculate must have been a cataclysmic collapse of an enormous underground salt dome. At the western fence line of Sky Mesa Ranch, the snow-capped La Sal Mountains are in full view with the summit of Mount Peale soaring to 13,100 feet in elevation.

Sundown at all of these locations was a good friend to John Hendricks. Like most photographers, he revels in the quest for perfect light captured at just the right moment each day. From fairytale rainbows to nearly animated night skyscapes, he managed to be there at just the right time.

What's next?

The captivating lands surrounding Gateway have seen much in their day, from dinosaurs to ancient hunter-gatherer tribes, from risk-taking miners to the outdoor enthusiasts of today. The "opportunity" that John Hendricks sees in these lands is one of appreciation for what is here: the planet itself, and the questions that it provokes.

Influenced by a father who shared his journeys and discoveries in life to stimulate his son's sense of wonder and curiosity, John spent his career in developing one of the world's greatest tools for sharing knowledge and satisfying curiosity. Today, the Discovery Channel and the other networks of Discovery Communications serve over 1.5 billion cumulative subscribers in over 170 countries. So, it comes as no surprise that John would work to share with others the remarkable experience of spending time in the wondrous canyons of Gateway. This is a region of North America that has been inaccessible for extended exploration due to the lack of lodging, dining, and even fuel services. Concurrent with his desire that people get an opportunity to personally witness one of planet earth's most dramatic landscapes, John has recruited a team of knowledge innovators who have created the Experius Academy which will offer enrichment programs in science and the humanities to complement the many recreational offerings at Gateway Canyons. The key mission of the Experius Academy is to create a special place in the world where lifelong learners can assemble to satisfy their many curiosities in an environment full of opportunities for recreation and adventure. From lectures in the field of geology to multimedia presentations on modern China, the Experius Academy has been designed to provide the world's most enriching vacation experience.

Located within the existing Gateway Canyons Resort grounds, the recently completed

Palisade Event Center will be the home of the Experius Academy. The facility includes a grand lecture hall, classrooms, an HD theater, art studio, library café, and more. Outdoor lectures, concerts, and events will be held at the resort's Mission Bell Amphitheater. To keep human impact on the undisturbed canyon country to a minimum, protective level, the Gateway Canyons Resort will contain luxury lodging to accommodate only 160 Experius Academy participants each week, assuming double occupancy in the approximately 80 rooms and suites of the Kiva Lodge (completed in 2007) and the Kayenta Lodge (scheduled for completion in late 2010).

A view of the resort area from above reveals the beautiful blending of the buildings of Gateway Canyons with their surroundings. It is truly hard to see where one ends and the other begins. All are constructed in adobe-styled architecture with earth-tone exteriors containing native stone, which combine to blend structure with the natural landscape. To avoid impacting wildlife habitats and open space vistas, all lodging, dining, and retail structures have been clustered and confined within the current boundary of human impact, within a radius of about one mile from the Gateway U.S. Post Office. The Kiva Lodge and the new Palisade Event Center are LEED-certified structures which incorporate green-building technology, including geo-thermal energy and solar water heating.

Gateway Canyons Resort has become a community hub for western Mesa County as it contains a fuel station, the region's only grocery store (surprisingly well-stocked with fresh produce, baked goods, and a café), and features a variety of special events and entertainment. The resort's Paradox Grille and soon-to-be-opened Entrada Restaurant offer the region's finest dining experiences. The Gateway Colorado Auto Museum, located at the resort, presents a stunning educational display of more than one hundred years of car design and engineering -- from the 1906 Cadillac Model H Coupe to the revolutionary 2008

all-electric Tesla Roadster – providing an interesting discussion platform as the nation and the world explore energy alternatives for transportation.

In addition to academic programming, the resort encourages "re-creation" of many styles, from outdoor adventures to spa services to the setting's endless inspiration. It's easy to imagine the eventual creative output.

Could I call this place home?

Upon discovering the powerful canyon lands and learning the history of the town of Gateway - its ups and downs, along with its enduring ability to welcome change - it was hard to deny the yearning to be a part of its "future history." Fortunately, the Hendricks family understood early on that others would want to be part of the effort to create a vibrant new future for Gateway and western Mesa County.

Approximately 500 acres of land at the confluence of West Creek and the Dolores River in Gateway have been set aside by the Hendricks family for the creation of the Experius Community at Gateway Canyons. Designed with ultimate respect for the land and environment, the Experius Community will be a unique and exclusive enclave of less than 300 homes reserved for individuals and families who treasure the opportunity to live and recreate in one of the most dramatic landscapes in the world. Experius home sites have been carefully situated to avoid sensitive riparian corridors along West Creek and along the Dolores River, which flows through the property on its northerly course to a rendezvous with the Colorado River.

Along with the natural amenities, Experius Community residents will enjoy access to Experius Academy events and facilities. As the "ancient peoples" who inhabited the canyons understood so well, this is a land of plenty, from earthly sustenance to soulful inspiration. As a former Colorado resident and a current inhabitant of this planet, I am grateful that John Hendricks and his family understand this as well. Their appreciation for the area's beauty and universal significance, along with their celebration of our human need to explore and discover, to question and discuss, will benefit us all.

Until you arrive here yourself, lace up your imaginary hiking boots and place yourself at the side of John Hendricks, armed with his trusty camera. Enjoy your tour!

Mary Judd

Delmar, New York

June 2009

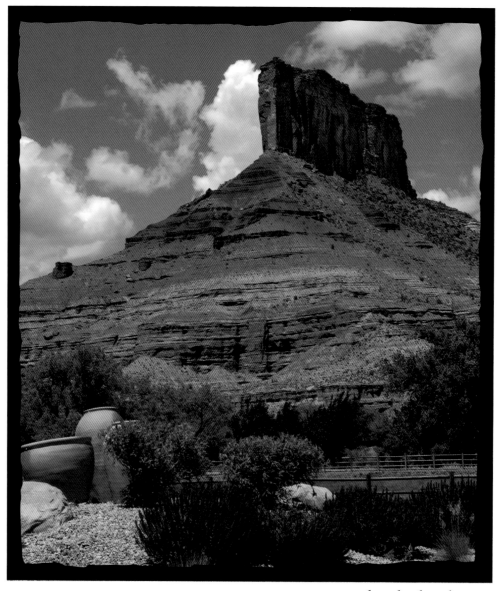

The Palisade and pottery

CHAPTER ONE
THE PALISADE

Like China's Great Wall and India's Taj Mahal, Gateway's Palisade rock formation commands attention and instills awe. Unlike the two former landmarks, the Palisade's origin holds no ties to mankind. This planetary timepiece emerged from deep within the earth hundreds of millions of years ago, revealing colorful layers that span nearly every age in history.

Some features remain constant, like the Permian red sandstone base, the massive Wingate walls that make up the "fin," and the tranquil waterways that line its base. But each day brings a new interplay between Mother Nature and the Palisade. Sometimes the results are downright, distractingly grand. Other exchanges are subtle, yet no less profound.

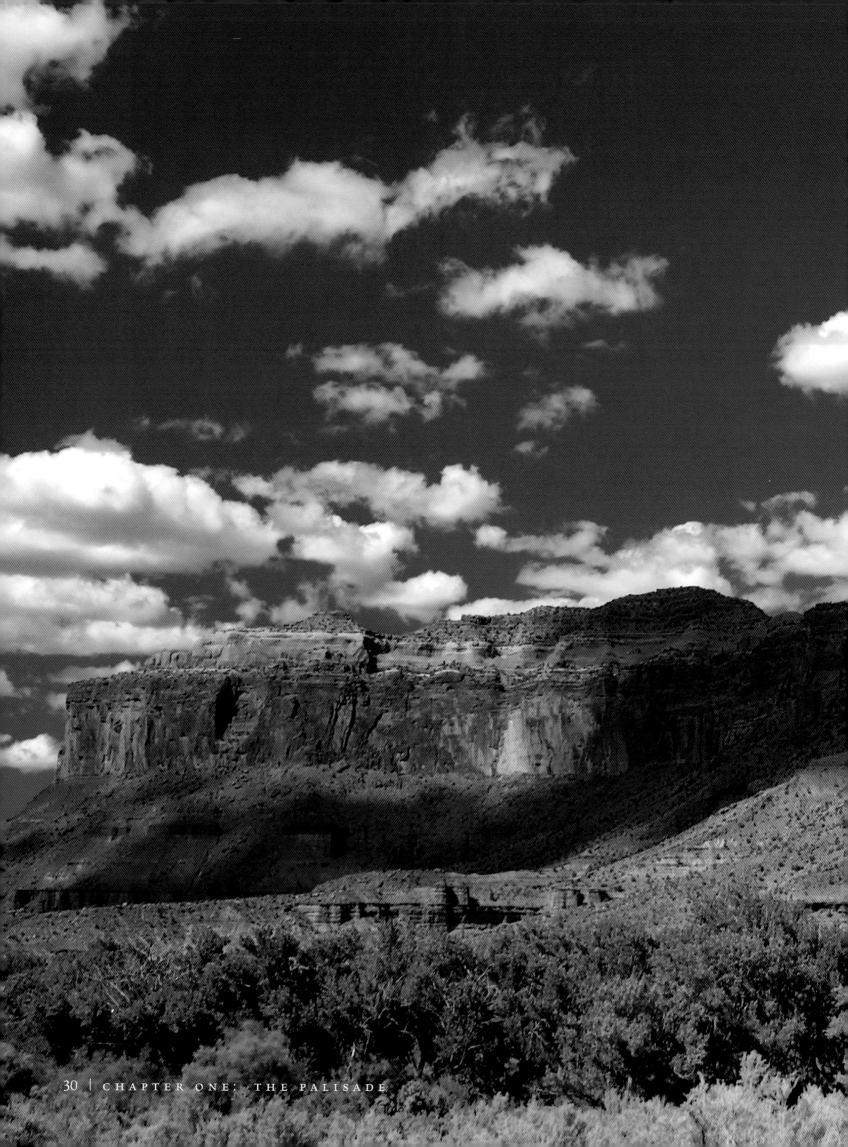

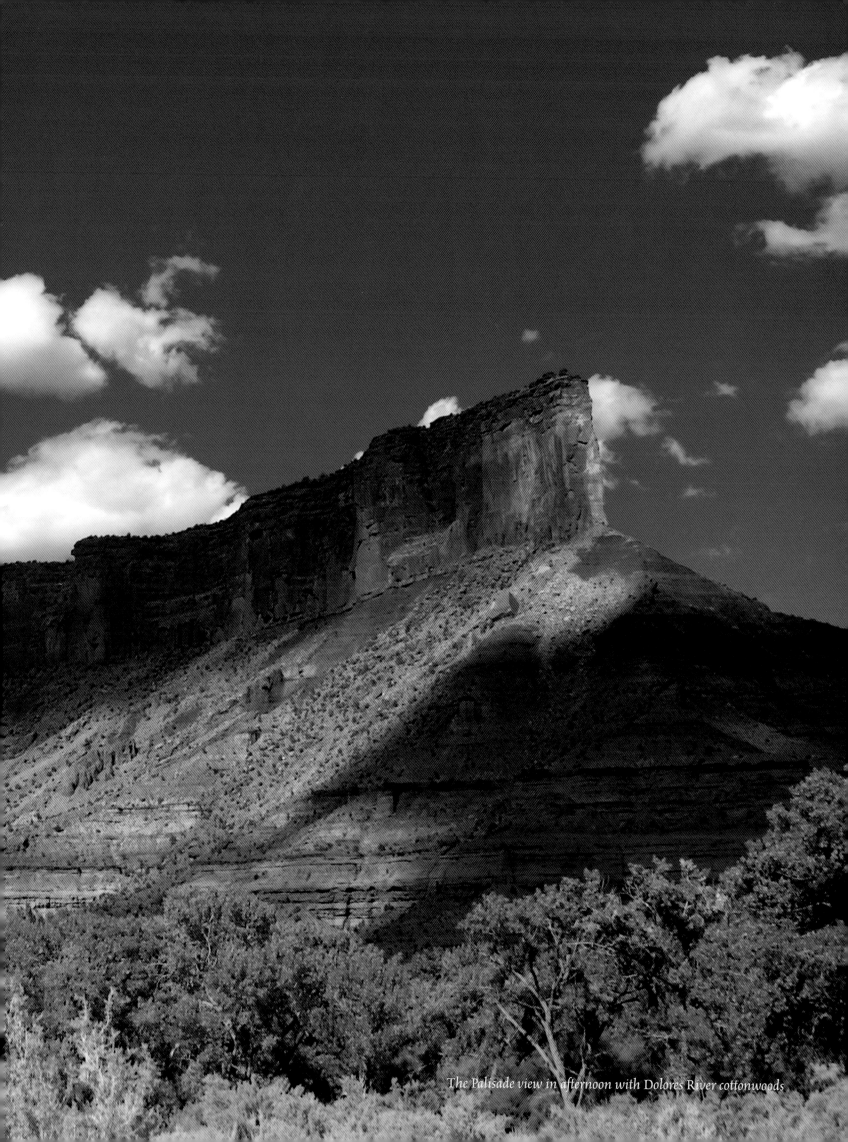

The Palisade view in afternoon with Dolores River cottonwoods

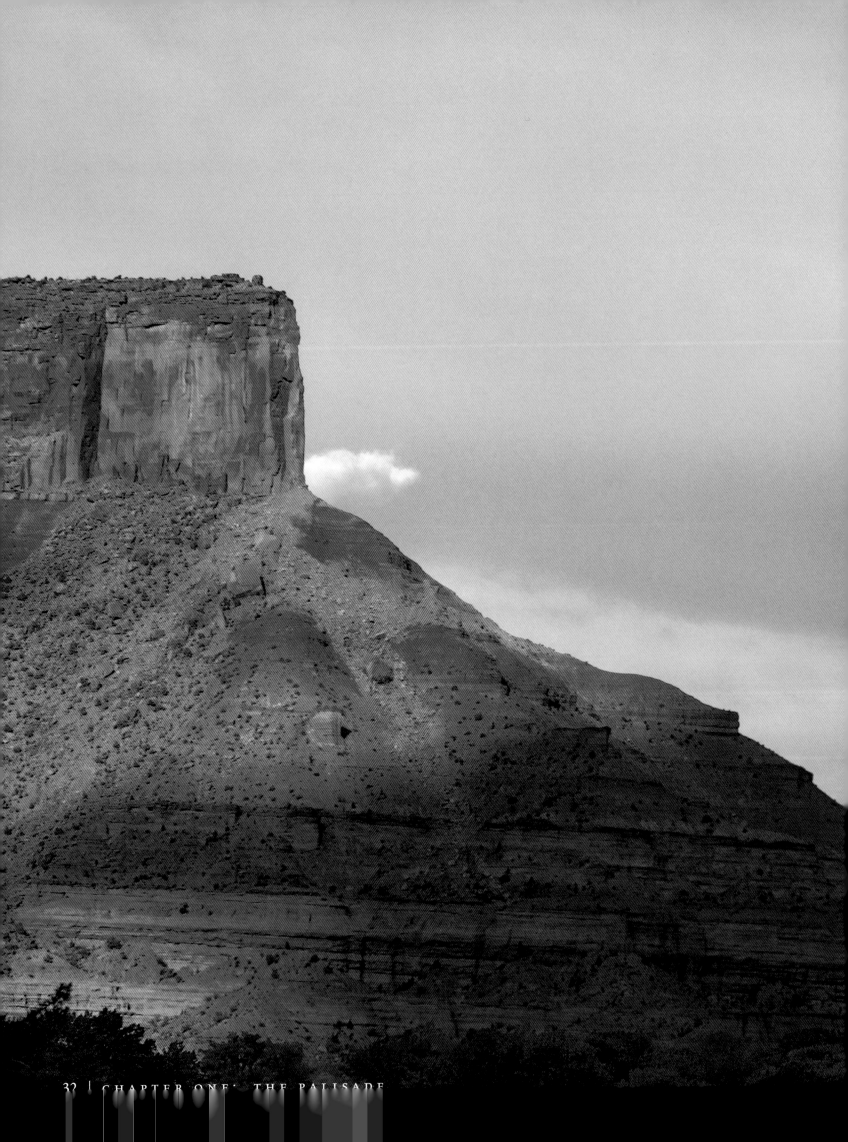

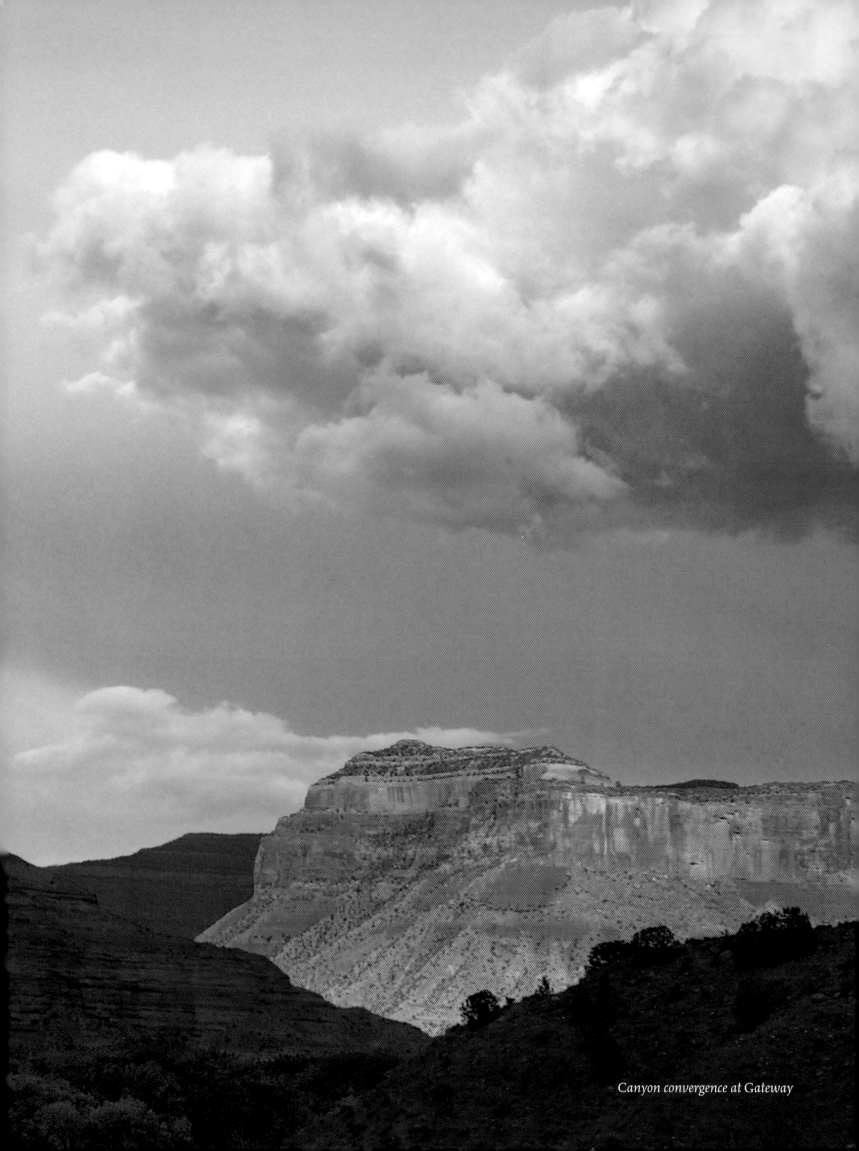

Canyon convergence at Gateway

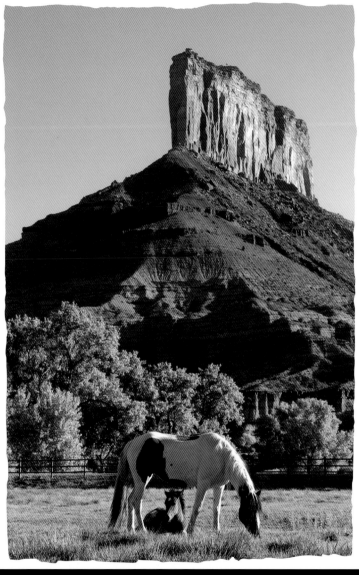

New colt and the Palisade

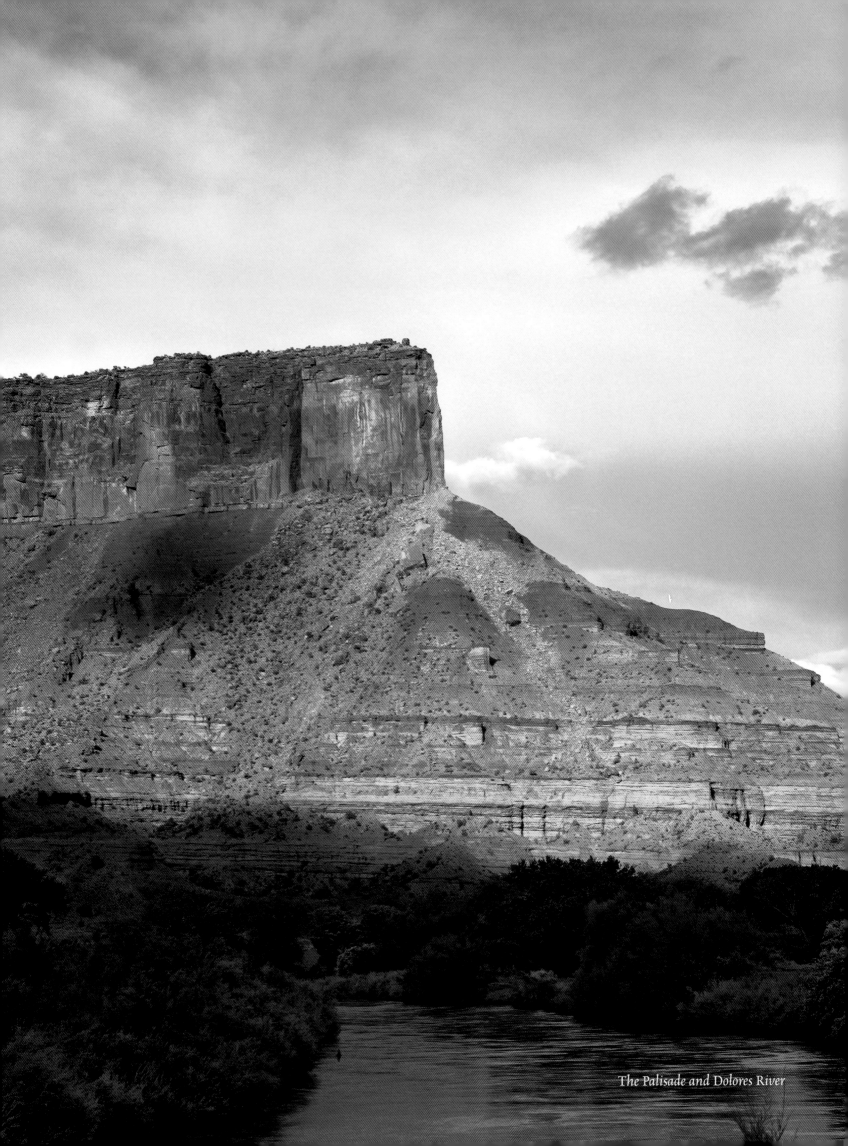

The Palisade and Dolores River

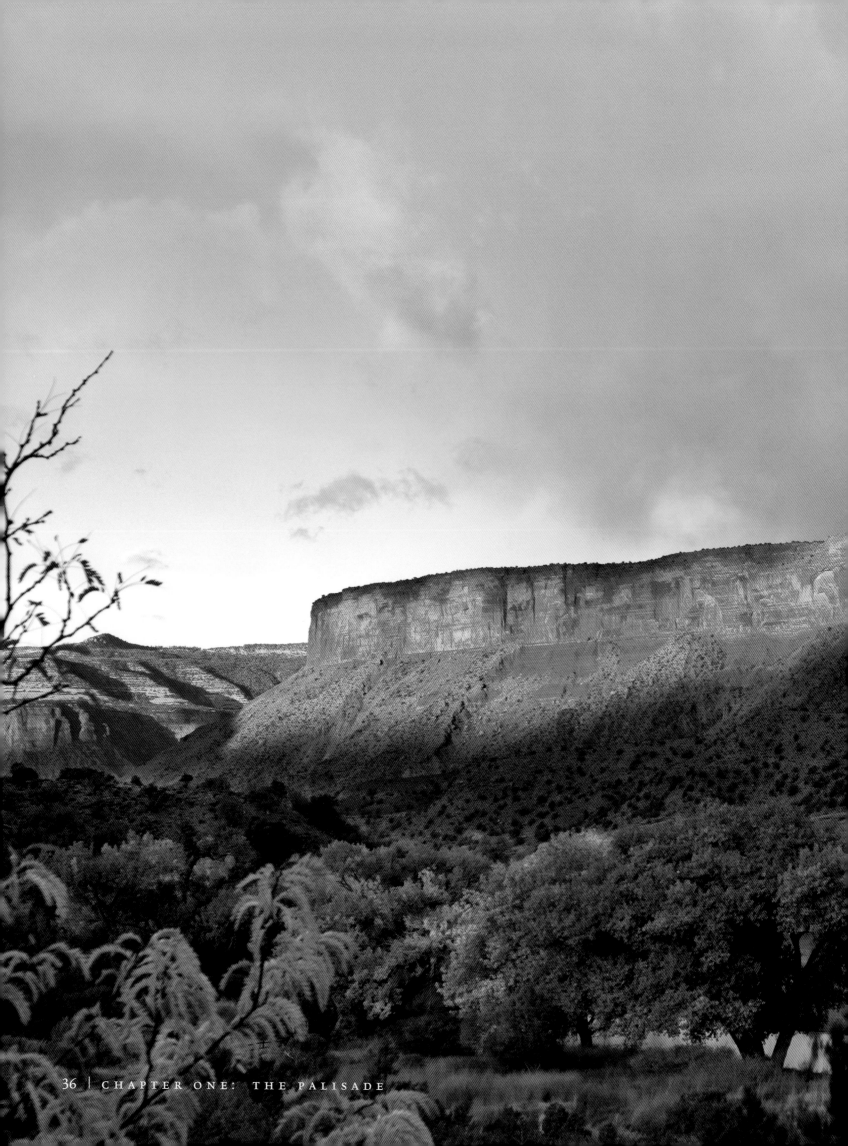

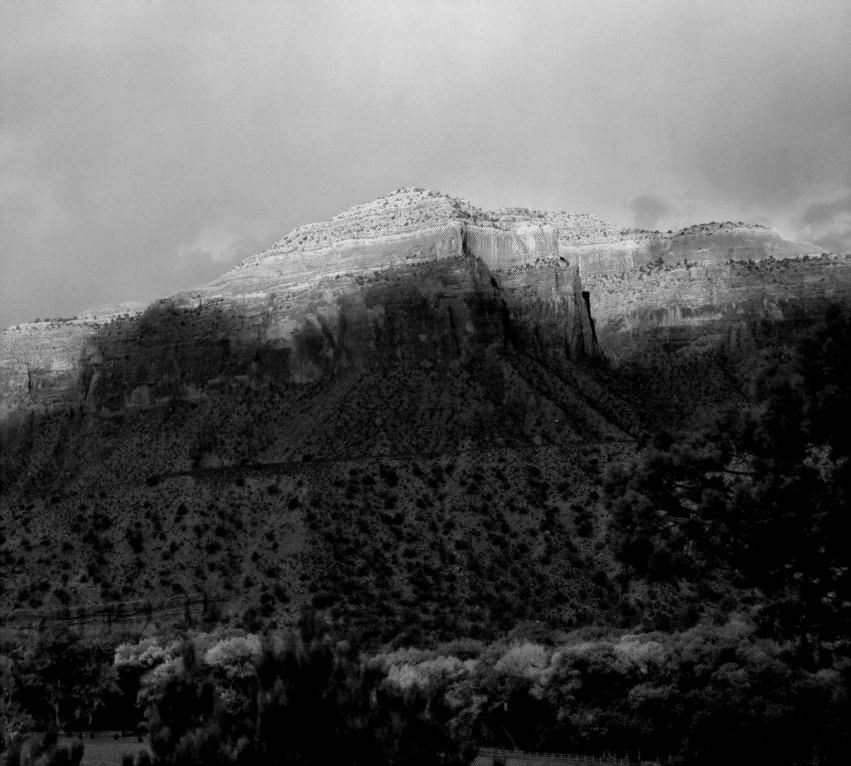

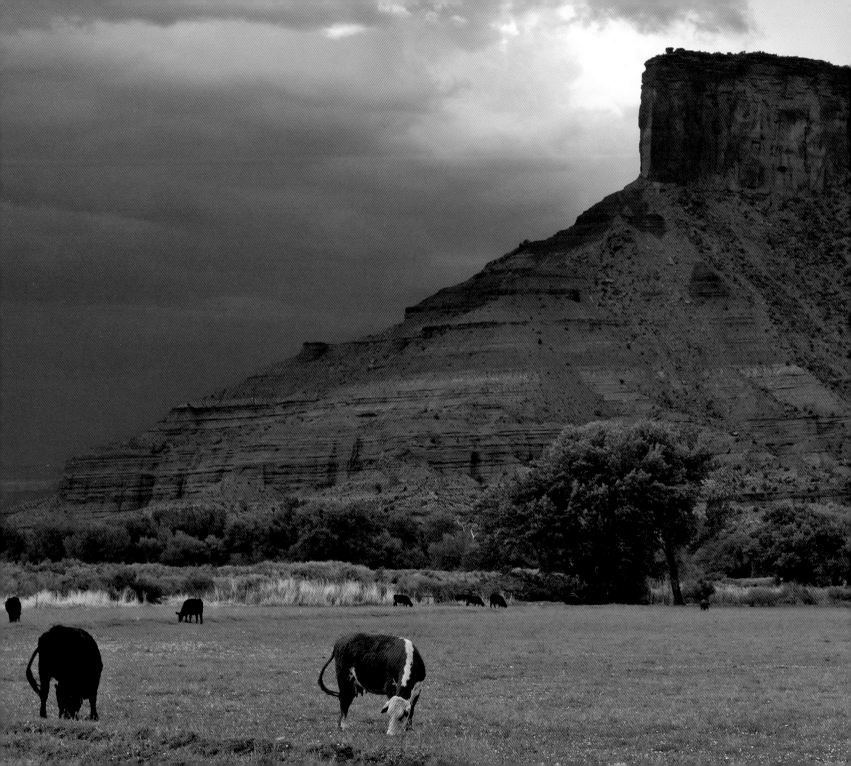

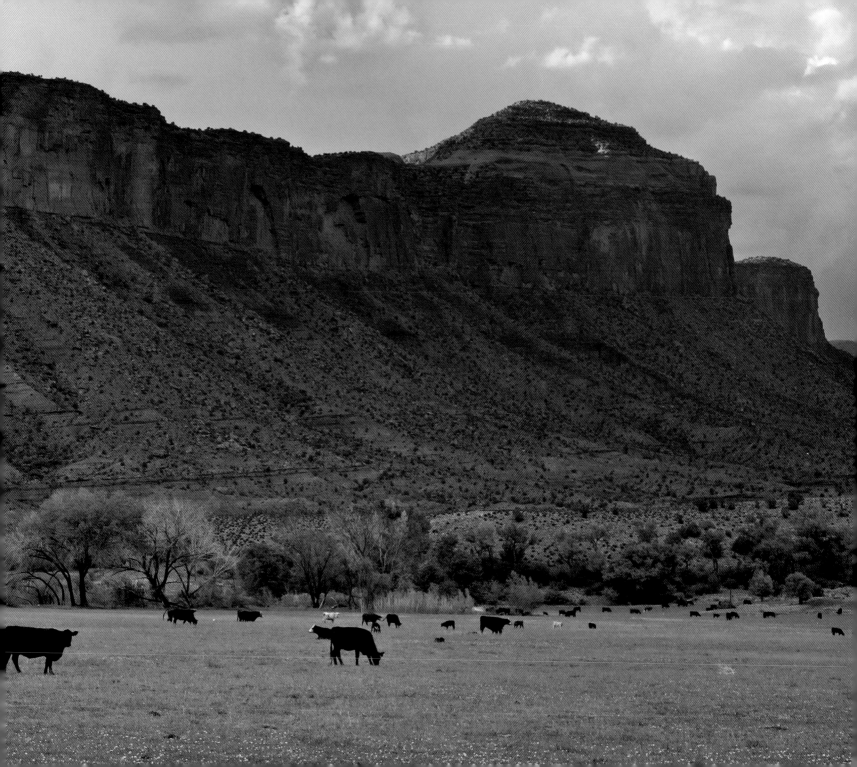

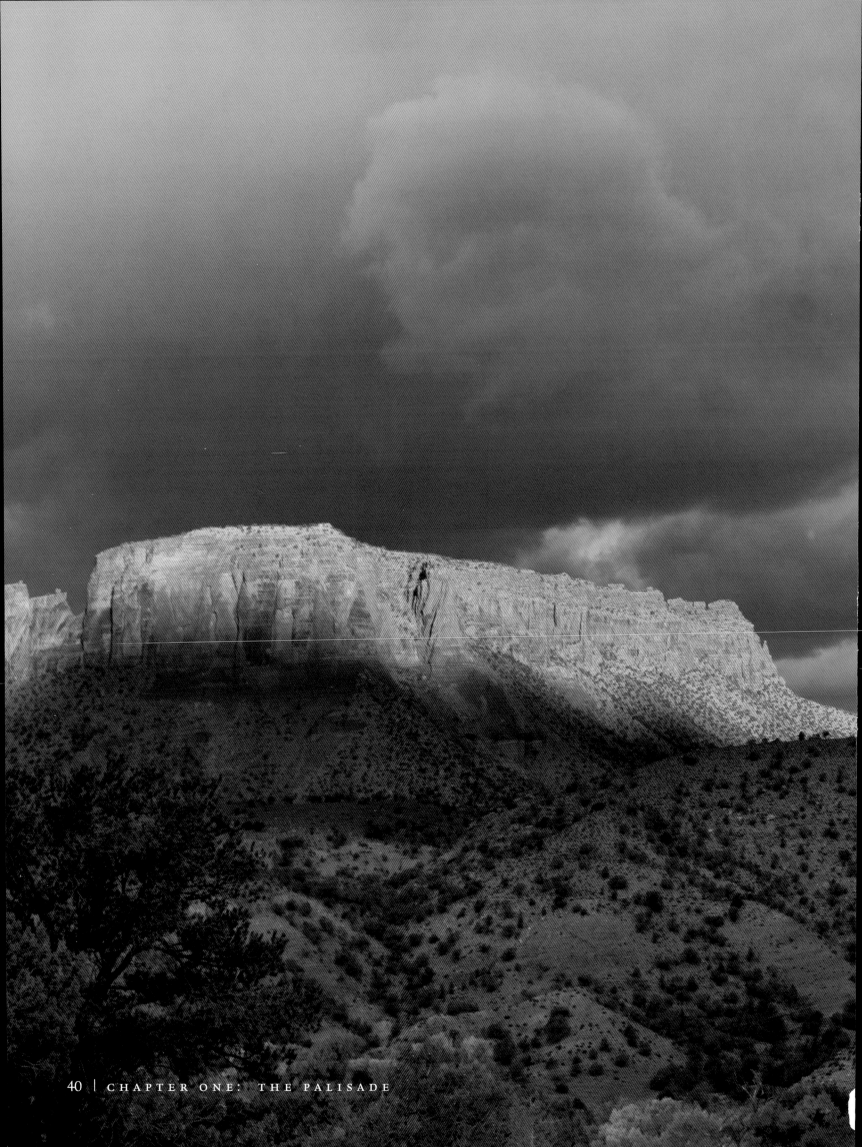

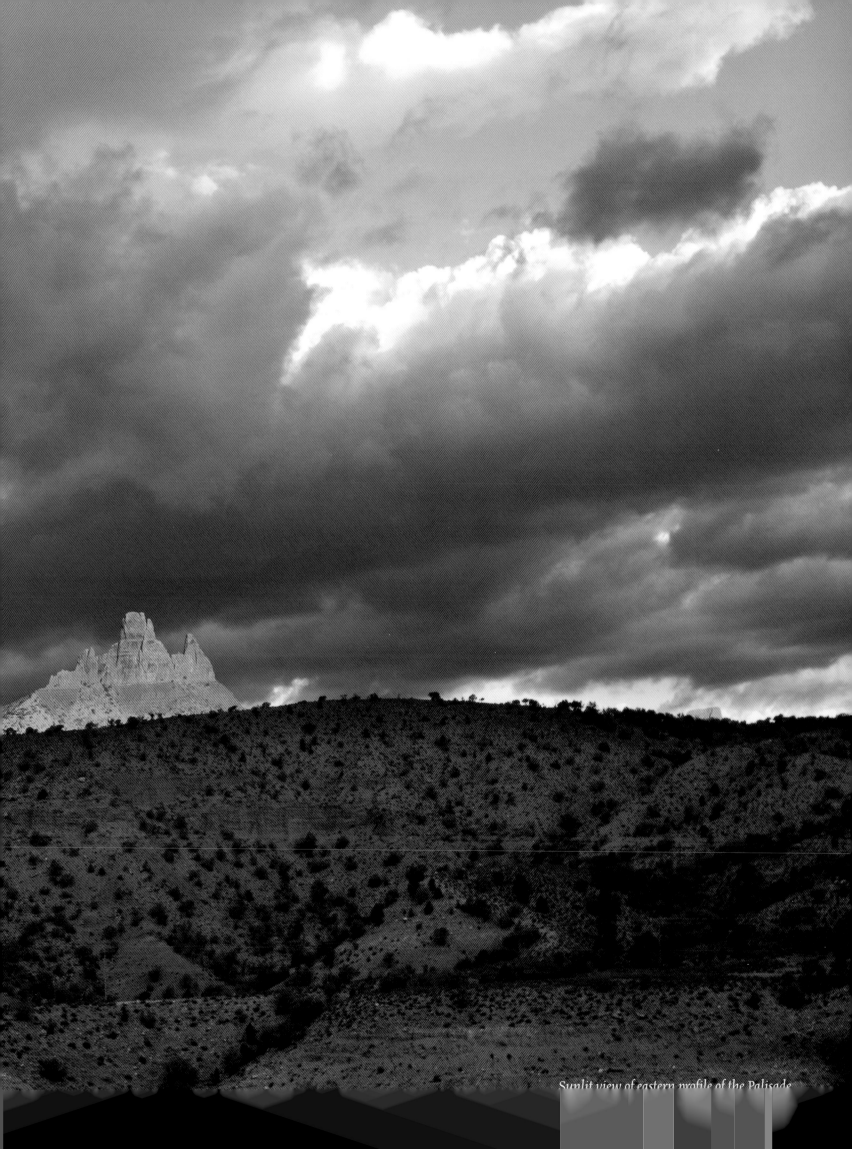

Sunlit view of eastern profile of the Palisade

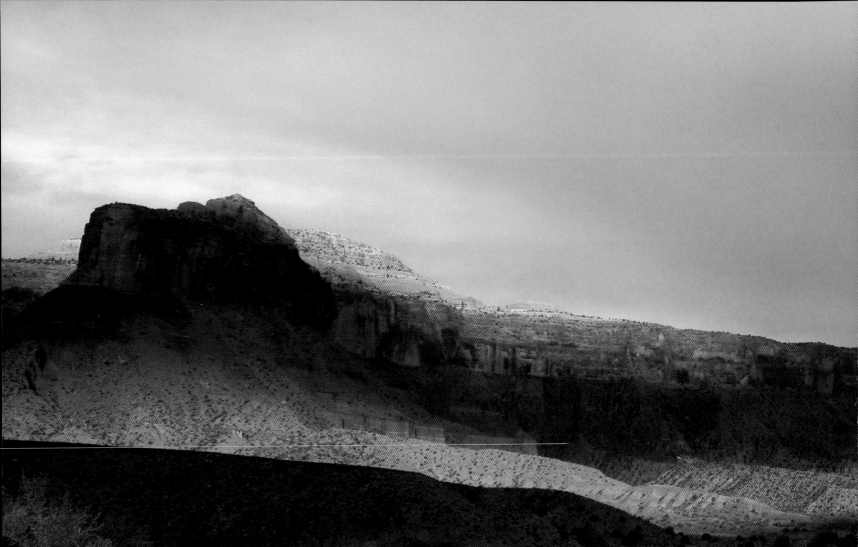

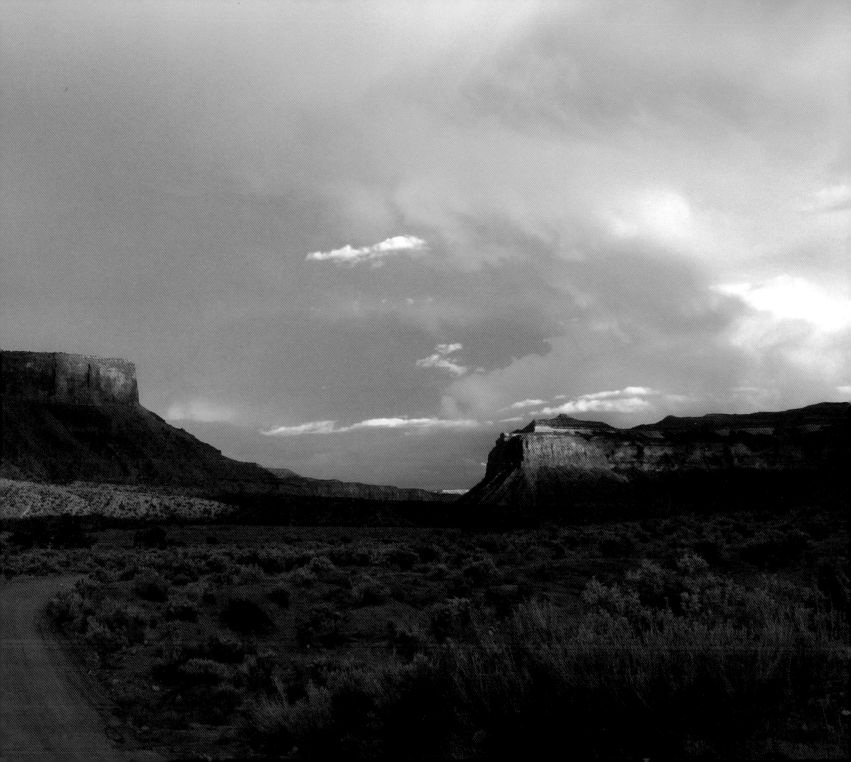

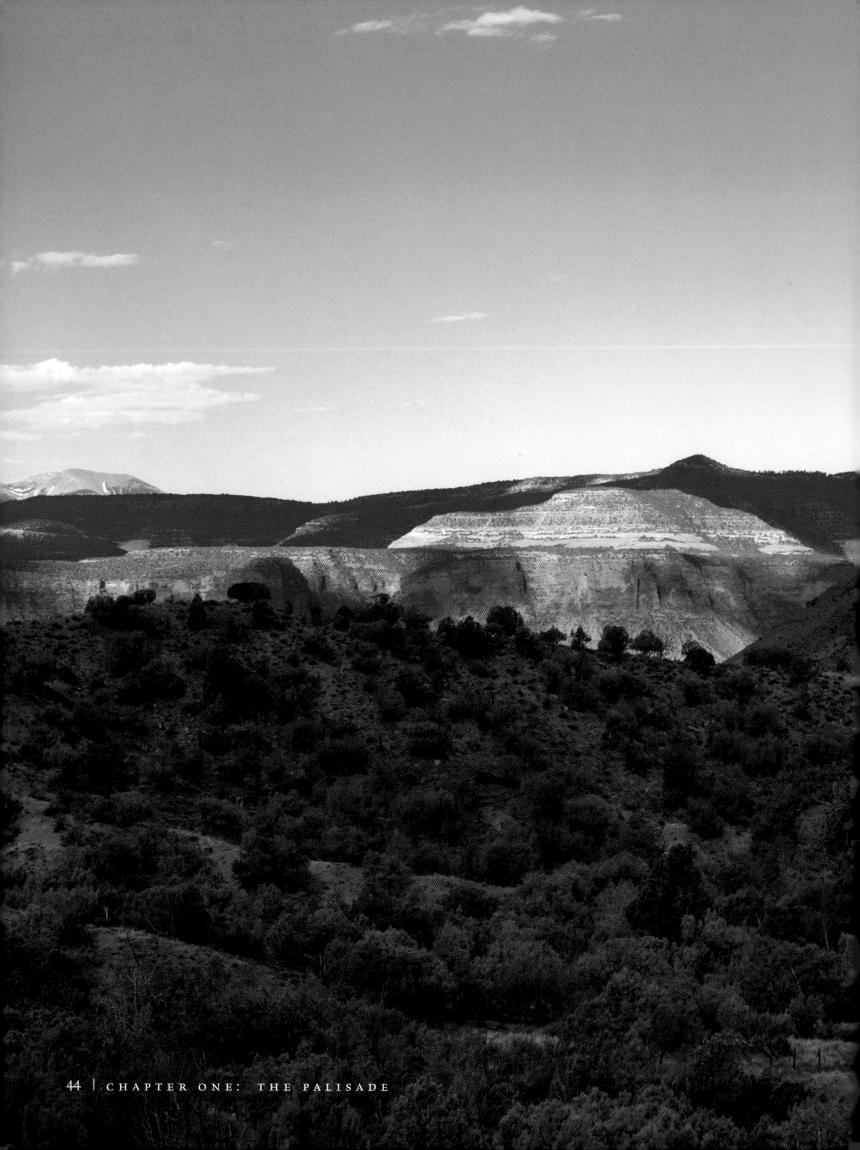

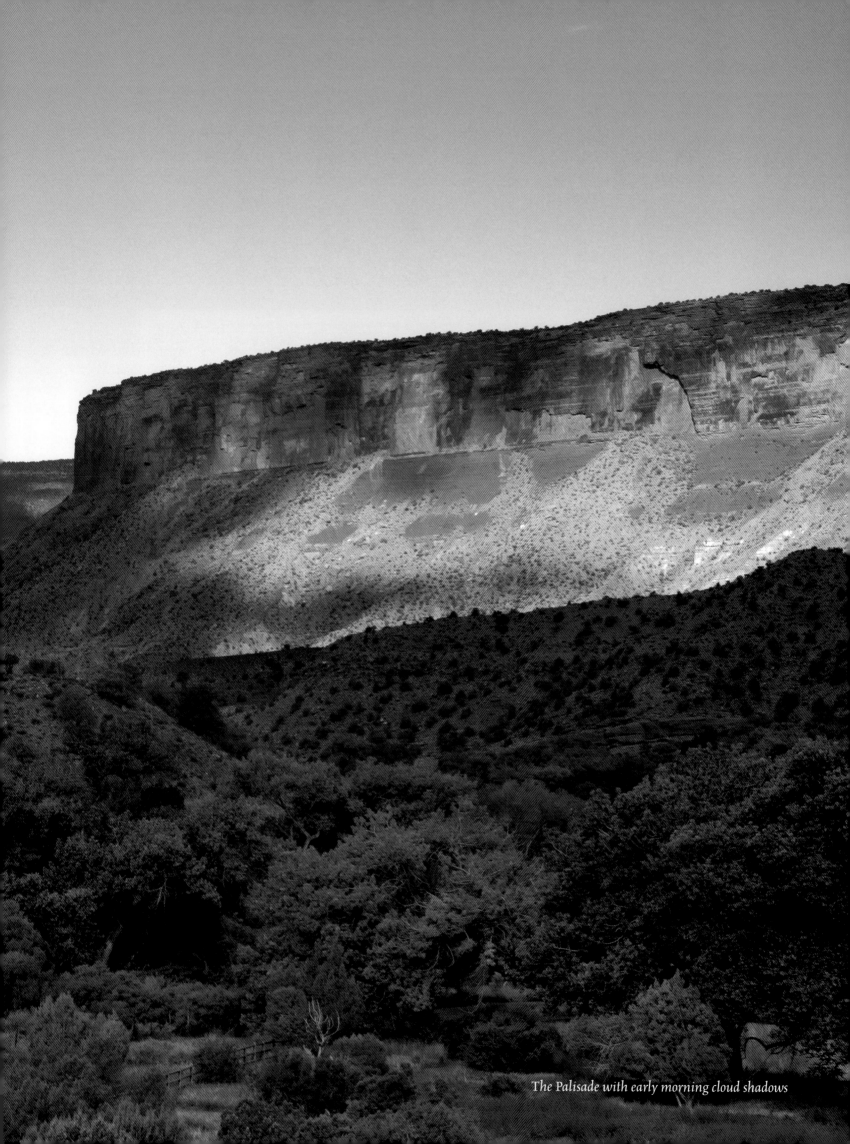

The Palisade with early morning cloud shadows

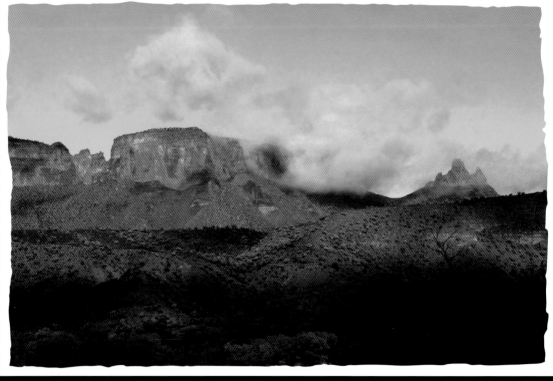

Clouds on eastern wall of the Palisade

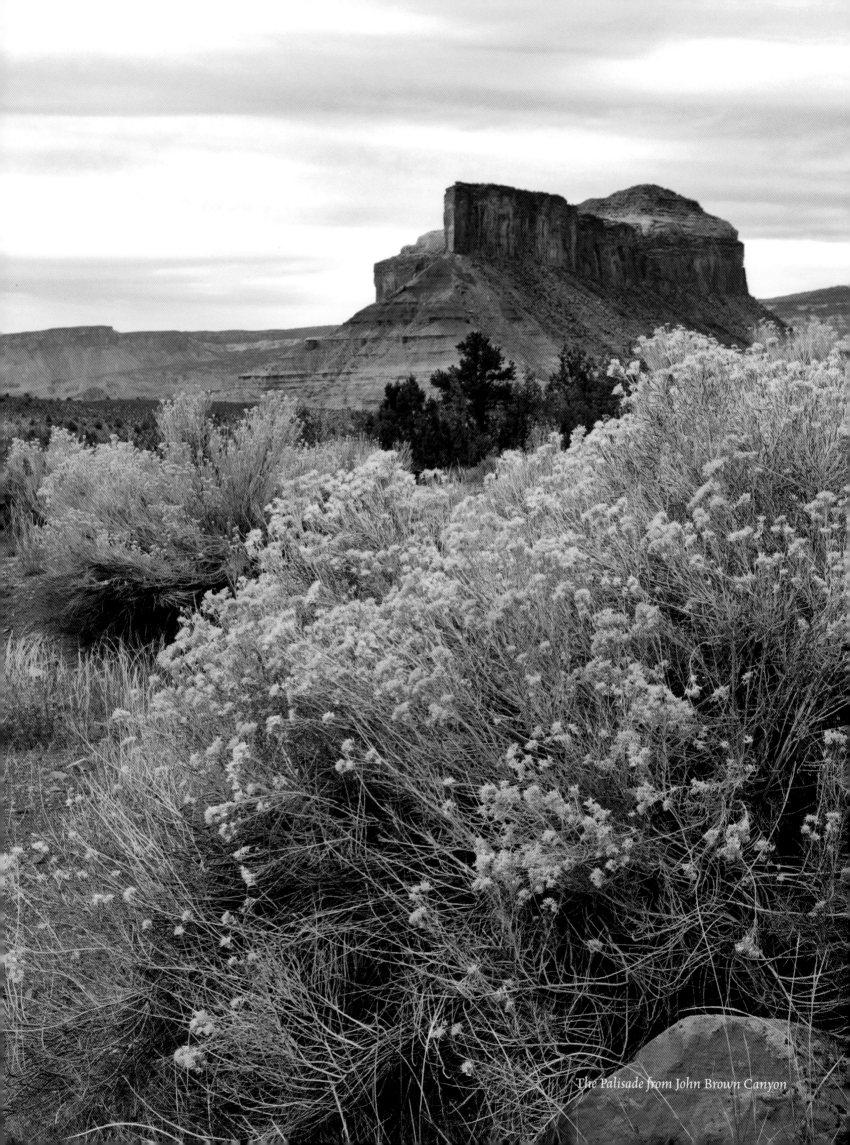

The Palisade from John Brown Canyon

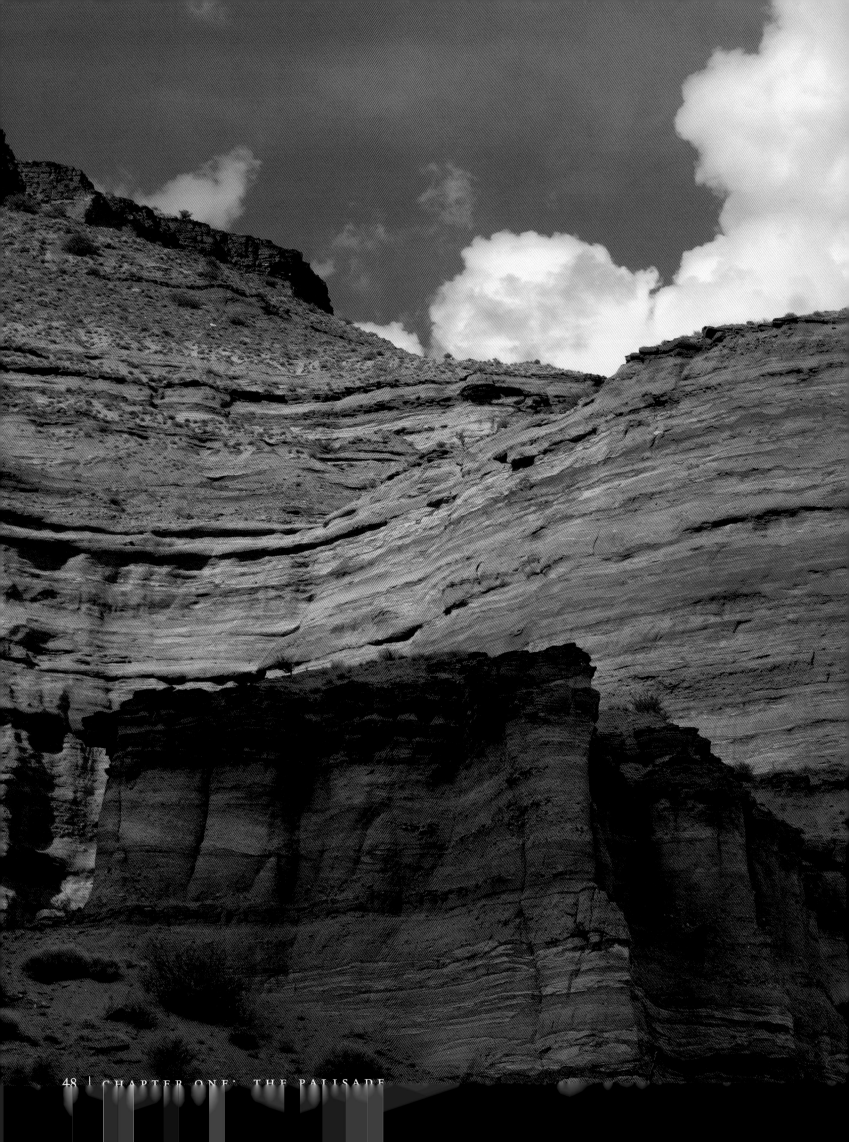

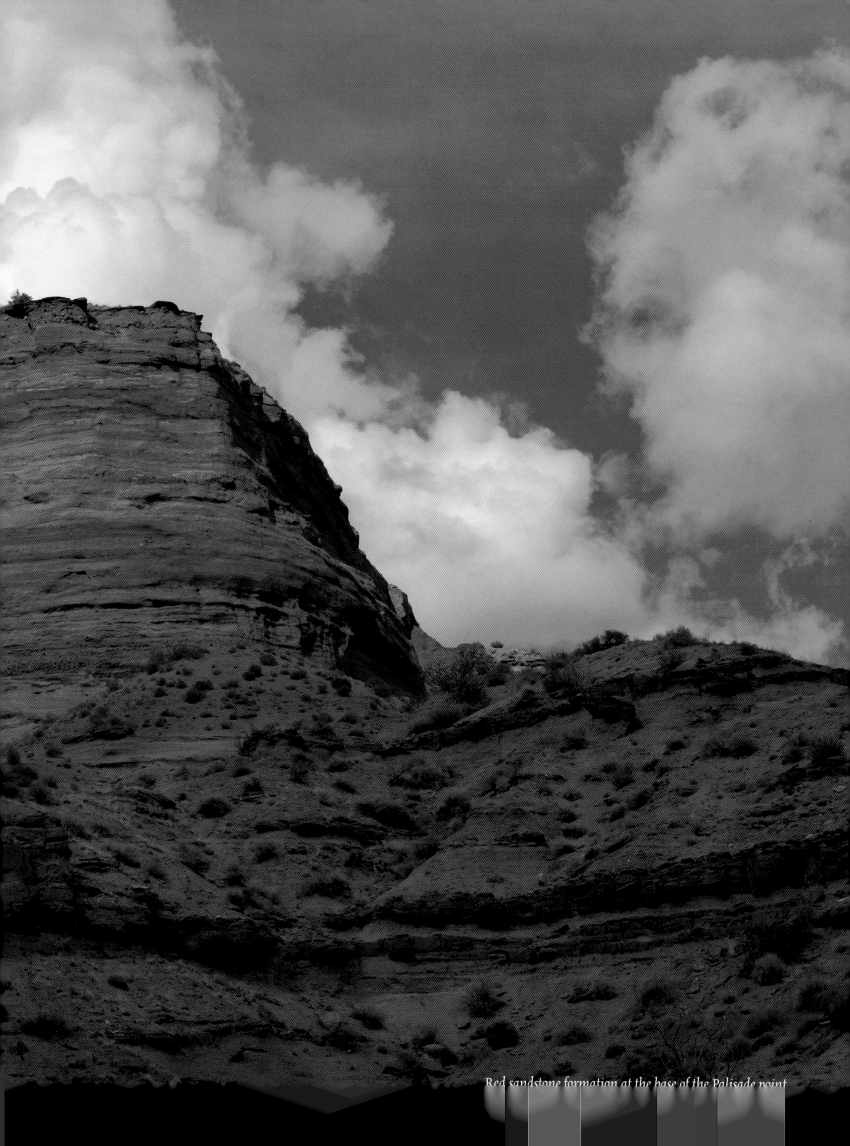

Red sandstone formation at the base of the Palisade point

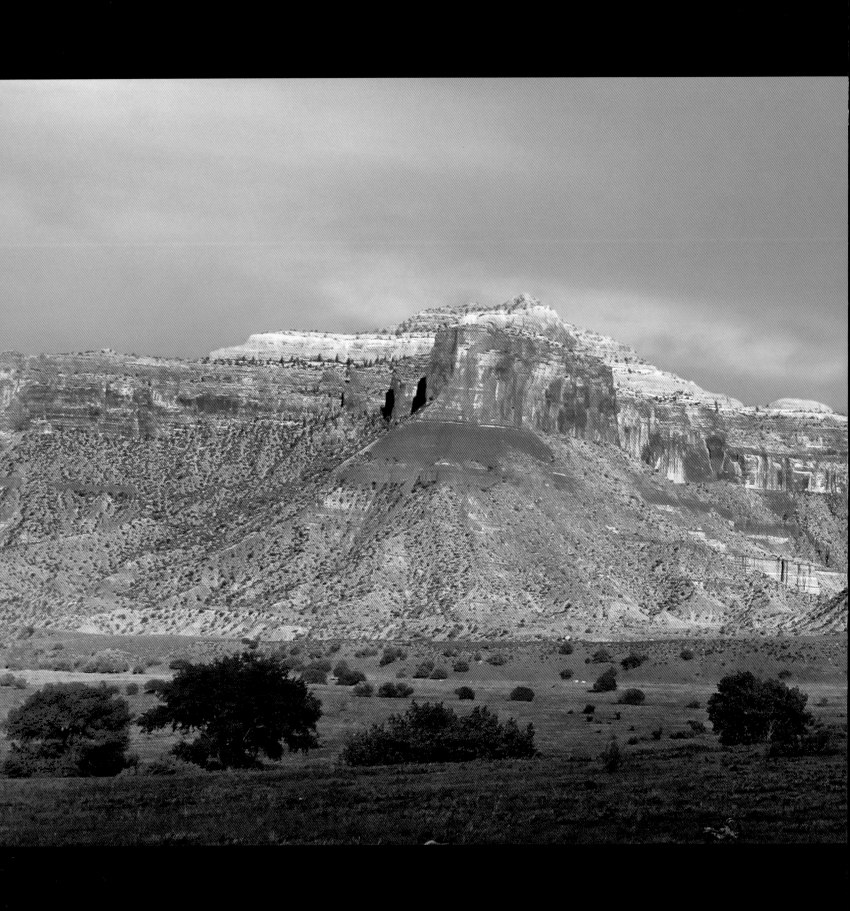

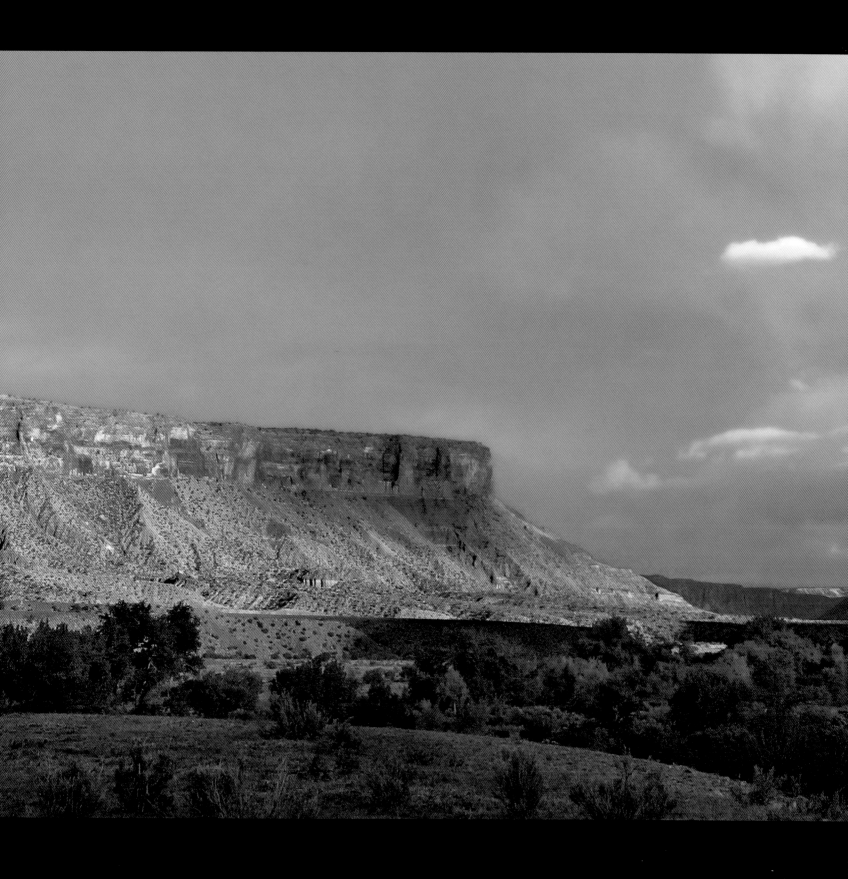

View from Dolores River of western profile of the Palisade

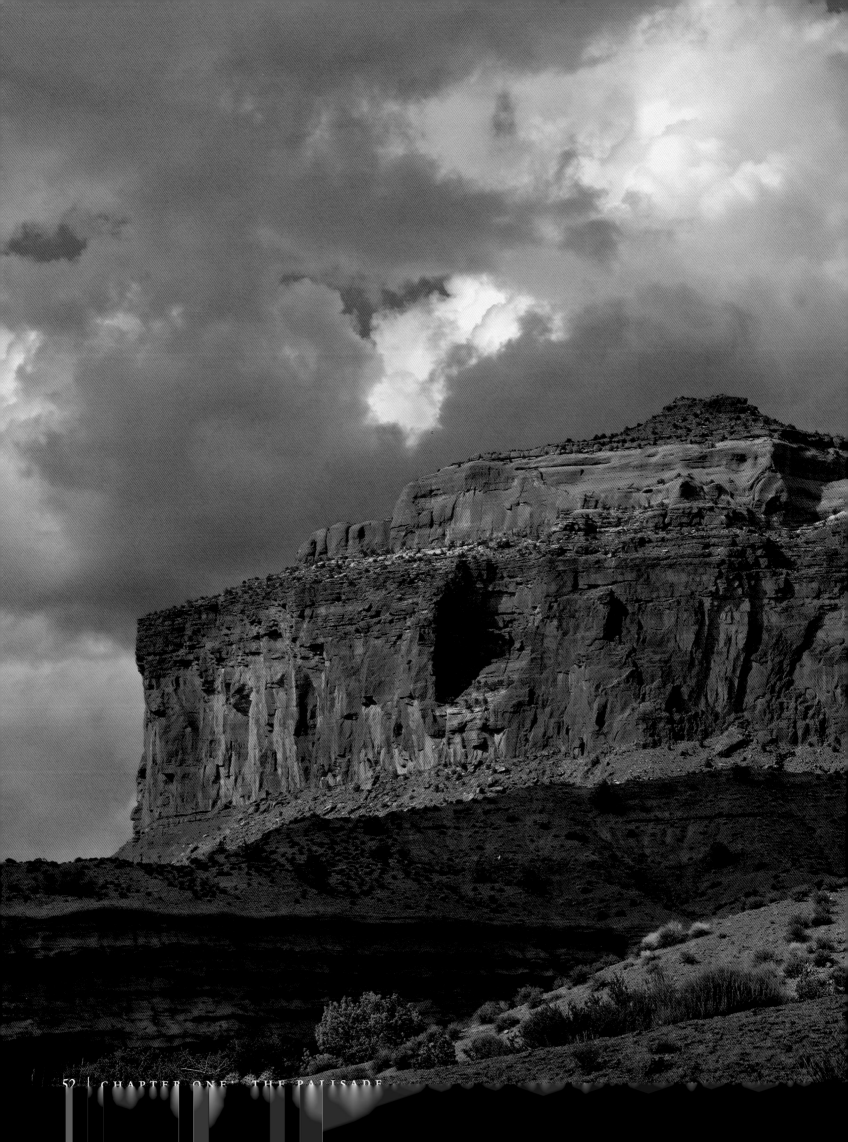

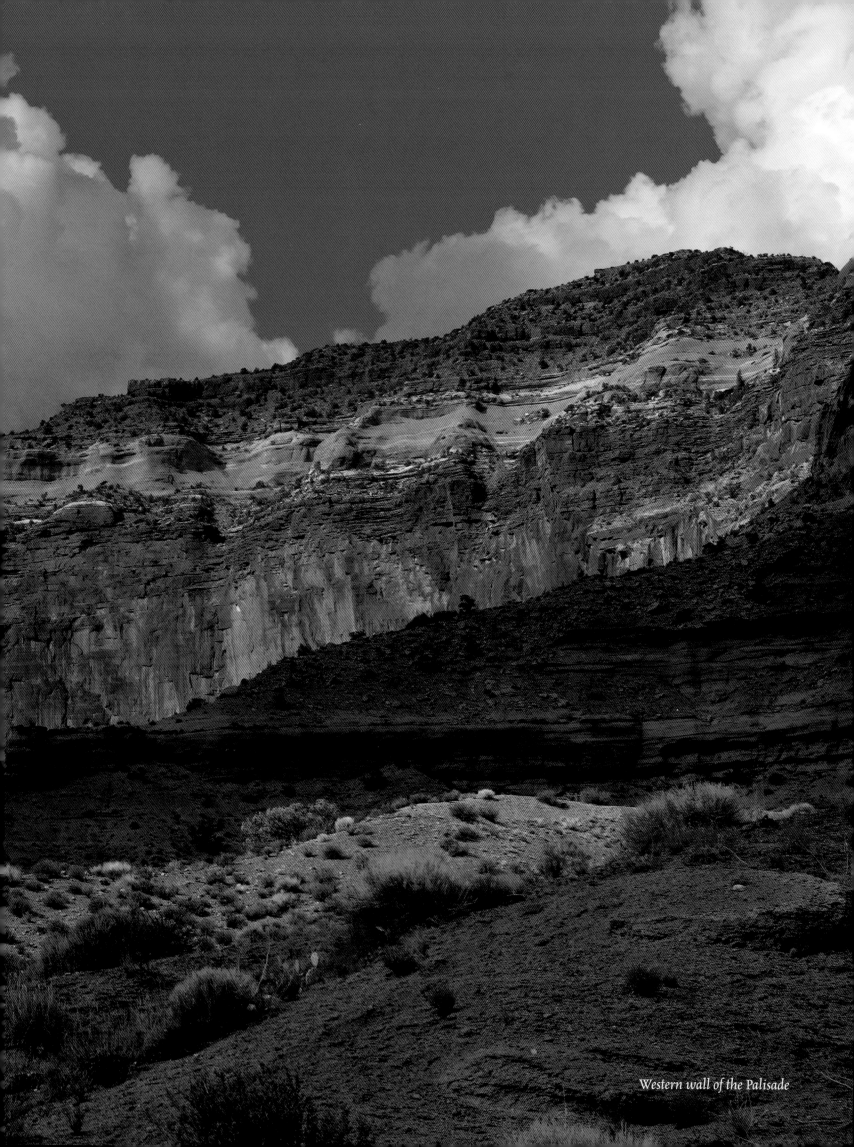

Western wall of the Palisade

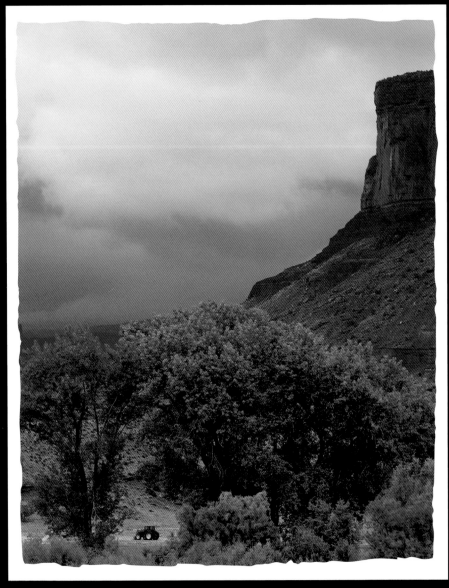

Tractor and the Palisade

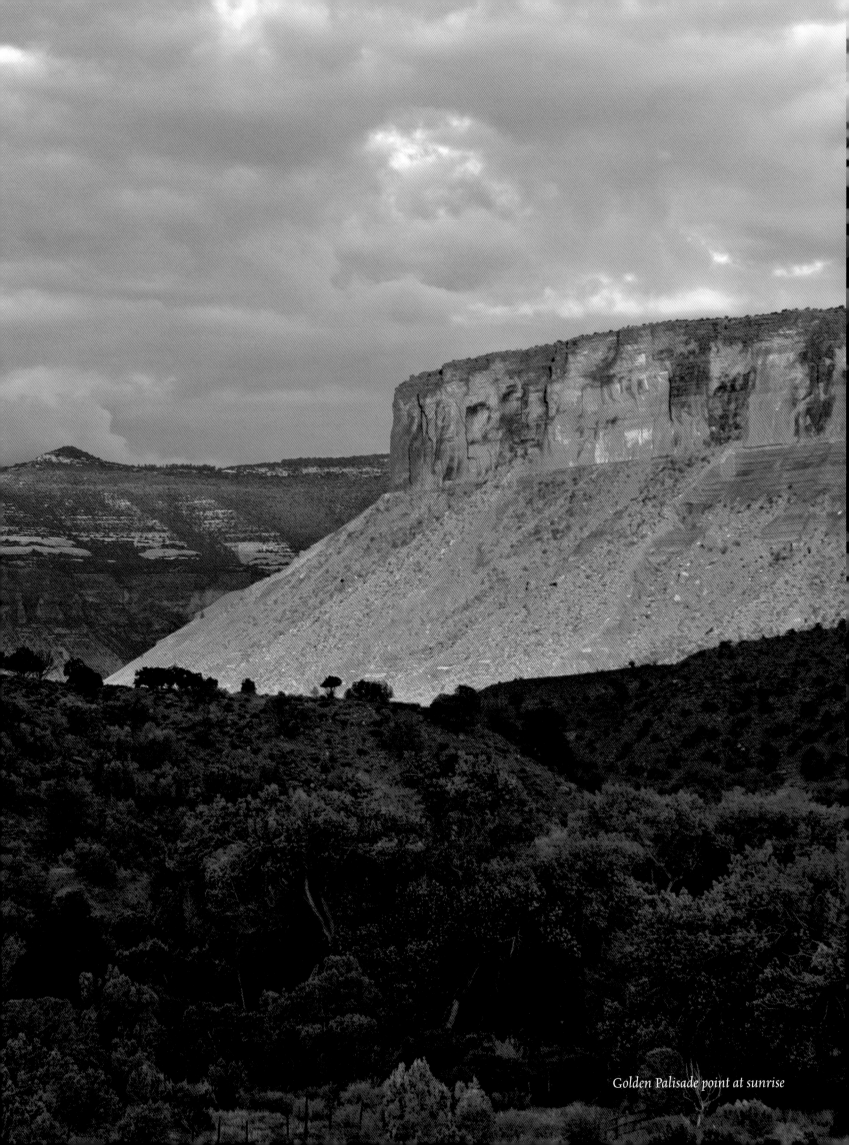

Golden Palisade point at sunrise

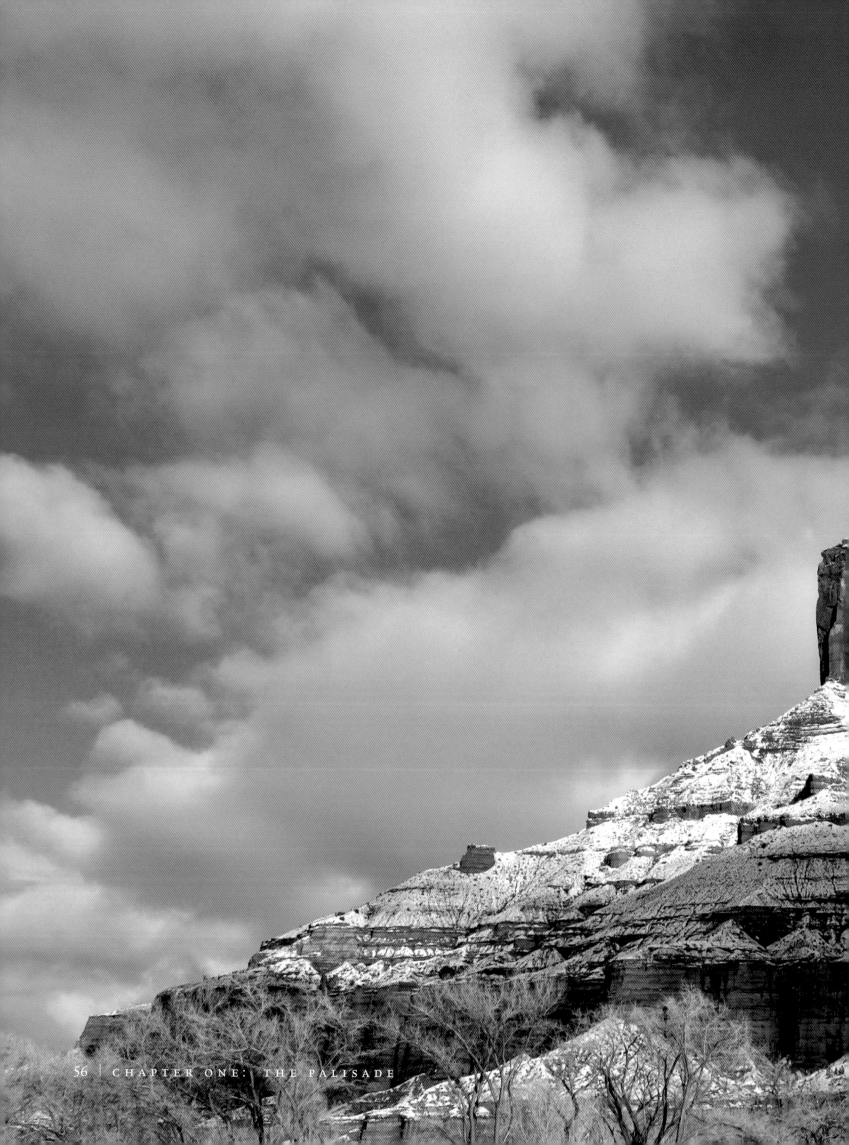

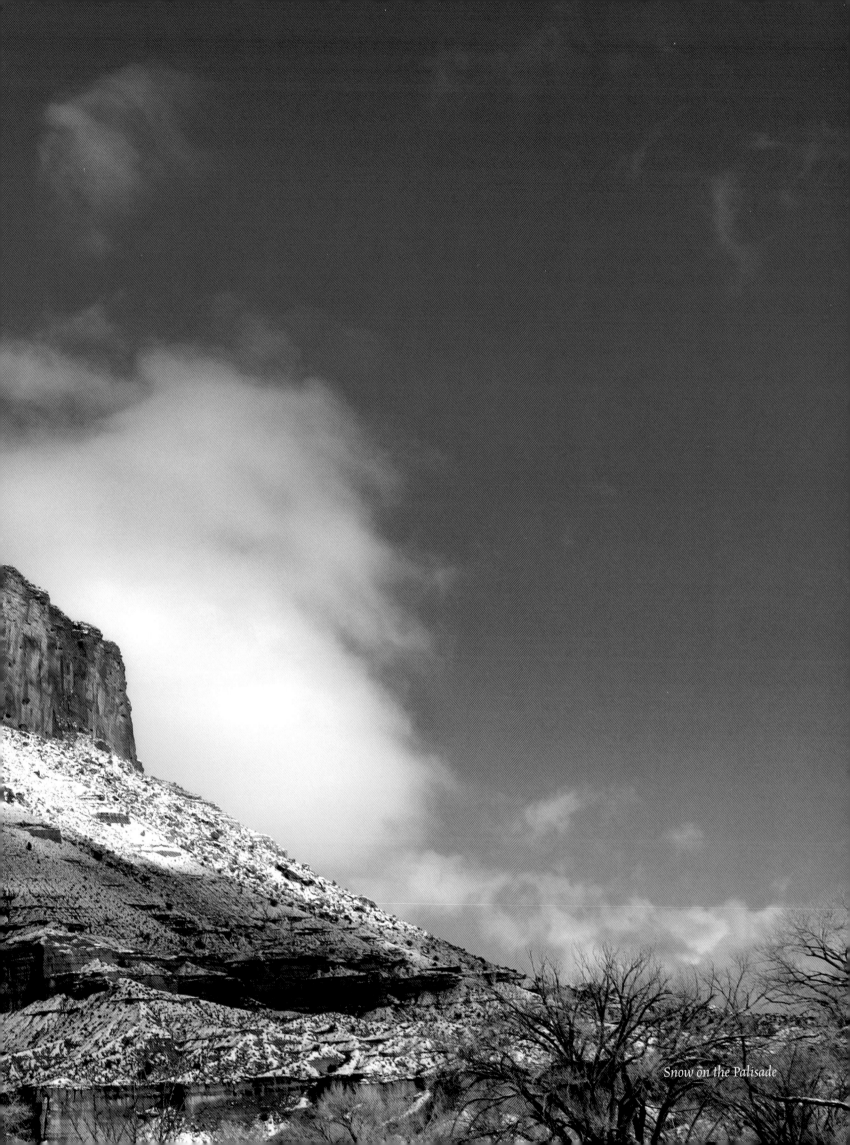

Snow on the Palisade

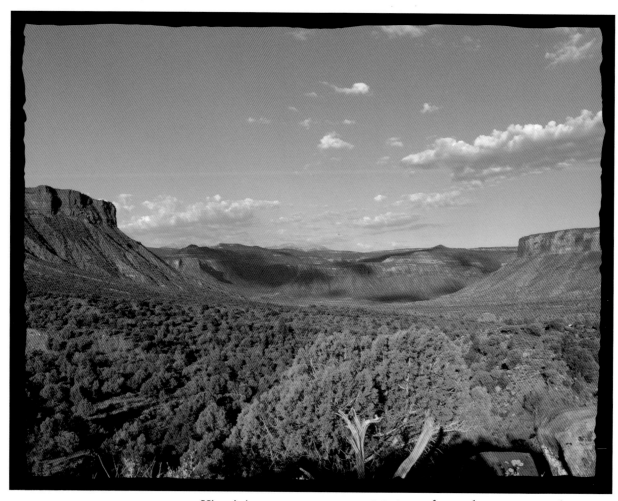

View into canyon convergence at Gateway from ridge in West Creek Canyon

CHAPTER TWO
DOLORES RIVER CANYON

The Dolores River Canyon was cut by the determined river that travels north past Gateway on its way to join the Colorado River in Grand County, Utah. It's an area rich in beauty, gilded in history, and populated by very few. Roads meander along rivers and creeks, revealing intermittent views of our intriguing past and stunning present.

The past shines from majestic cliff walls that display geologic layers reaching back more than 300 million years. It peeks out from ancient petroglyphs etched into protected cave walls, and from meadows lined with cottonwoods where teepees once stood. The past is wrapped in the beauty of the present as much of this land is preserved, and private landholding is rare. It's a place where the planet opens up to tell its story, and much remains unchanged.

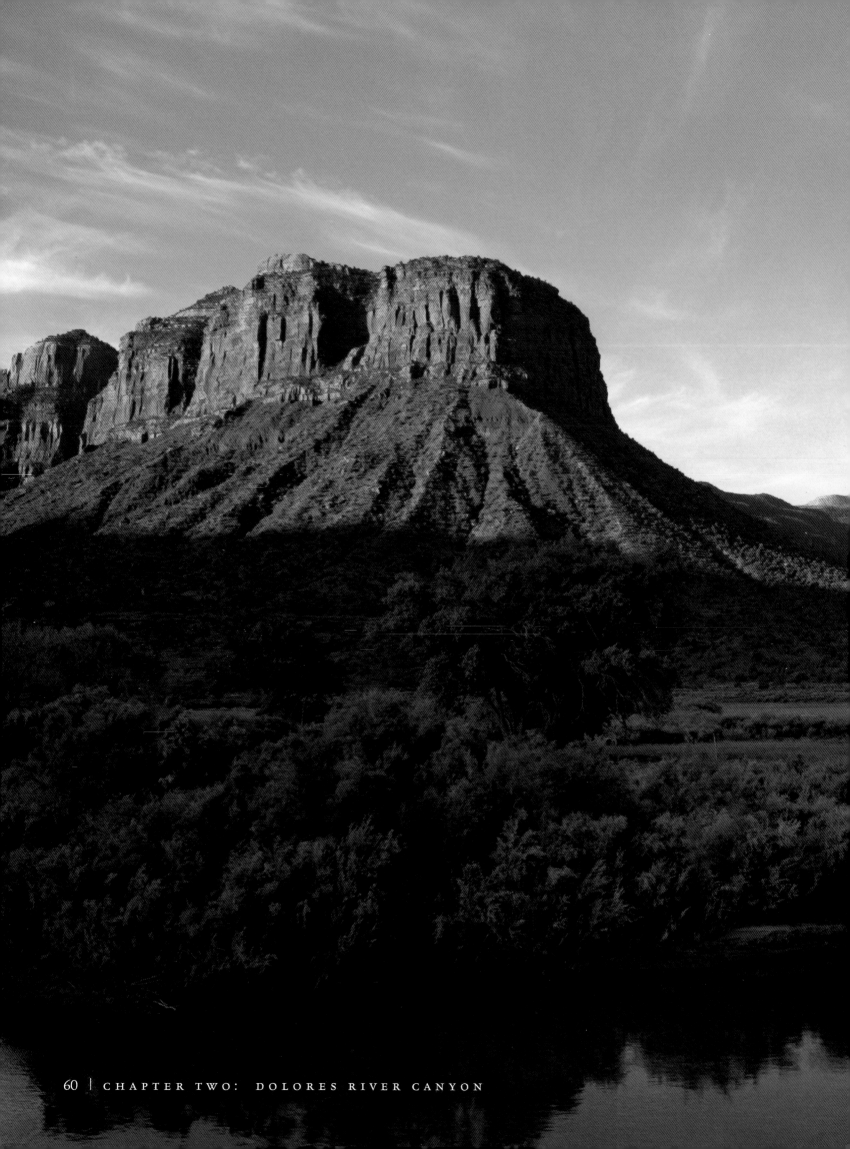

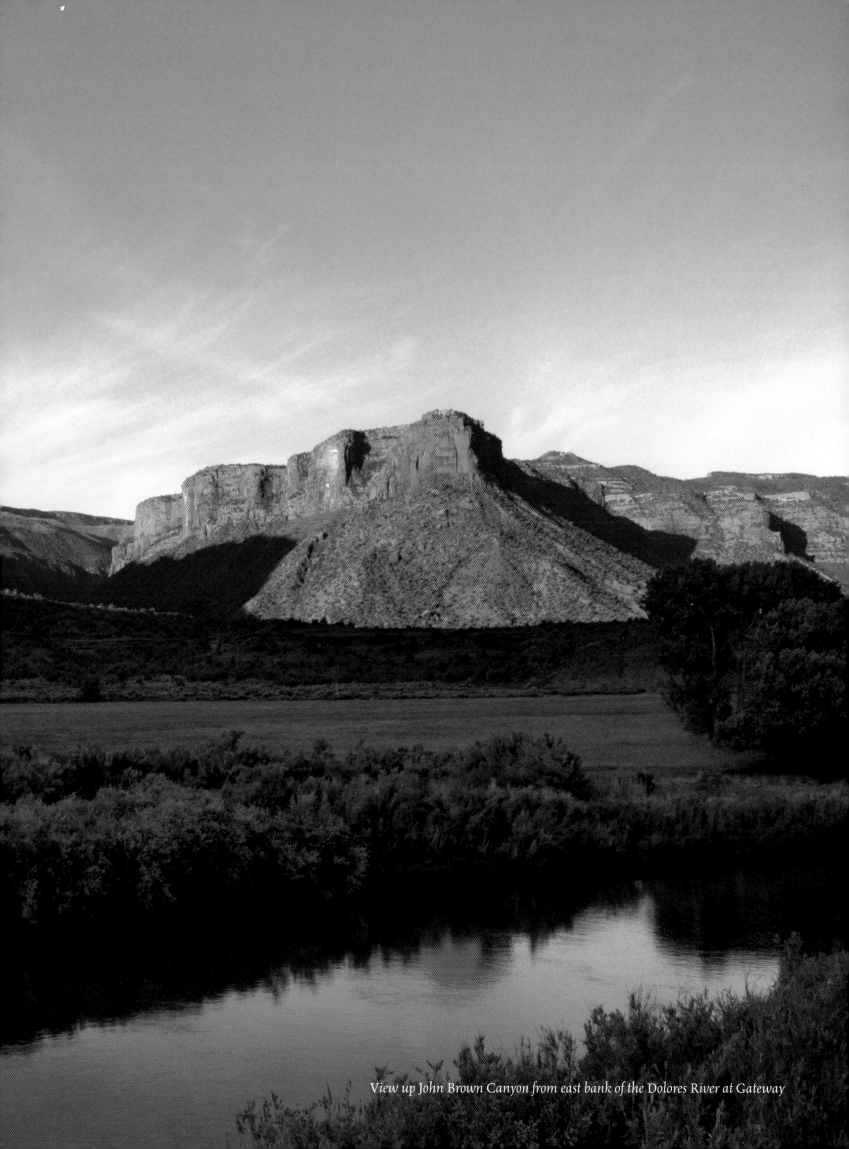

View up John Brown Canyon from east bank of the Dolores River at Gateway

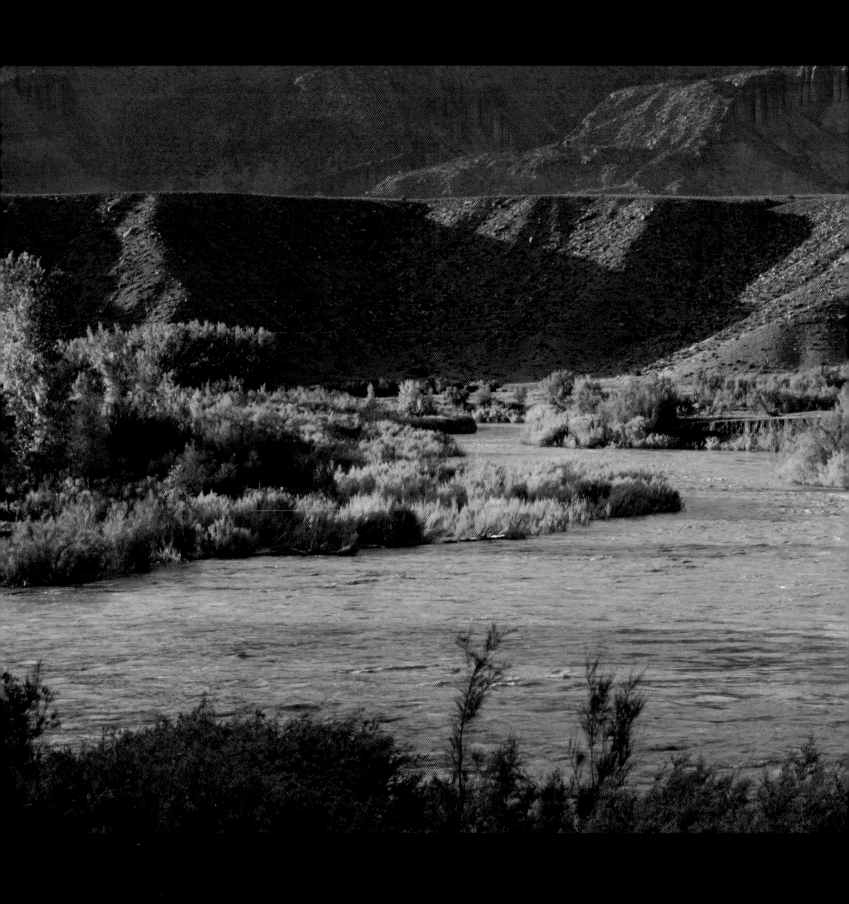

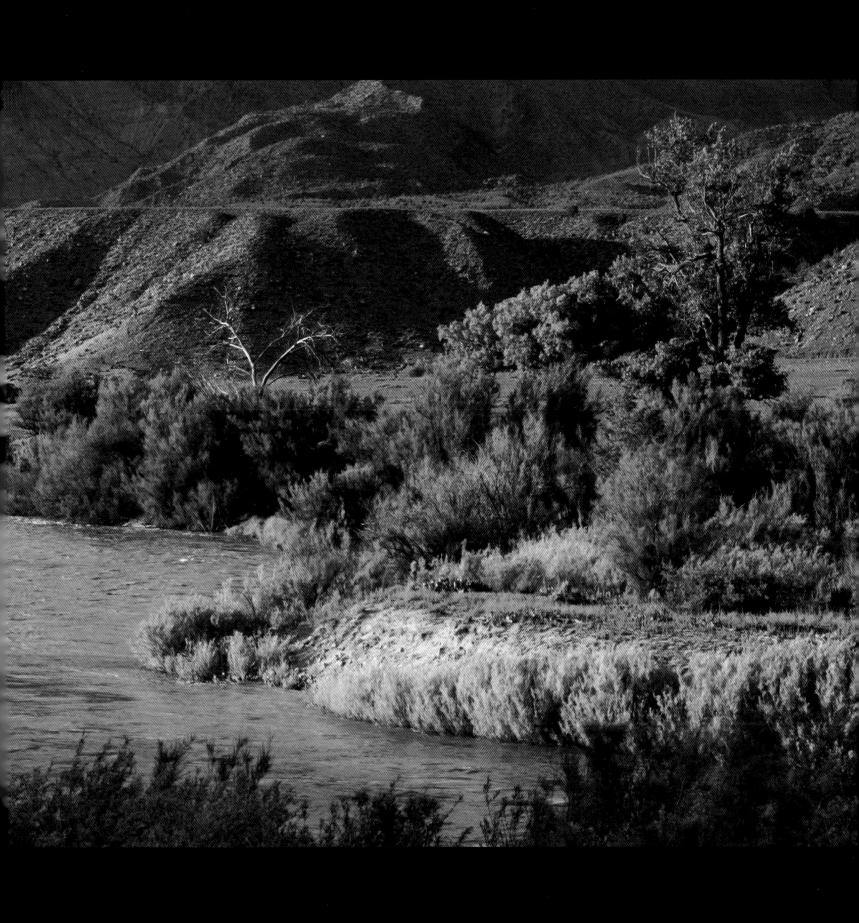

Dolores River flowing northwest toward Utah and its rendezvous with the Colorado River

Ranch house under towering red canyon walls of the Dolores River at Gateway

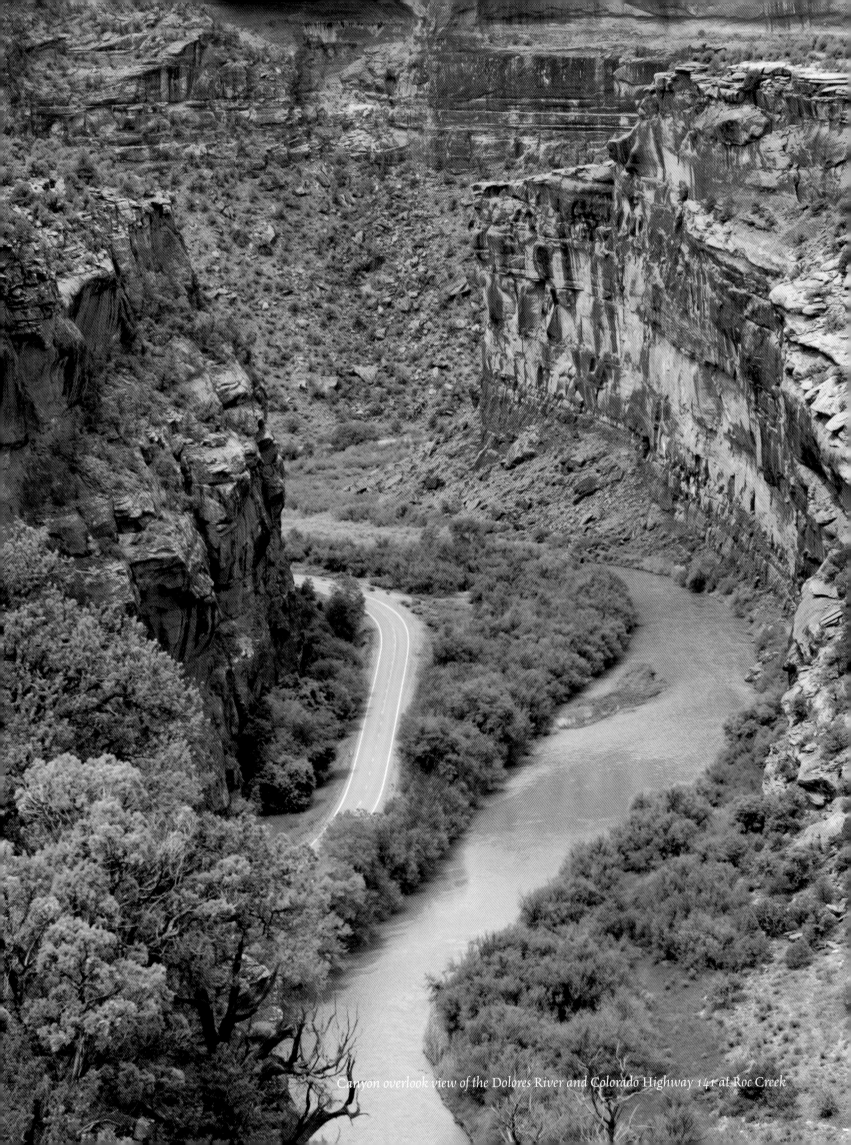

Canyon overlook view of the Dolores River and Colorado Highway 141 at Roc Creek

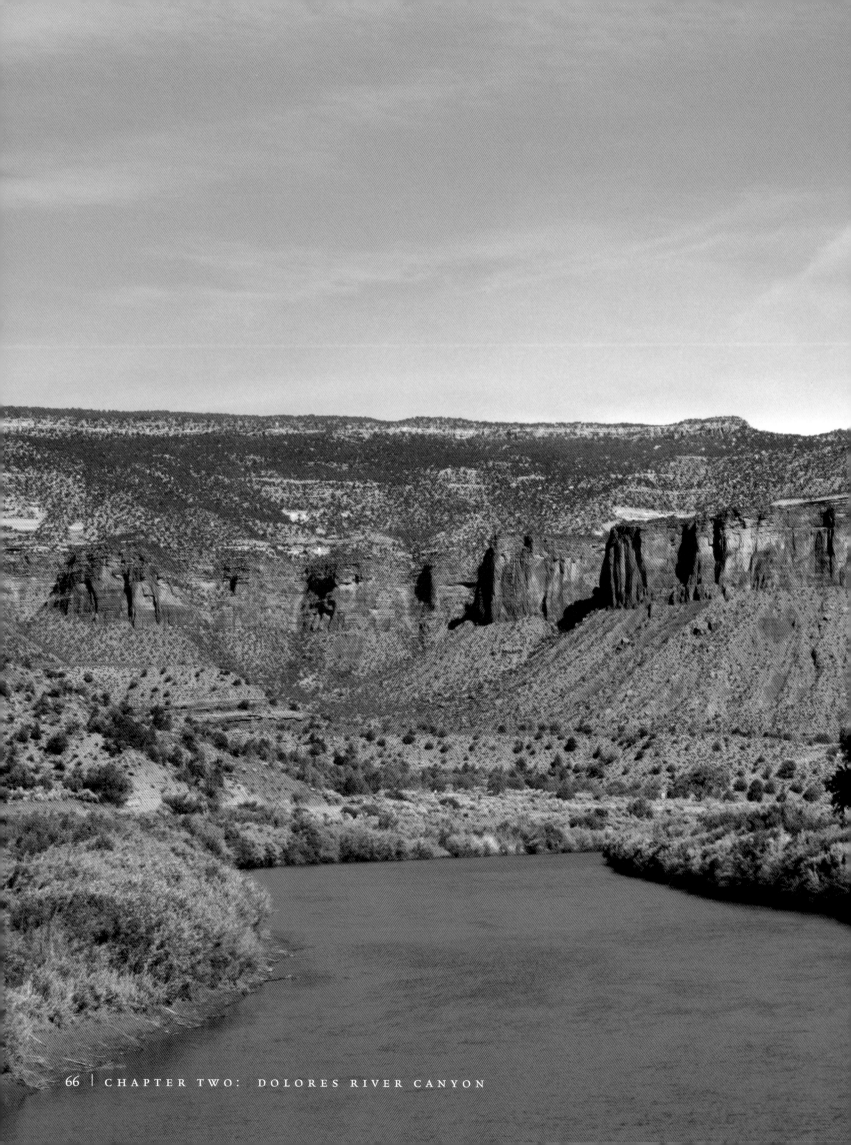

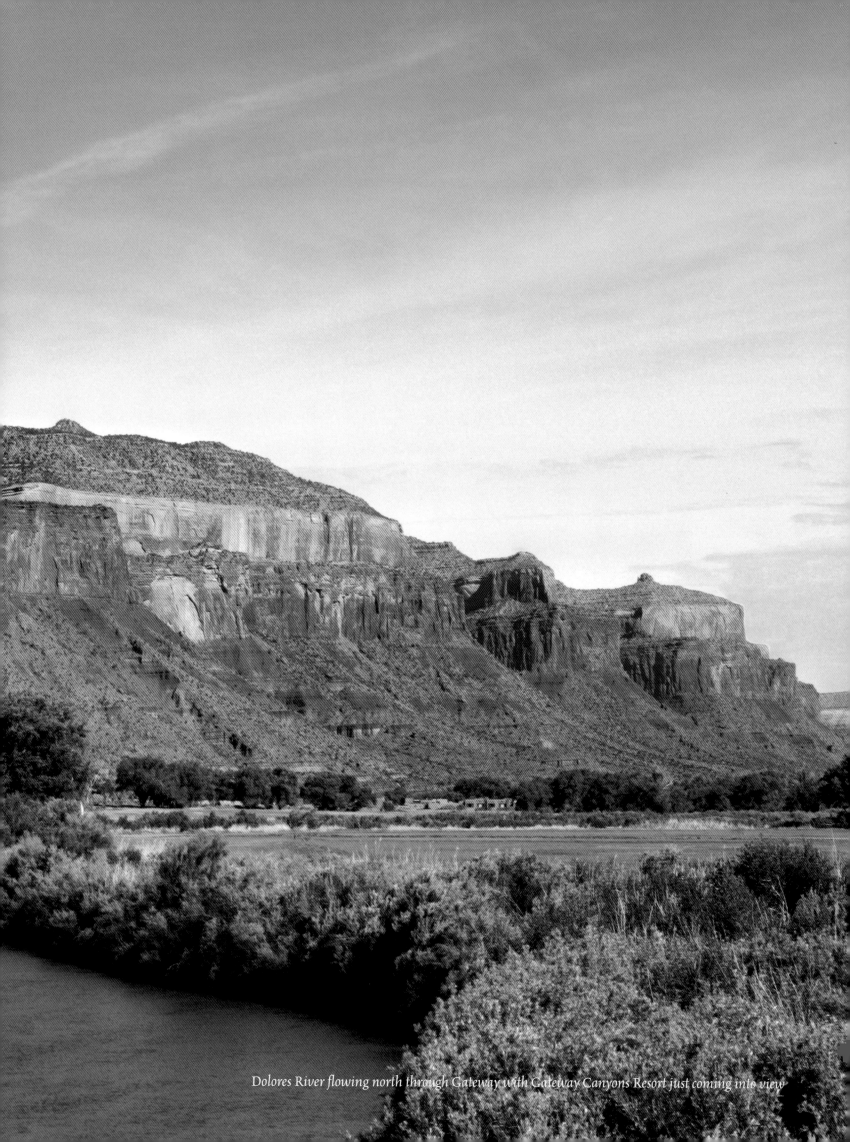

Dolores River flowing north through Gateway with Gateway Canyons Resort just coming into view

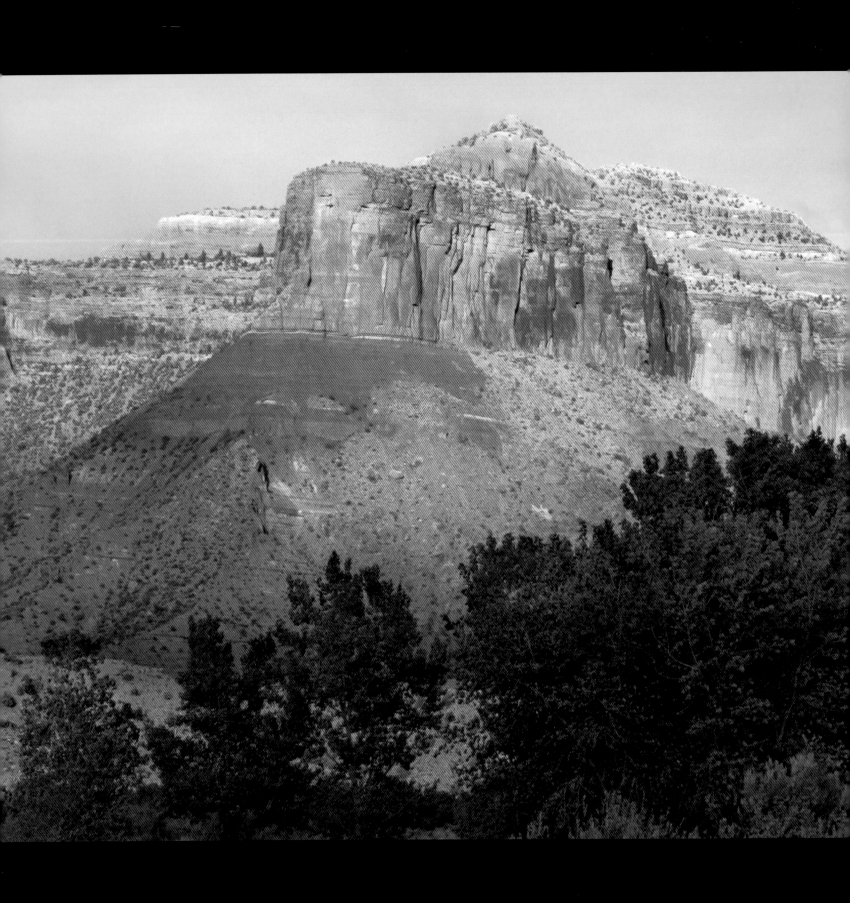

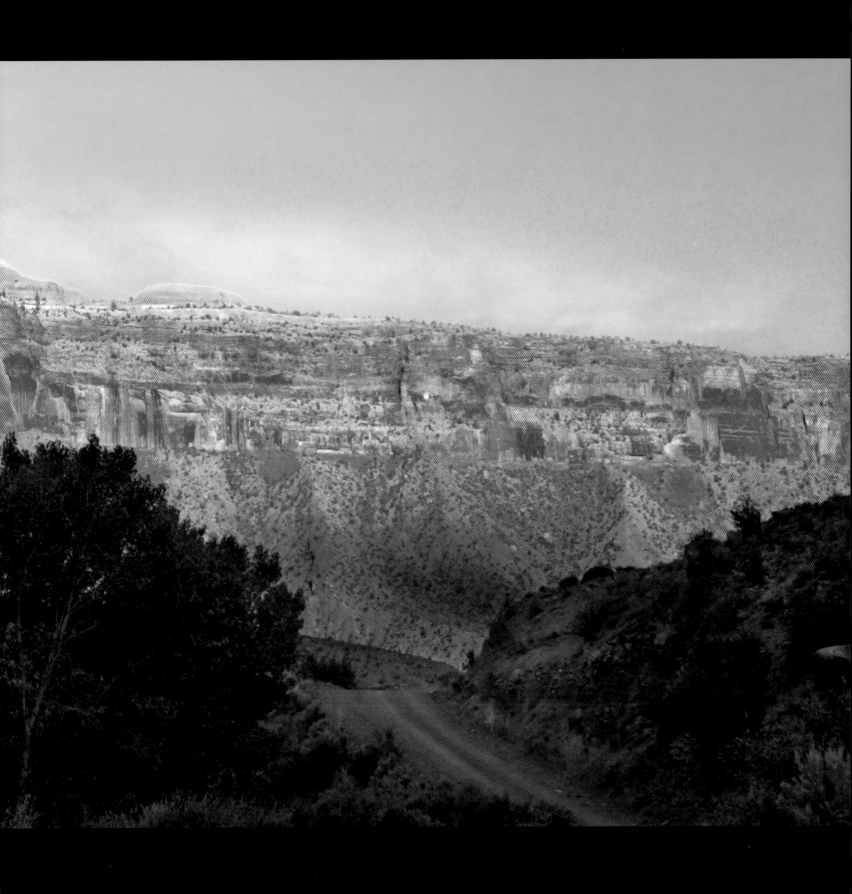

Cottonwood trees on west bank of the Dolores River in silhouette

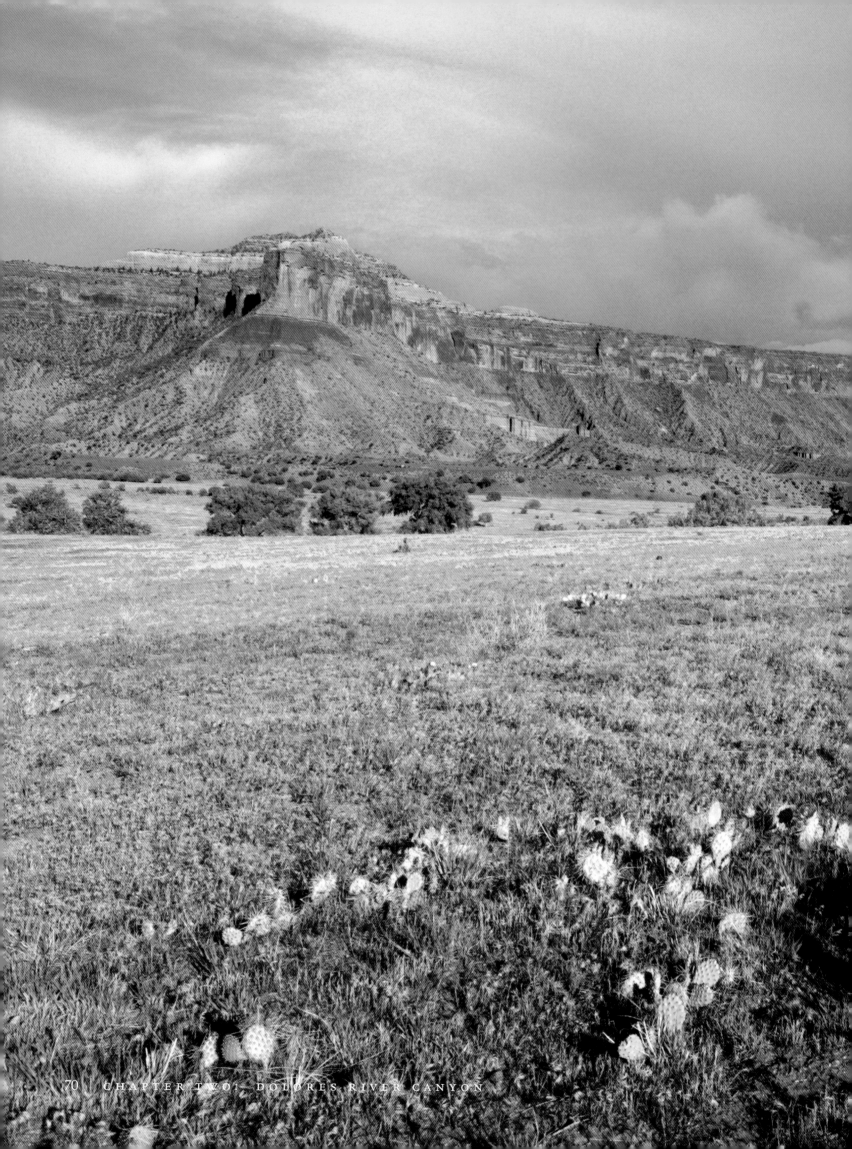

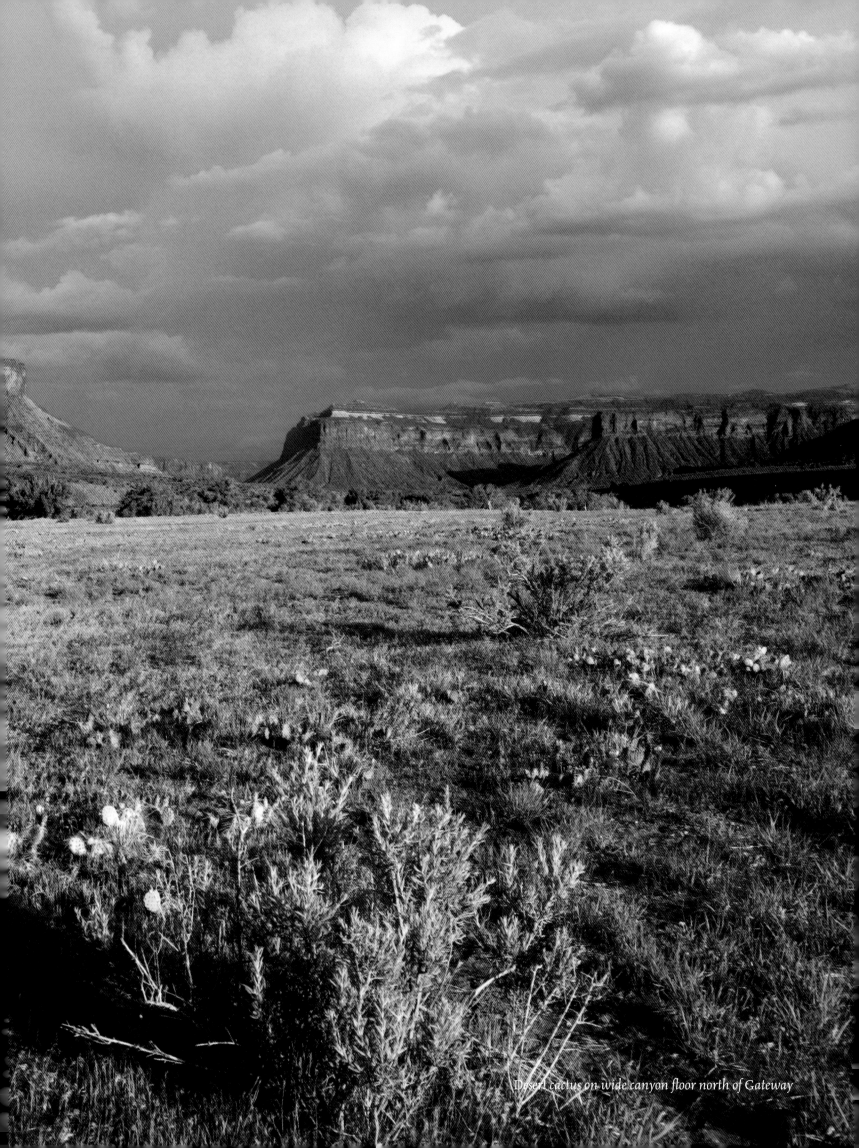

Desert cactus on wide canyon floor north of Gateway

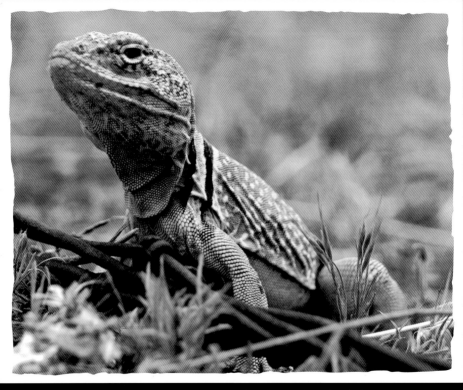

Collared lizard in the Dolores River Canyon

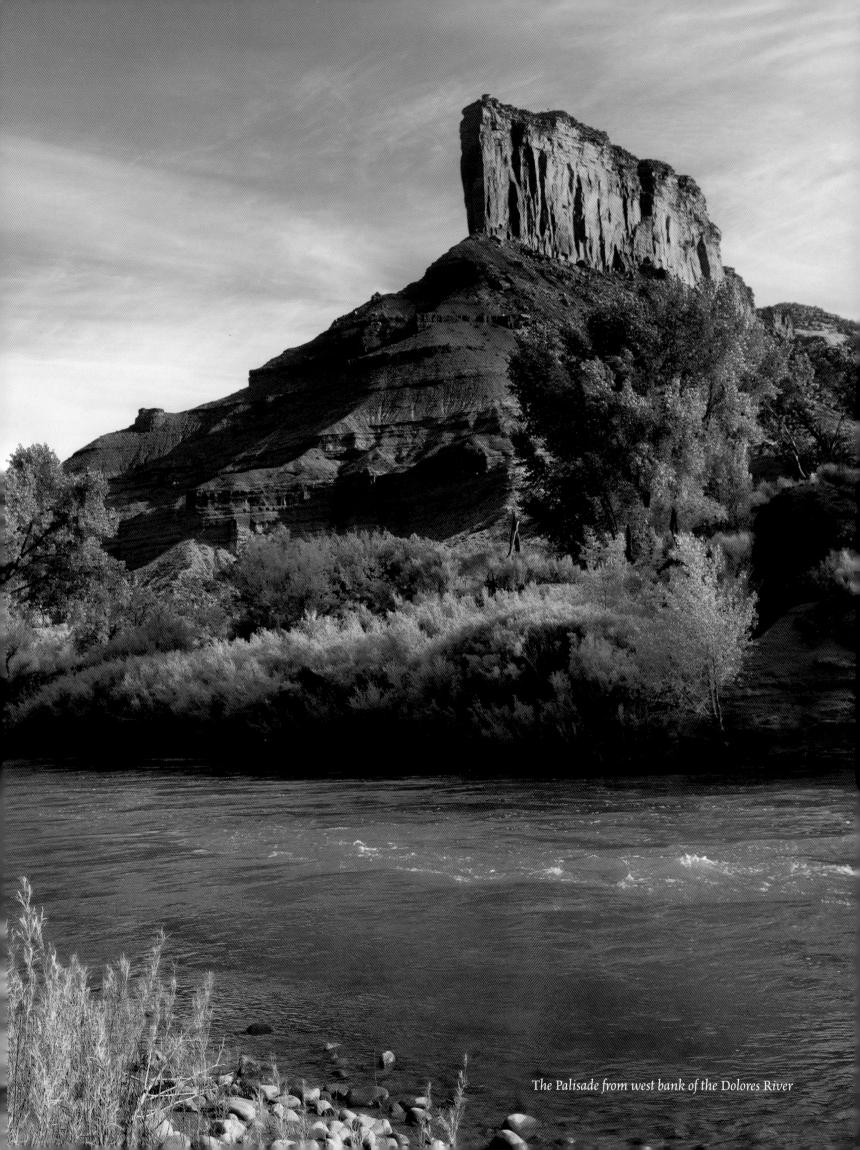

The Palisade from west bank of the Dolores River

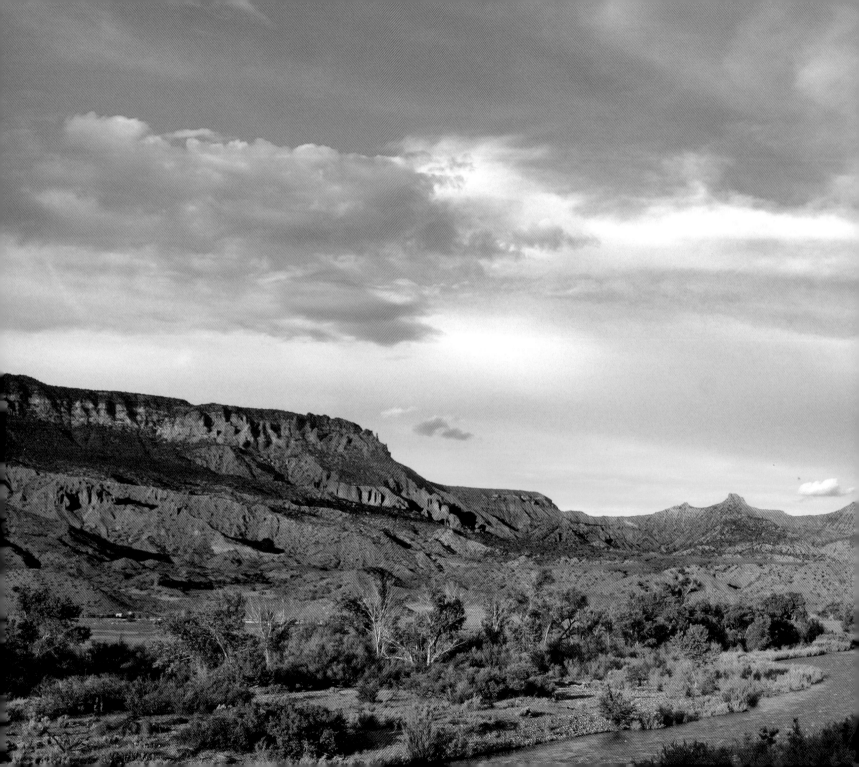

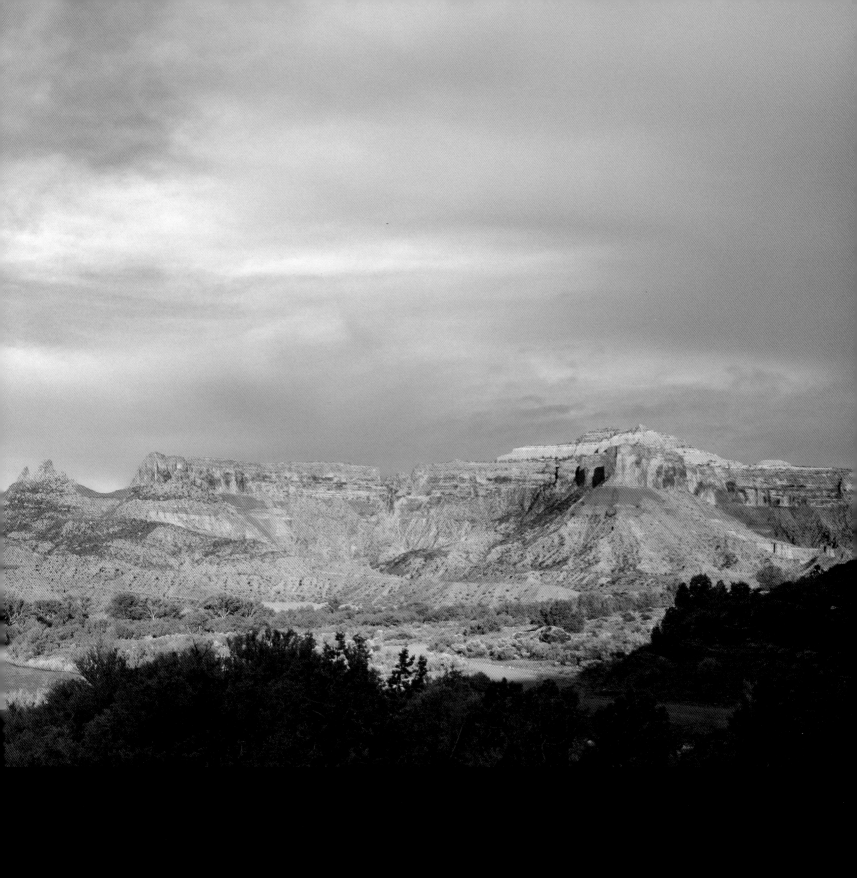

Panorama of the Dolores River Canyon as 4.1 Road winds its way south toward Gateway.

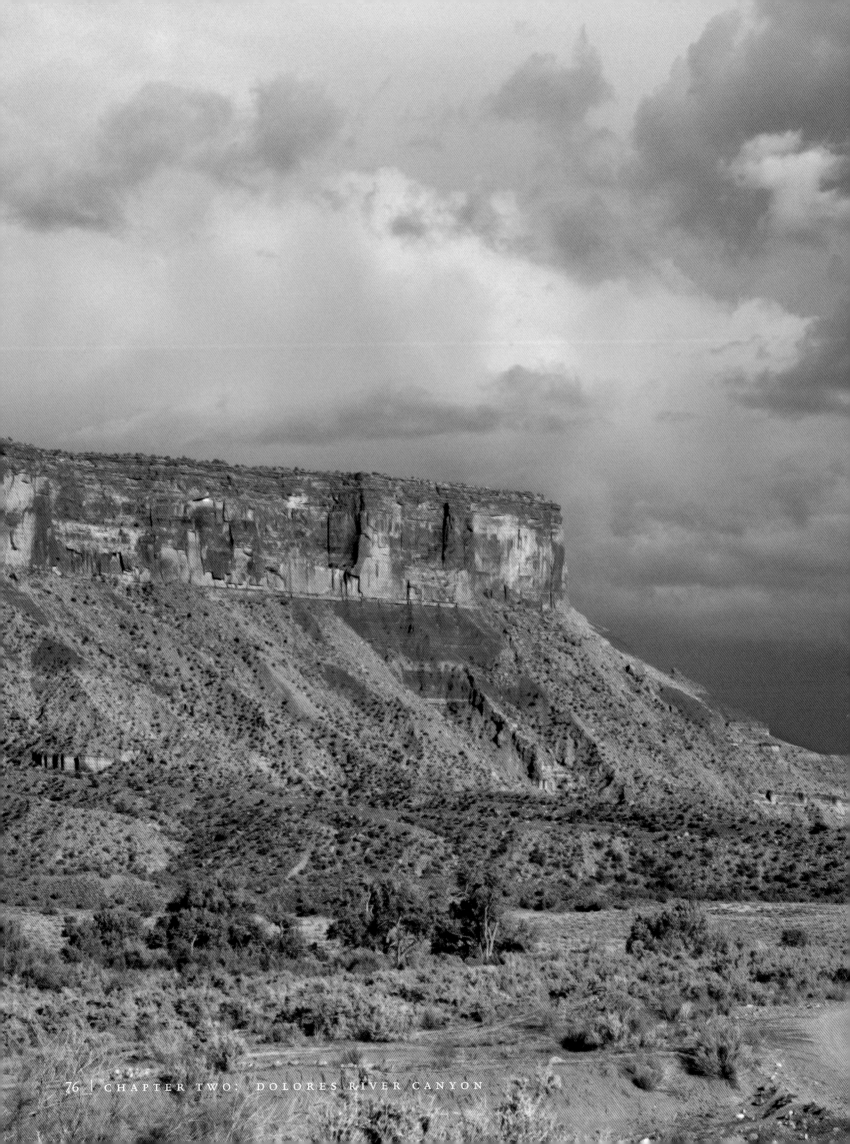

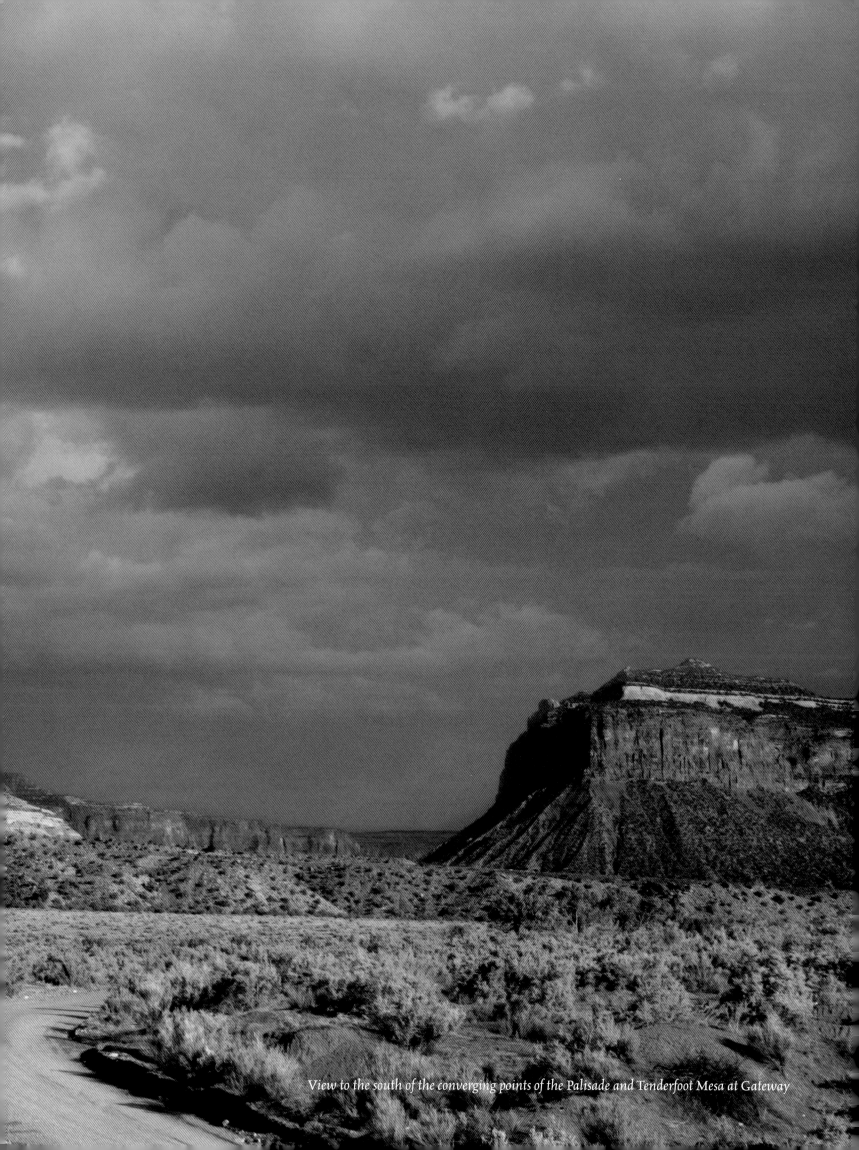
View to the south of the converging points of the Palisade and Tenderfoot Mesa at Gateway

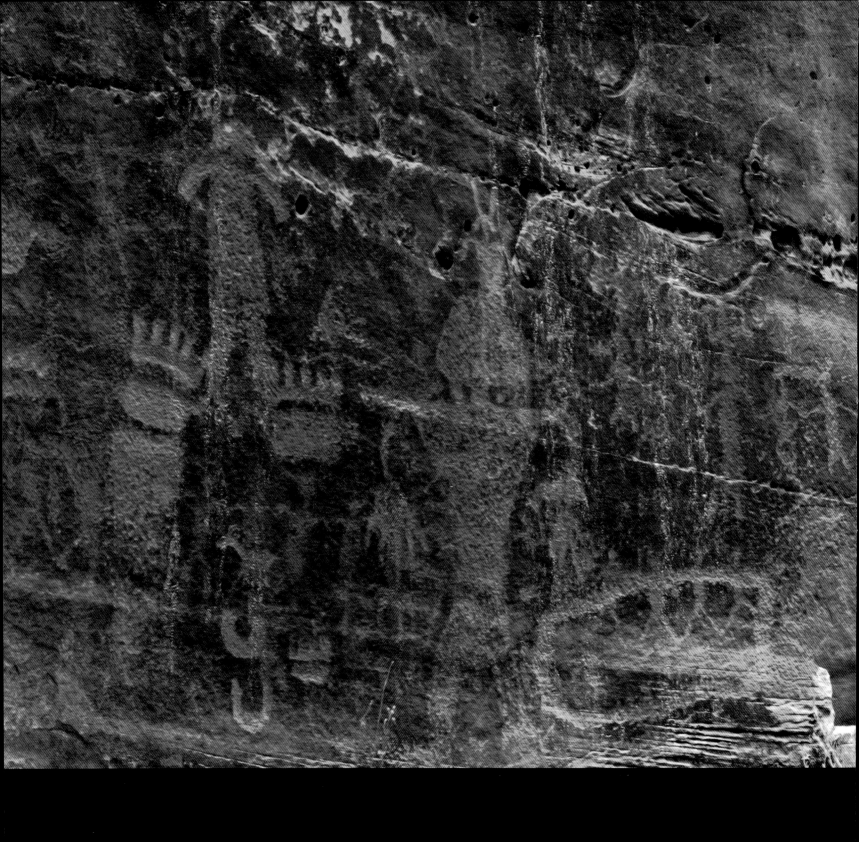

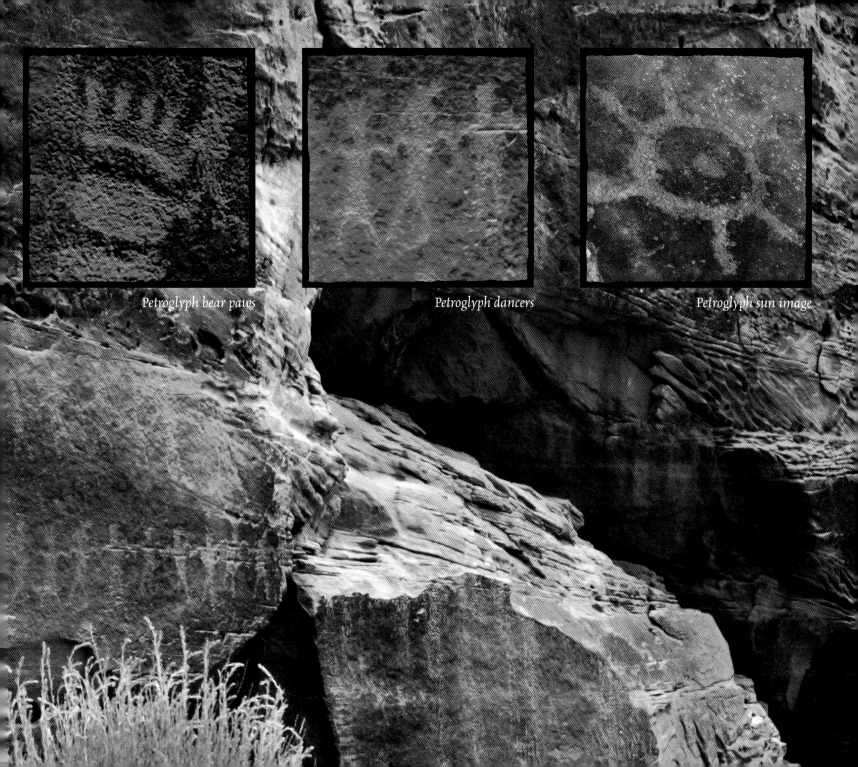

Petroglyph bear paws

Petroglyph dancers

Petroglyph sun image

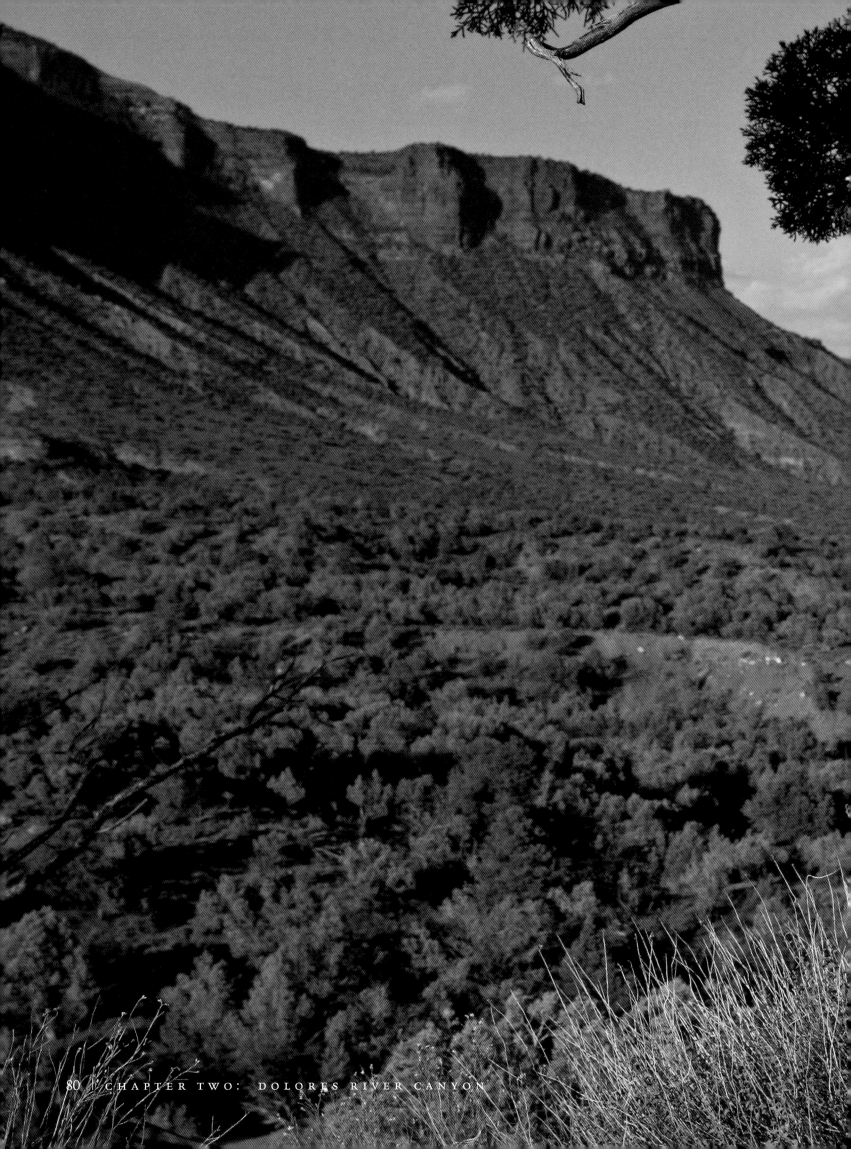

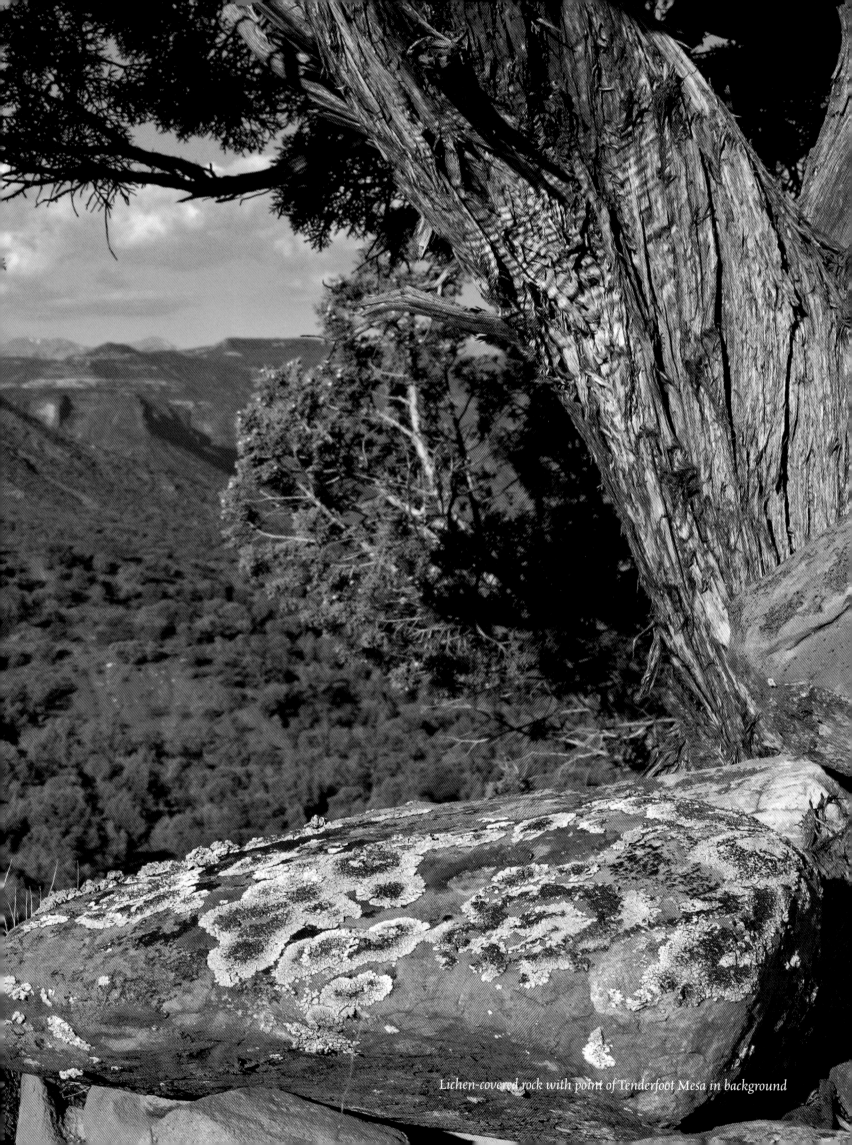

Lichen-covered rock with point of Tenderfoot Mesa in background

Exploring a side canyon of the Dolores River near Roc Creek

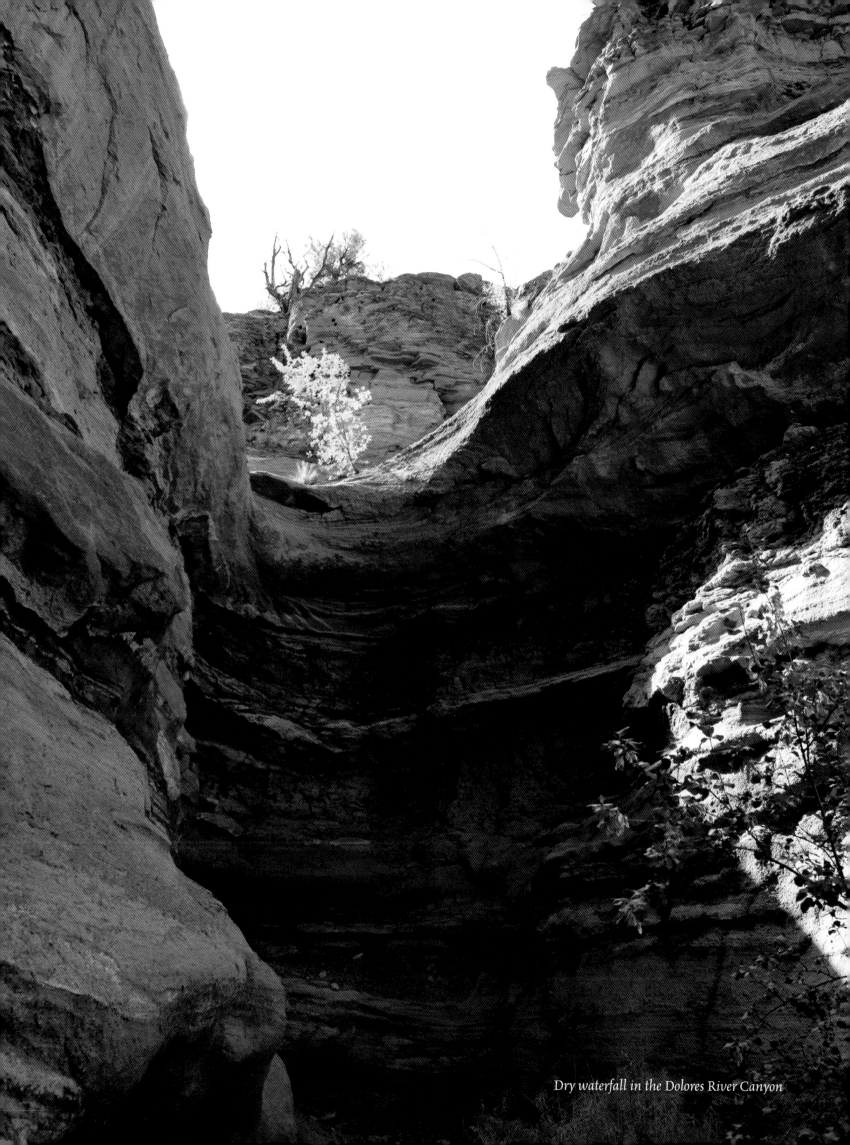

Dry waterfall in the Dolores River Canyon

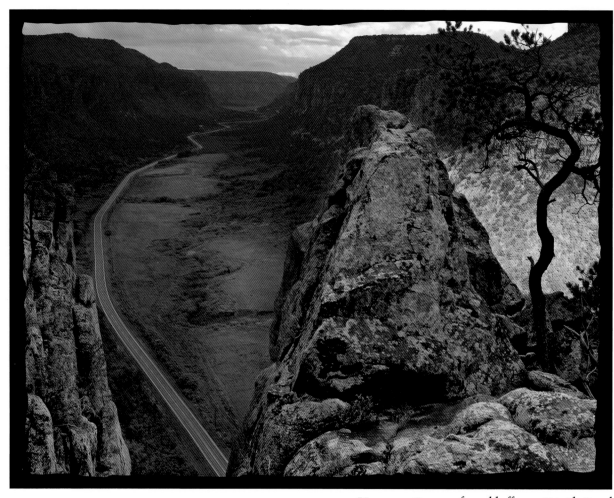

Unaweep Canyon from bluff near Divide Road

UNAWEEP CANYON

The Ute called the canyon, "Unaweep," meaning, "the canyon with two mouths." It is the only such canyon in the world. The land through which the canyon cuts was uplifted more than 4,000 feet some 70 million years ago in a titanic earth upheaval known as the Uncompahgre Uplift. Consensus on exactly how Unaweep Canyon itself was formed still remains elusive. What is certain is that Unaweep Canyon is a place of geological wonder, great mystery and enduring paradox. Like the two creeks flowing in opposite directions, most travelers who find their way to Unaweep Canyon depart feeling forever changed.

A journey along Colorado Scenic Highway 141 reveals the transformation of the canyon walls from red sandstone at the canyon mouths to the ancient gray rock walls of the Precambrian in the canyon's deep recesses. Precambrian rock is rarely exposed on the earth's surface to the extent seen in Unaweep Canyon. Travelers occasionally spot an expert rock climber who has journeyed to this part of the planet to tackle the vertical ascension of sheer Precambrian rock walls of 600 feet and more.

Paradox abounds here. Journey to the high canyon and you'll see the lush pasture floor seemingly within reach of the towering mesa tops above. Wander over to the Uncompahgre Plateau and you'll discover flat cattle grazing country located within a ponderosa pine forest. This is an ancient land of continual surprise.

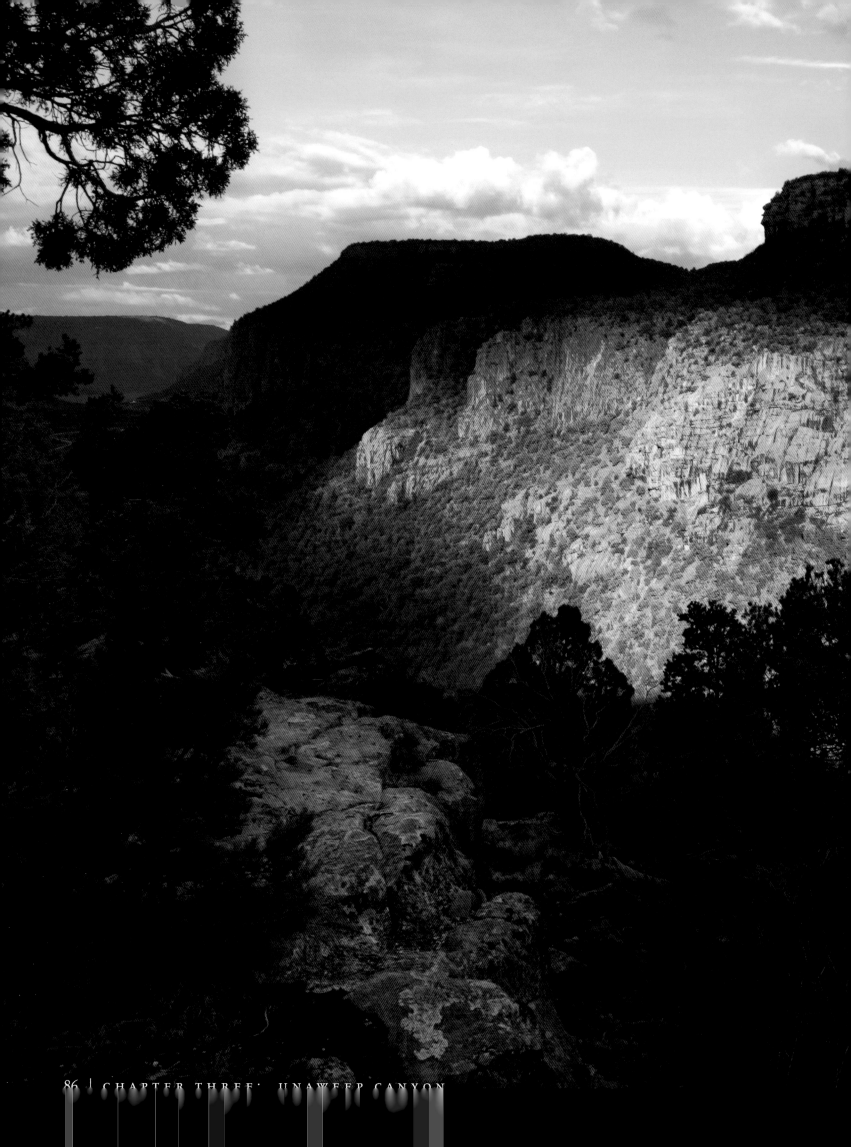

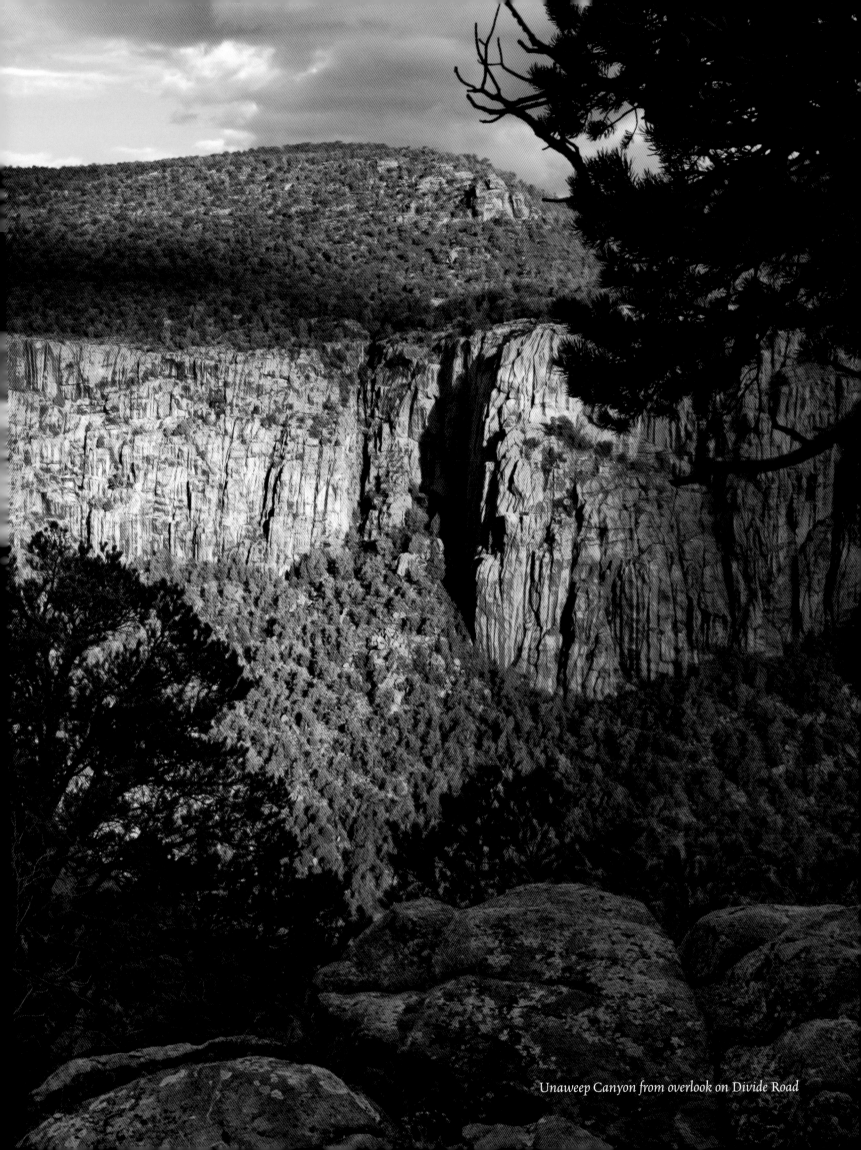

Unaweep Canyon from overlook on Divide Road

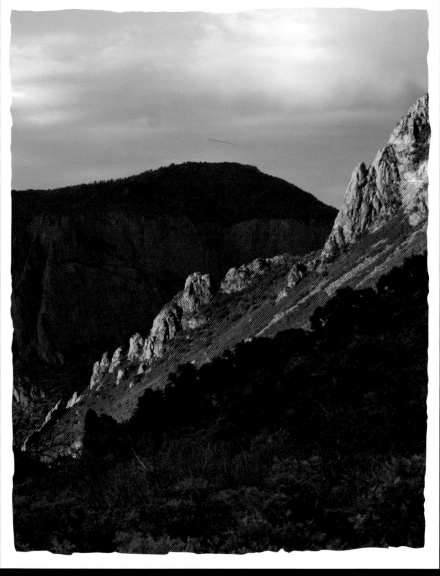

Unaweep Canyon cliffs at sunset

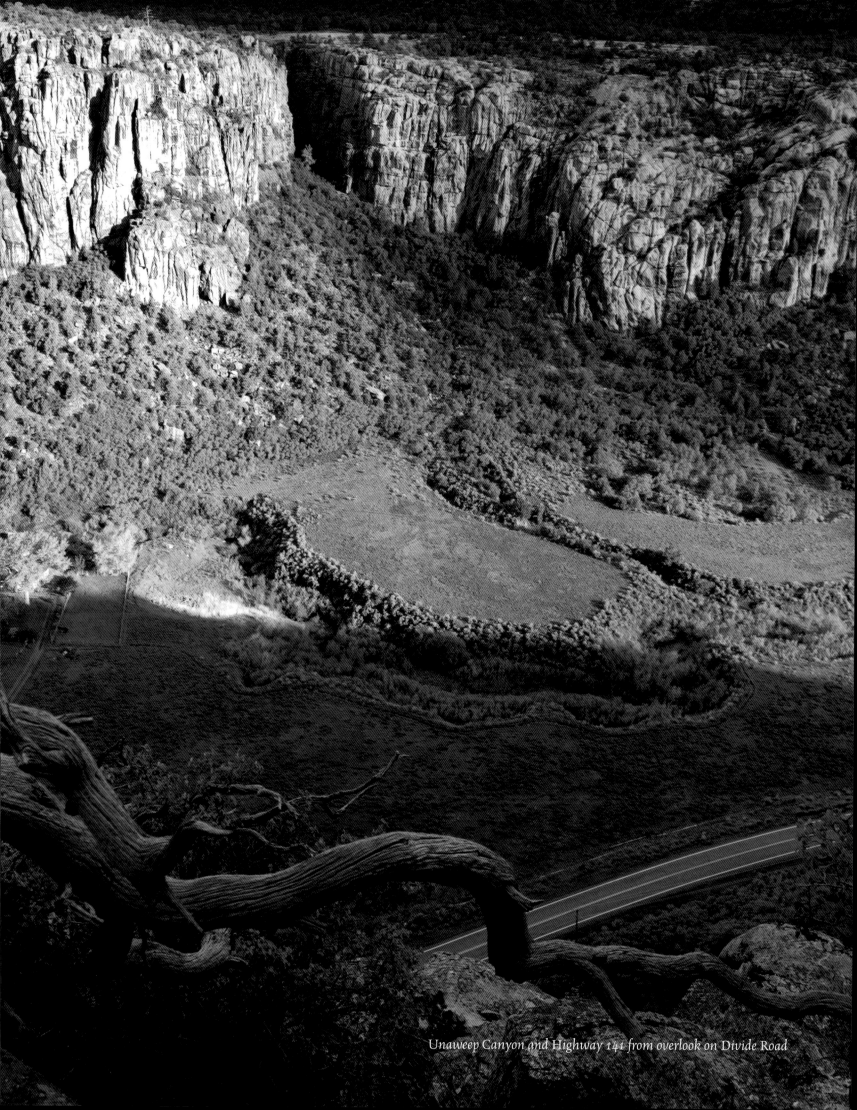

Unaweep Canyon and Highway 141 from overlook on Divide Road

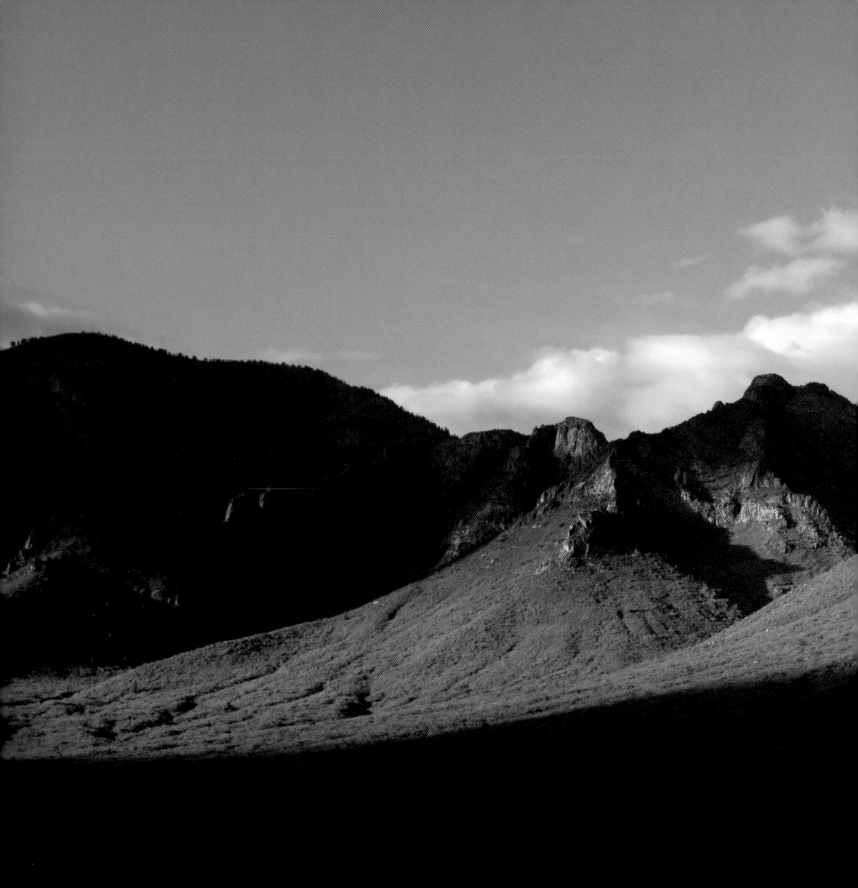

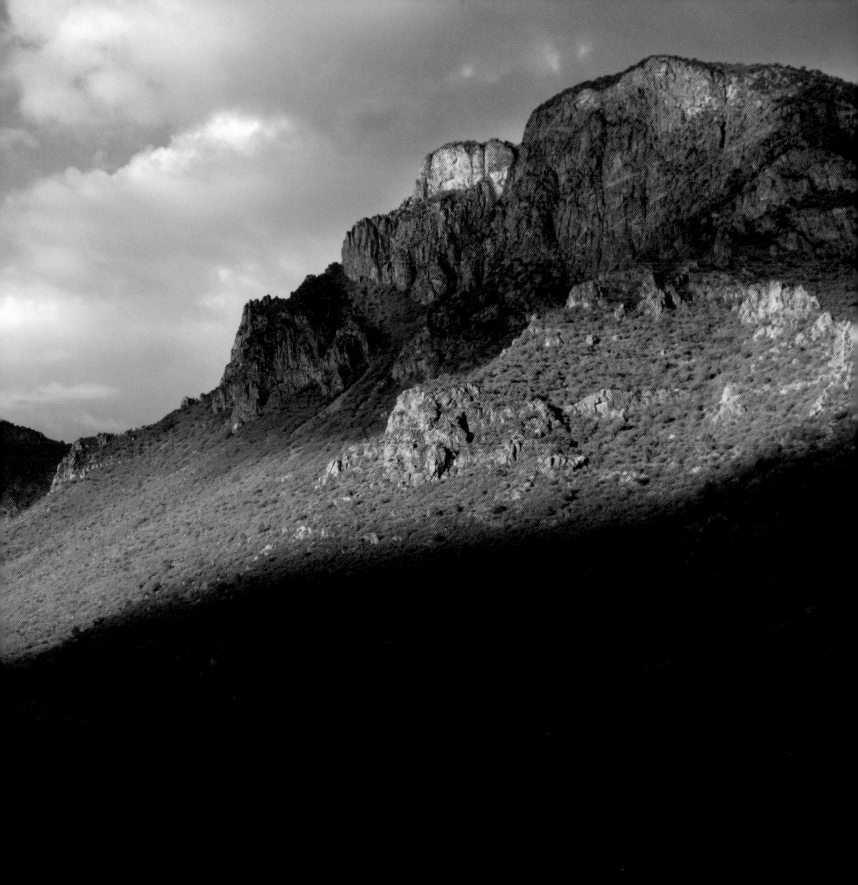

Gentle green slopes at base of Ungween cliffs

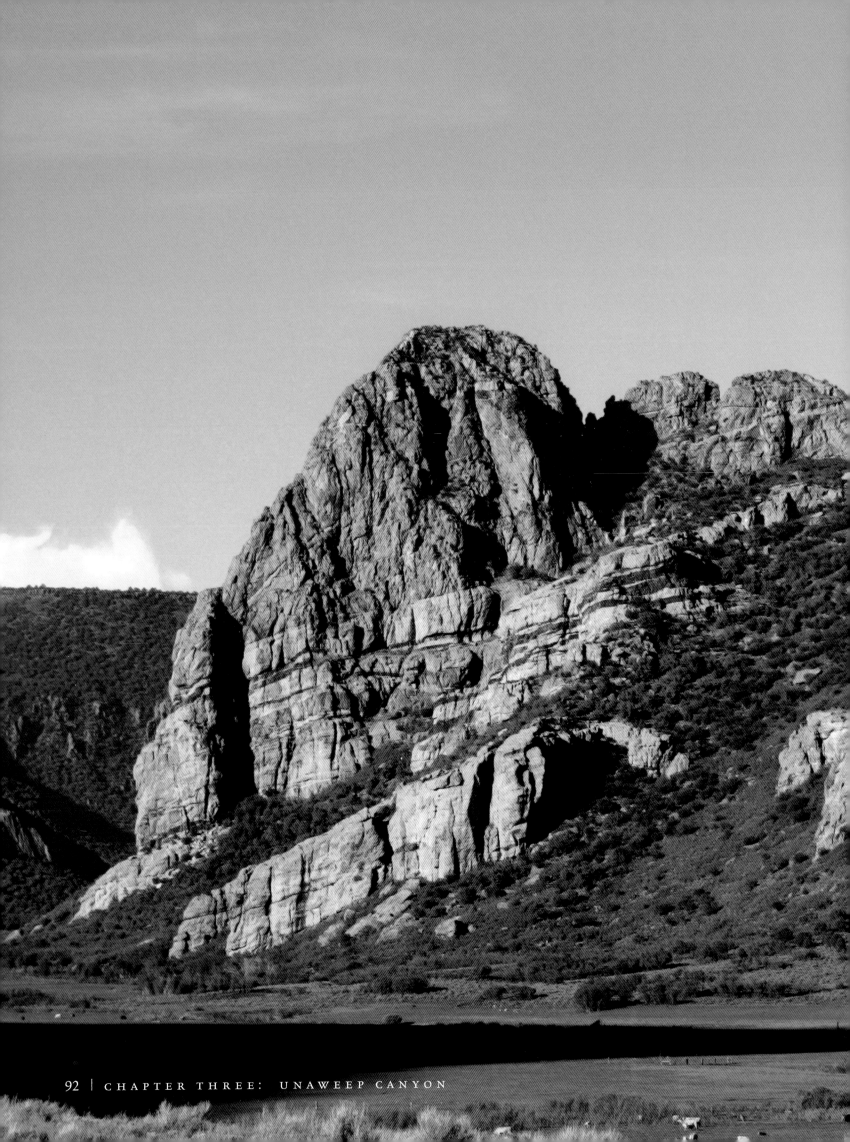

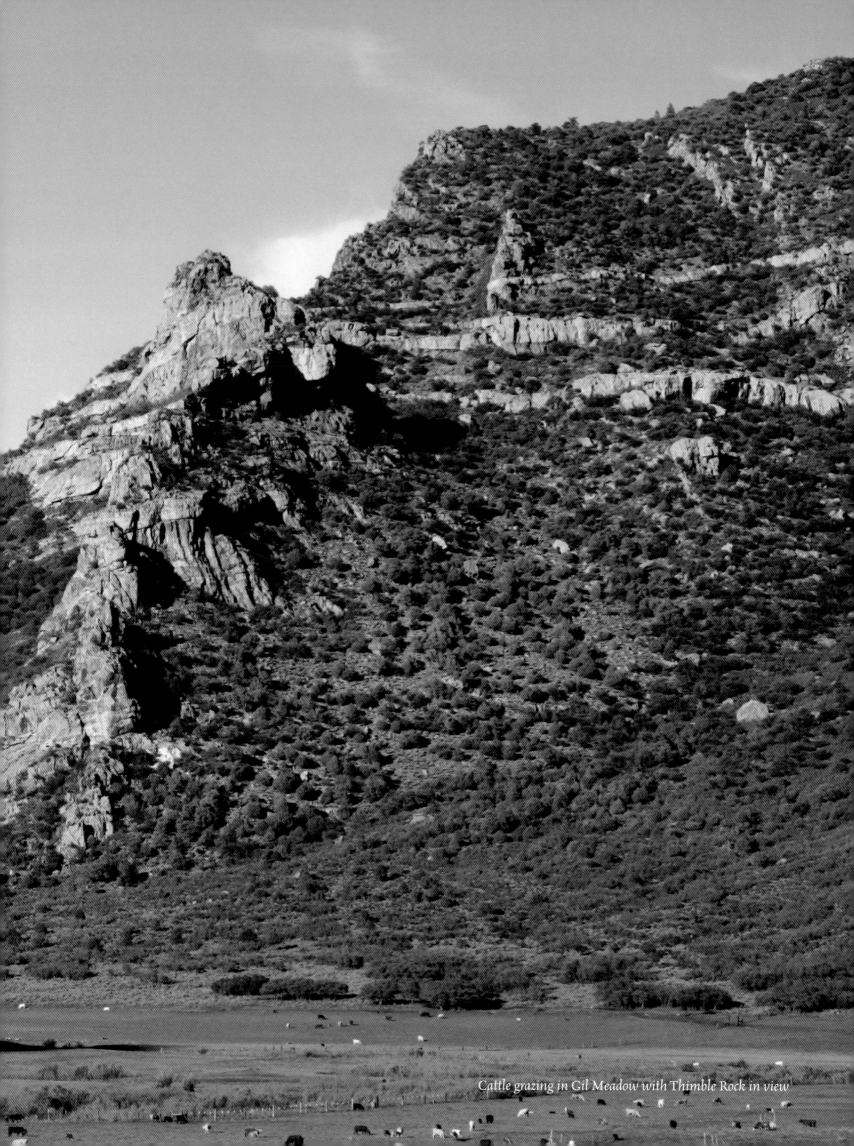

Cattle grazing in Gil Meadow with Thimble Rock in view

Golden hay stack in Unaweep Canyon

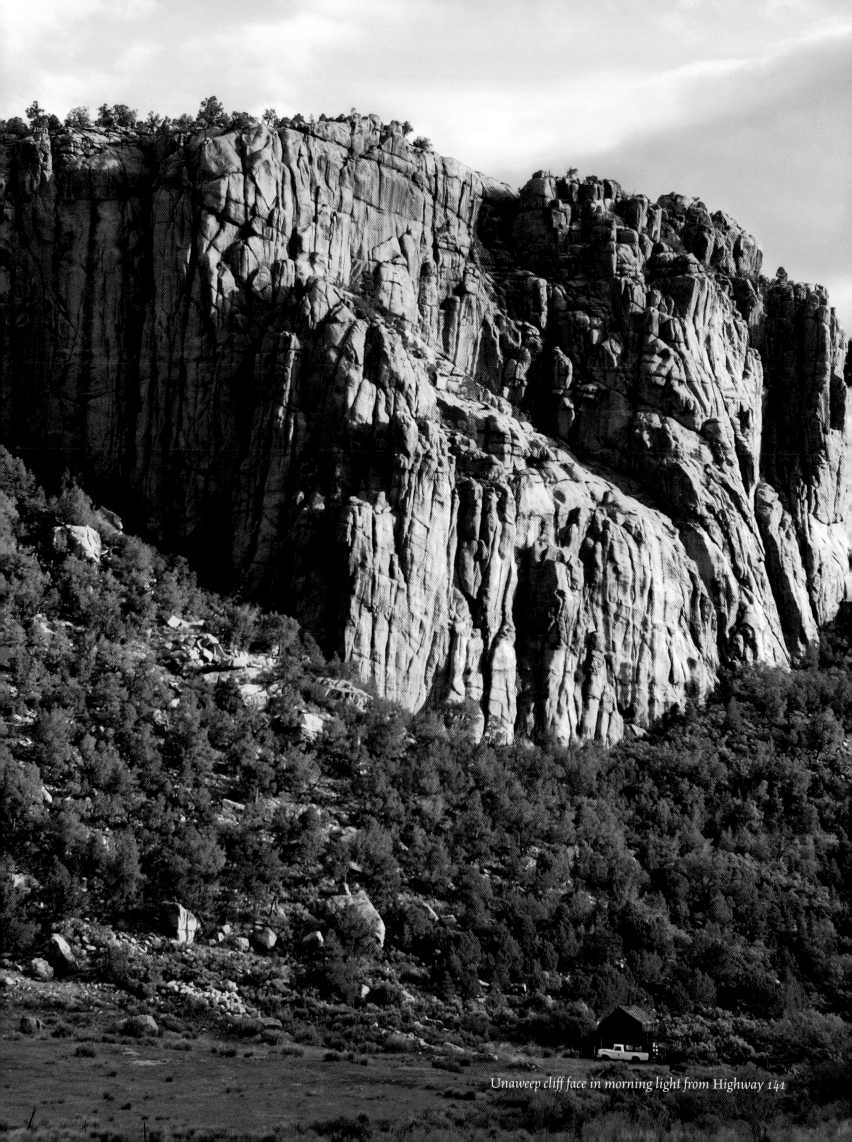

Unaweep cliff face in morning light from Highway 141

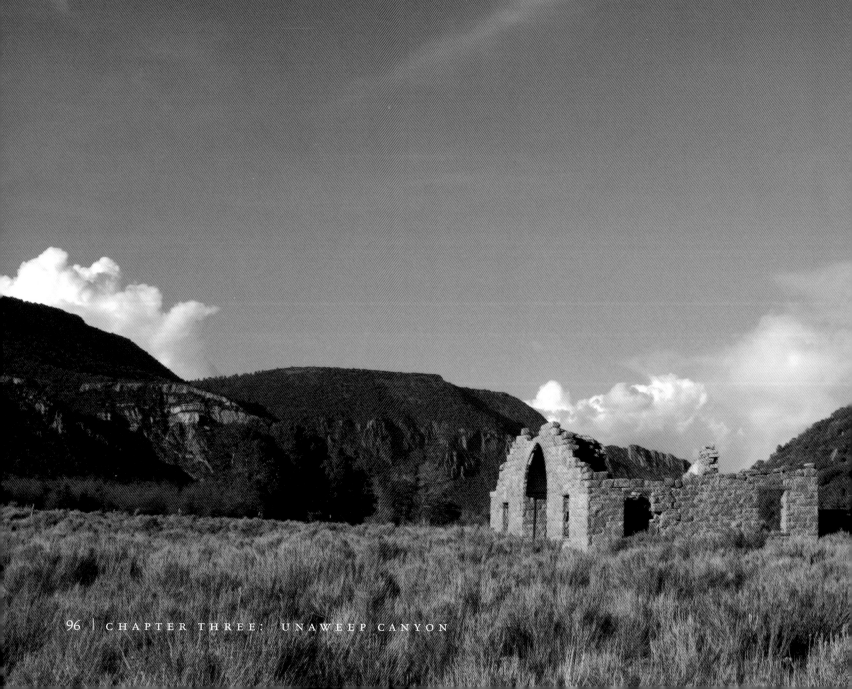

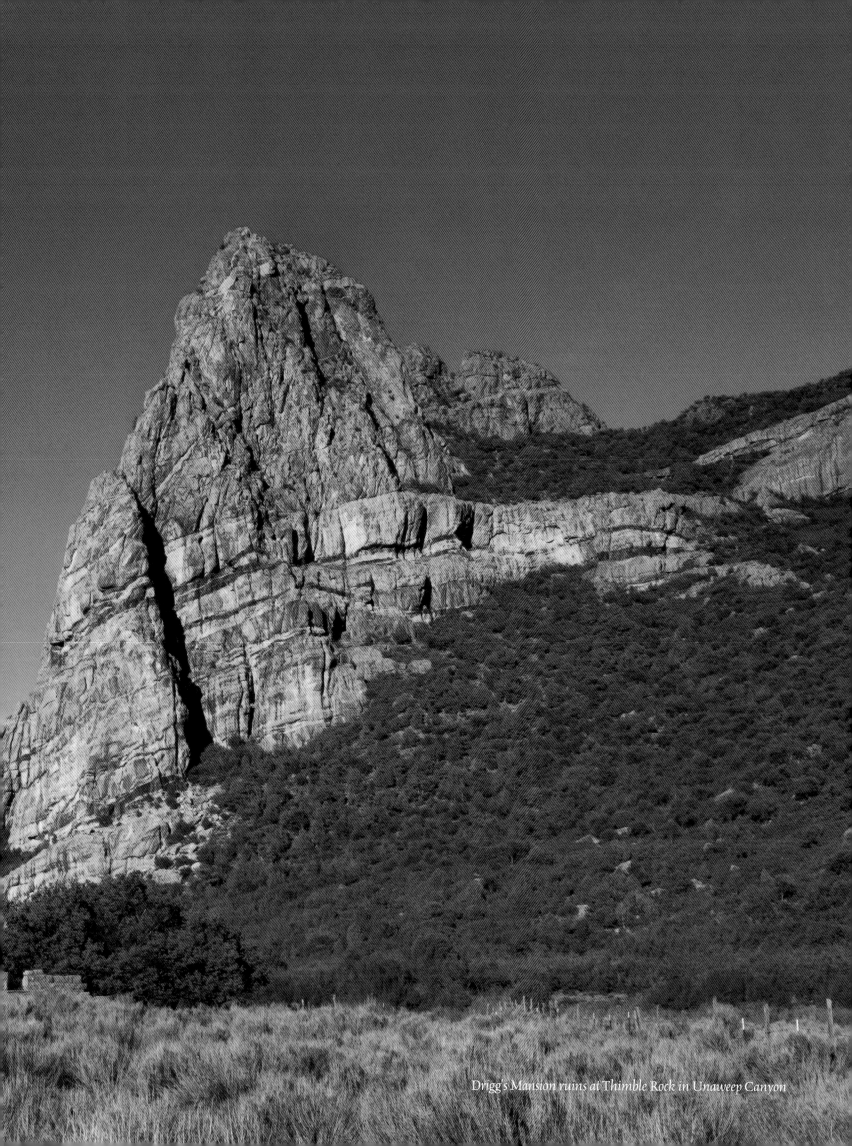

Drigg's Mansion ruins at Thimble Rock in Unaweep Canyon

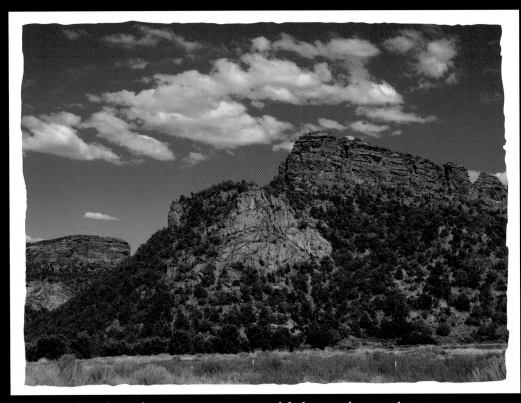

Red sandstone formation over ancient uplifted Precambrian rock in Unaweep Canyon

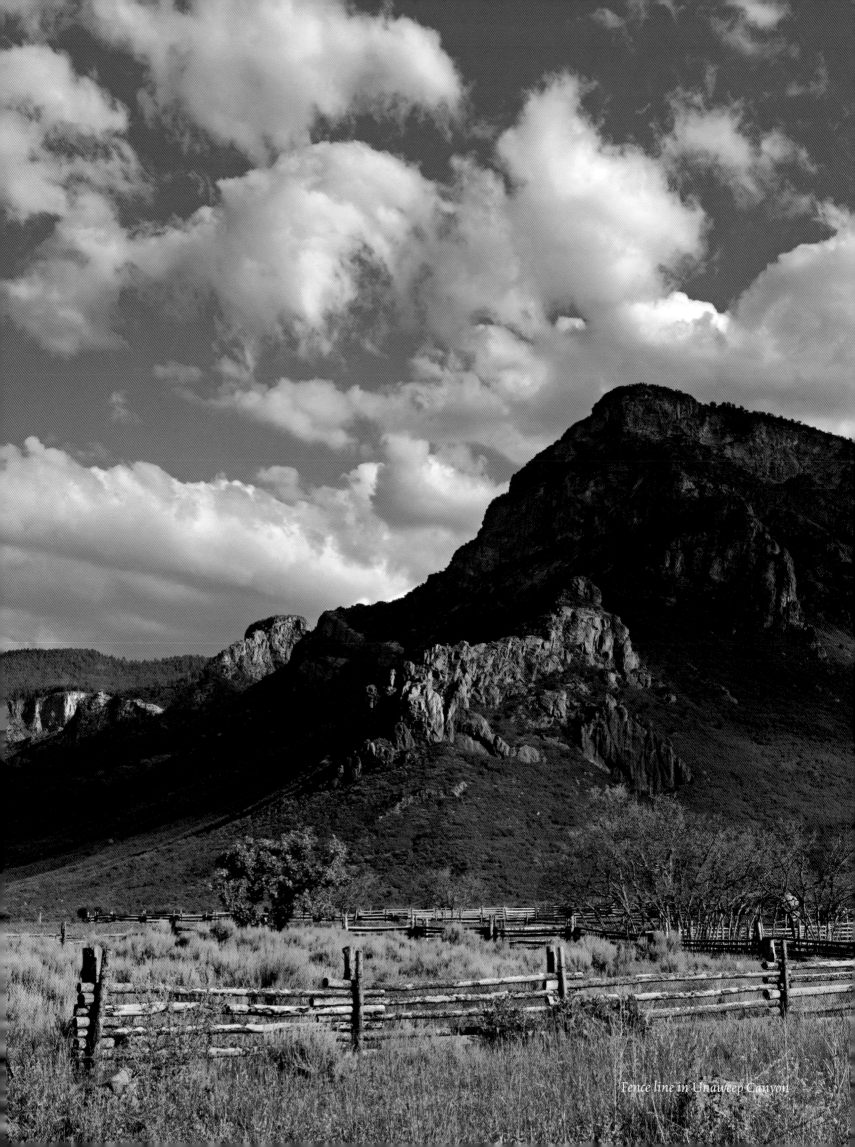

Fence line in Unaweep Canyon

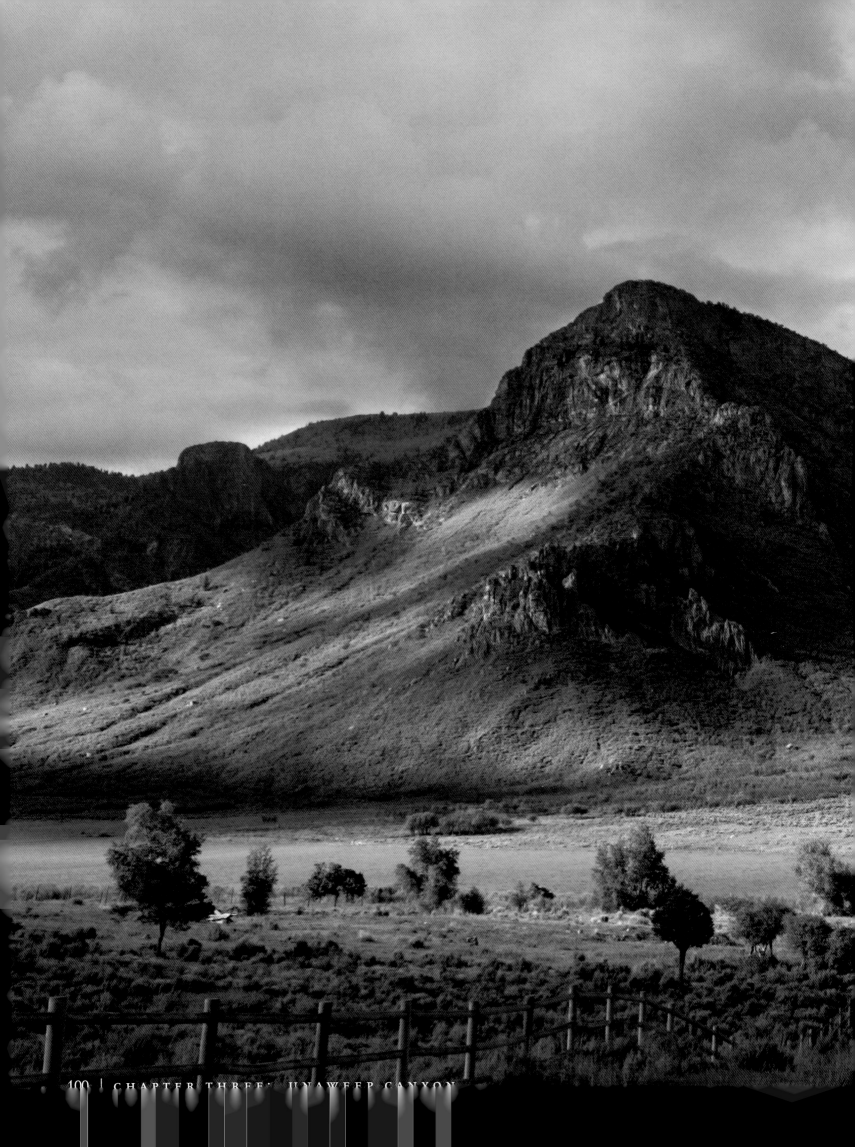

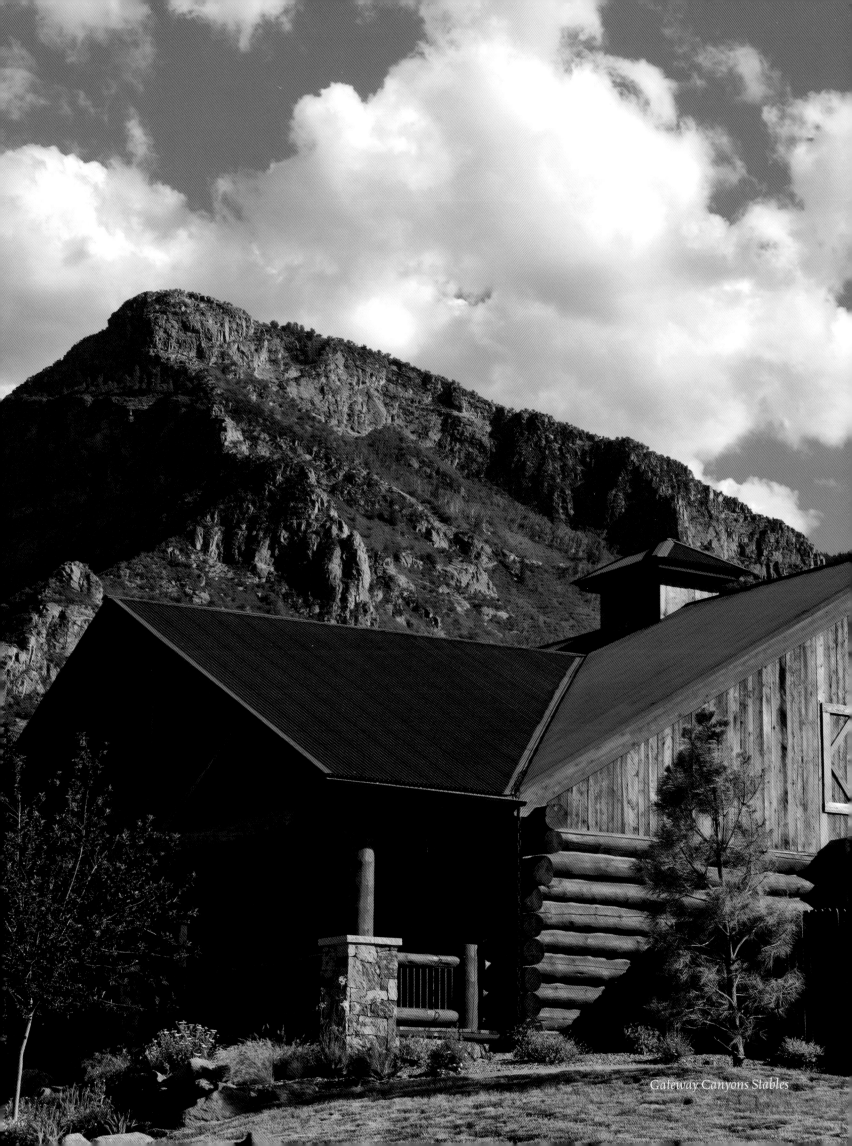

Gateway Canyons Stables

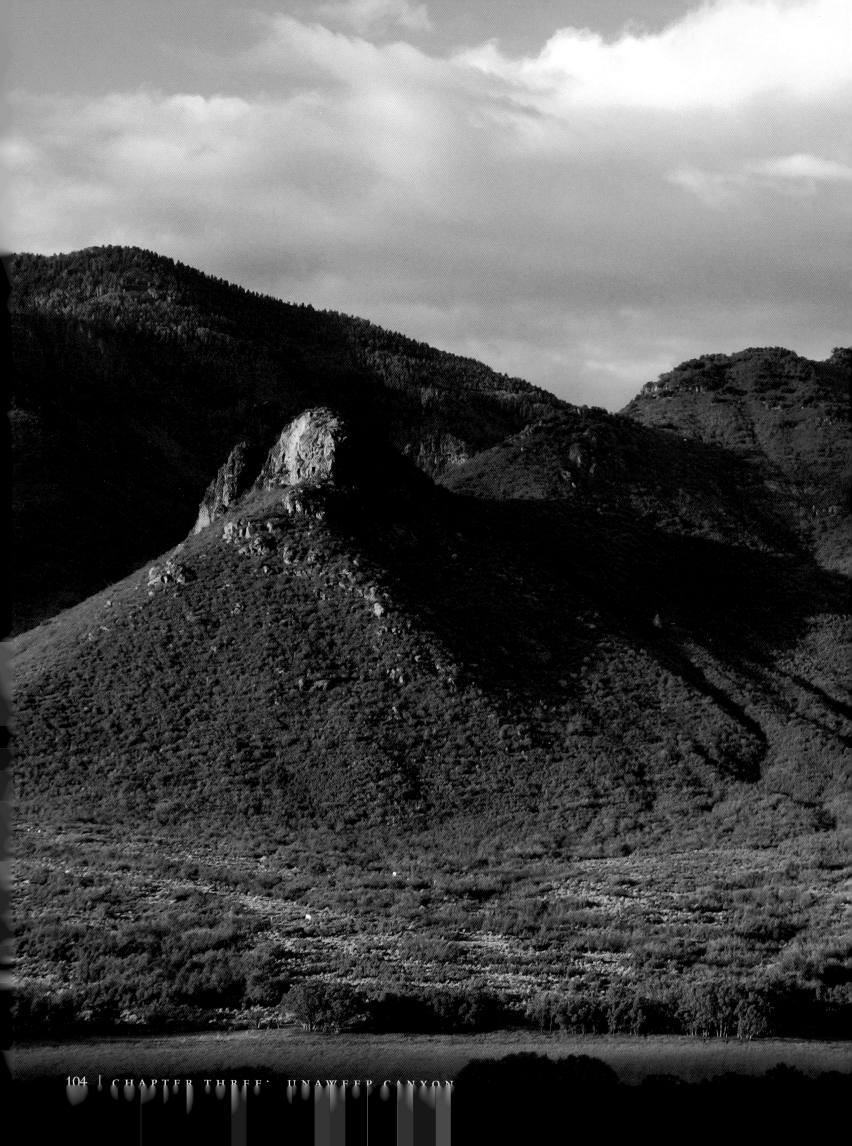

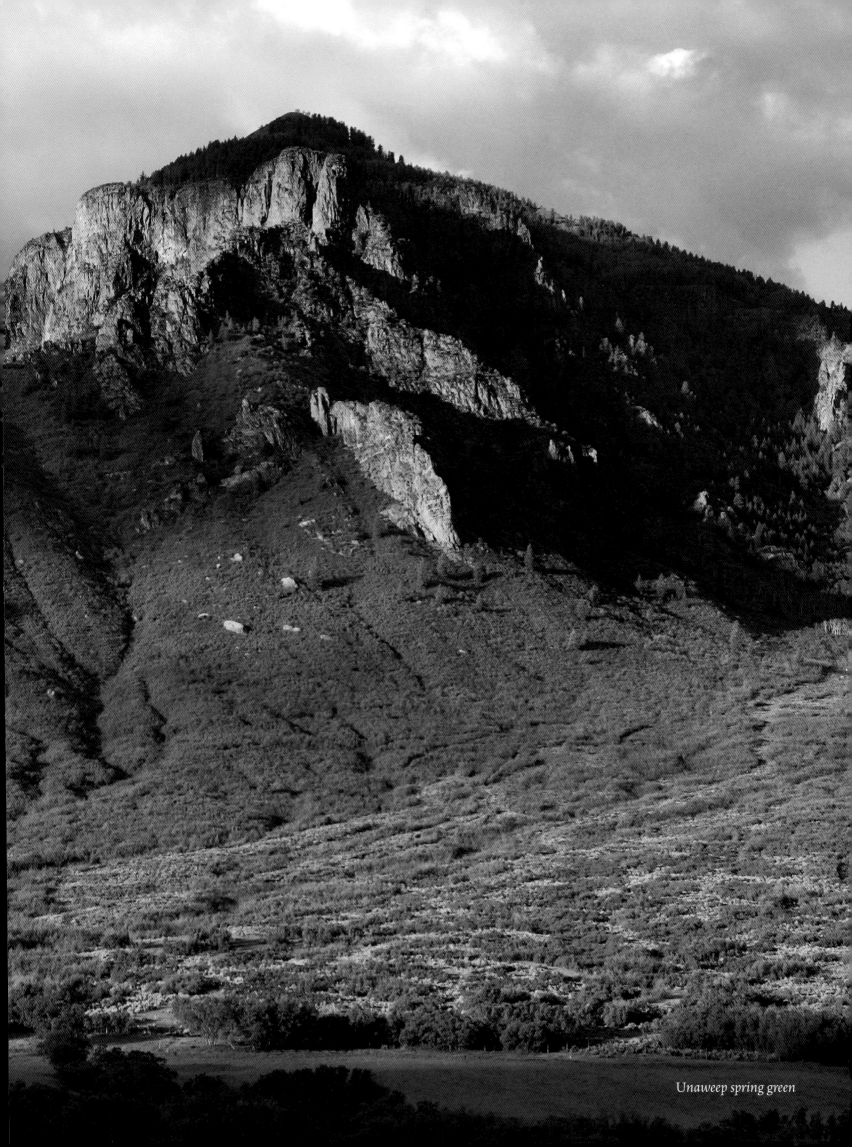

Unaweep spring green

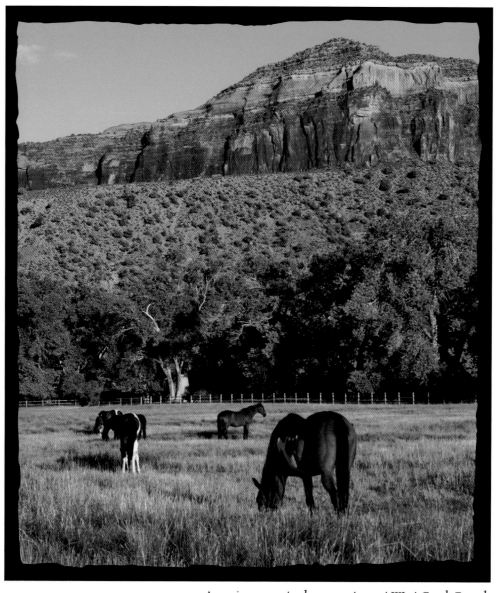

American quarter horse pasture at West Creek Ranch

WEST CREEK RANCH

West Creek Ranch is a calm retreat situated in the heart of nature's splendor. Located about three miles northeast of Gateway near the western mouth of Unaweep Canyon, West Creek Ranch is nestled into the broad Unaweep Canyon floor. Red Wingate cliffs of Tenderfoot Mesa peer down from the south and the striking Palisade formation beckons from the north. The peaceful beauty and protected location have attracted settlers from the Anasazi or Fremont tribes, to pioneer families, prospectors, and the Hendricks family today.

The ancient peoples left petroglyphs estimated to date between 100 A.D. and 700 A.D. located on a high bluff overlooking the creek. Pioneers constructed a small log cabin on the banks of the creek in the mid-1890s. These snapshots of the past remain intact today. The Hendricks family has tucked their residence into the soft curves of the foothills, blending their adobe-styled southwestern ranch house quietly into the pale sandstone surroundings. A grass airfield, hangar, stables, and a guesthouse are a leisurely stroll away. Lush, green irrigated pastures house American quarter horses, Arabians, Belgian draft horses, and American bison – all reliable complements to the ever-changing skies.

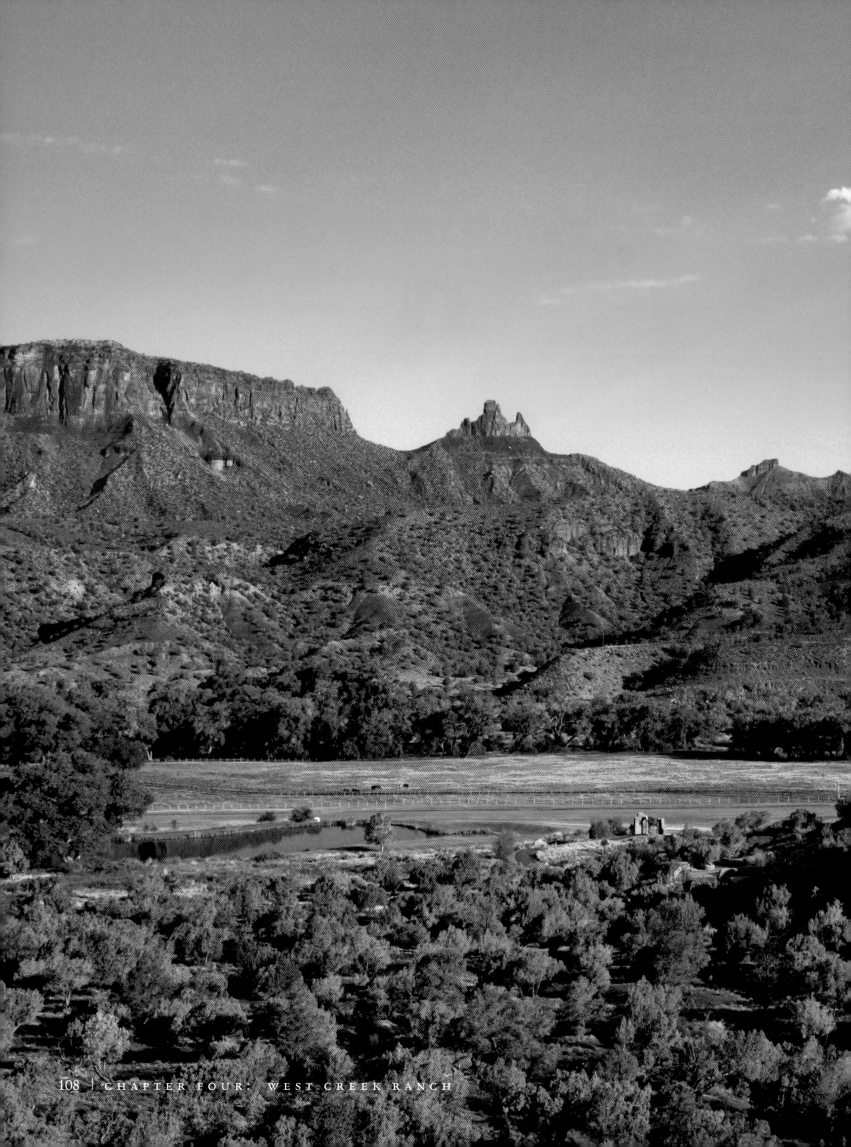

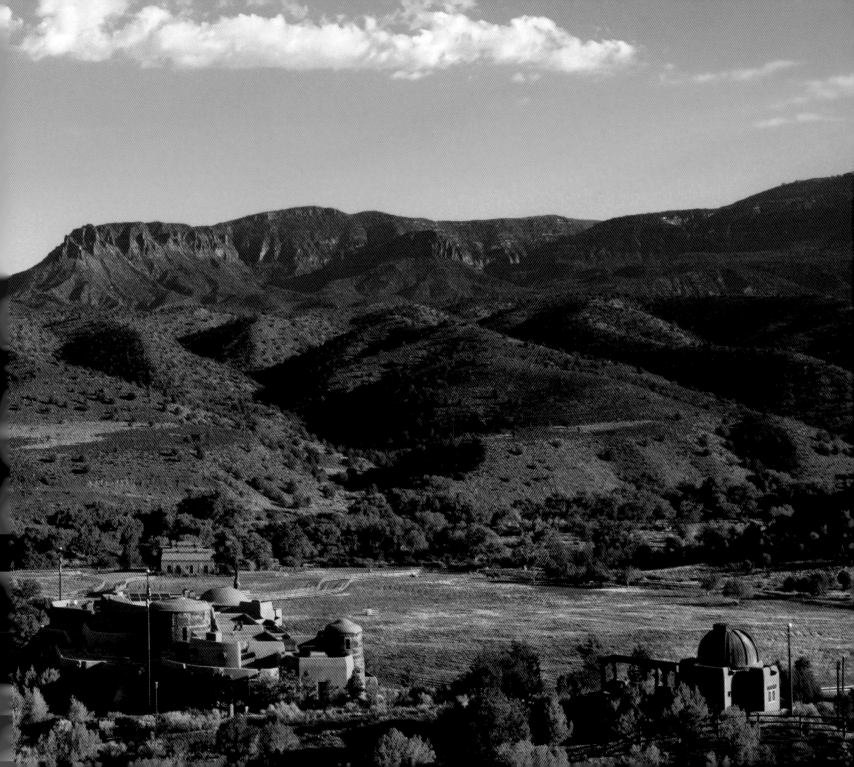

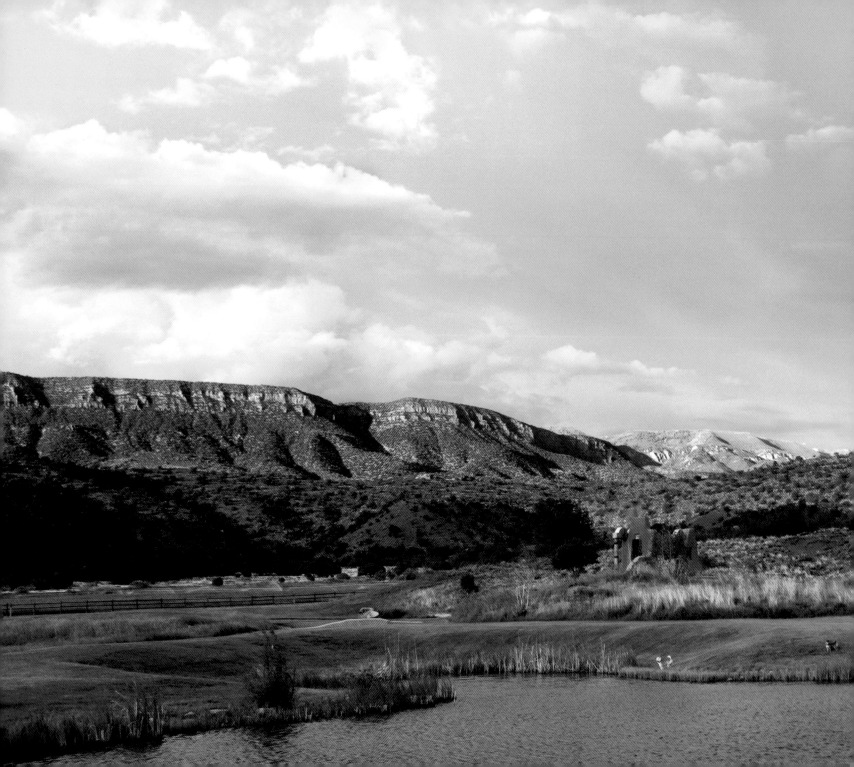

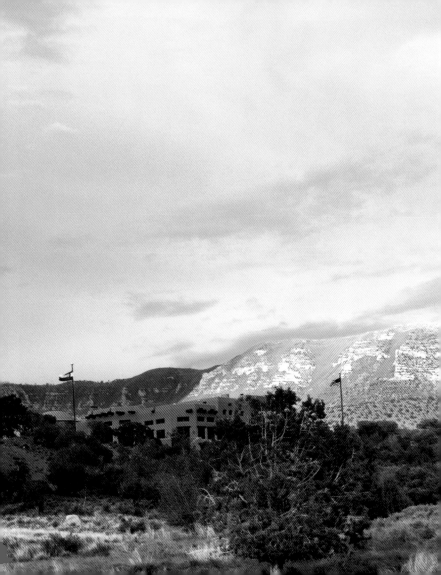

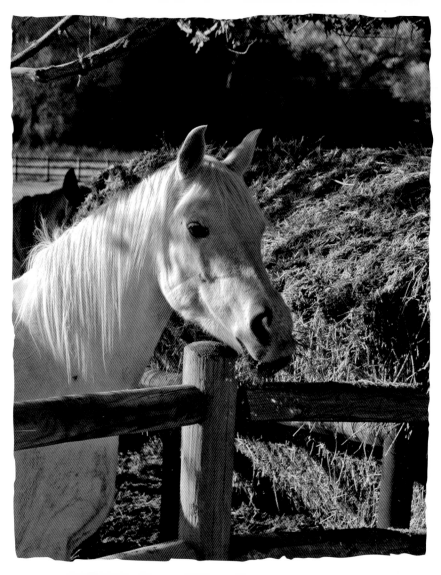

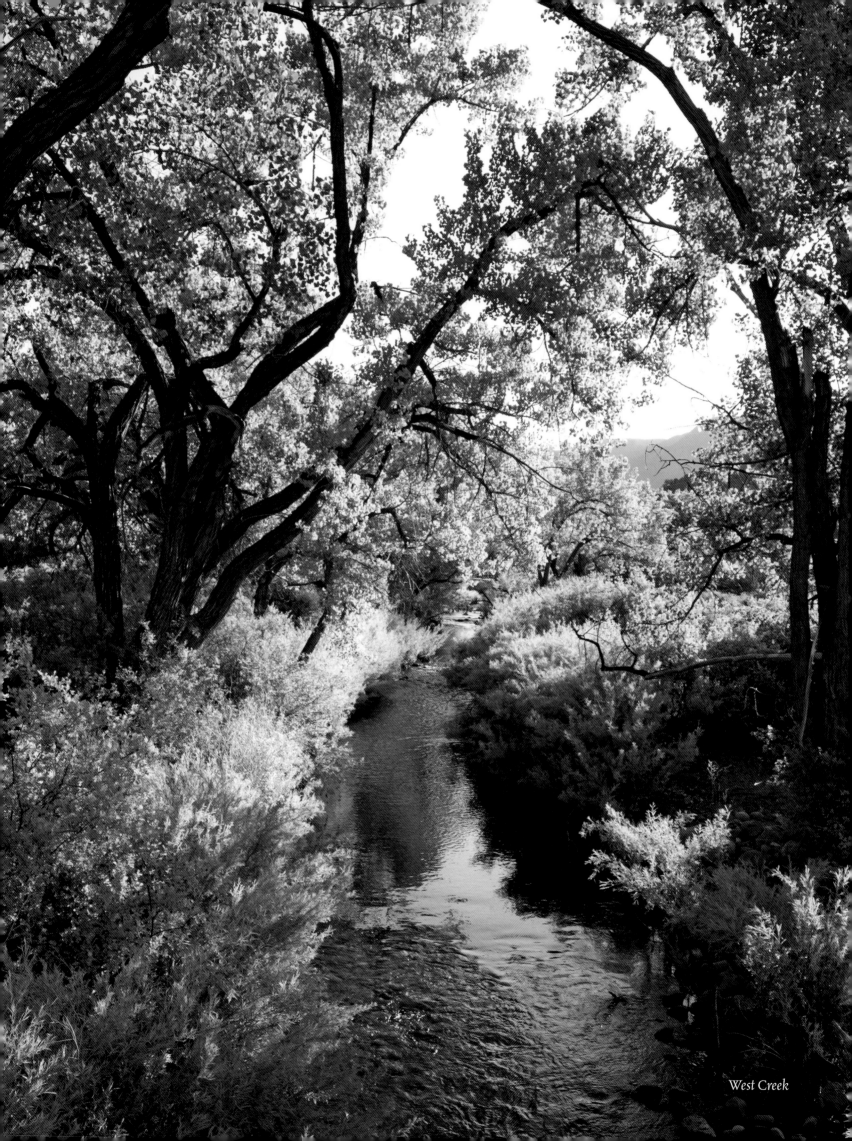

West Creek

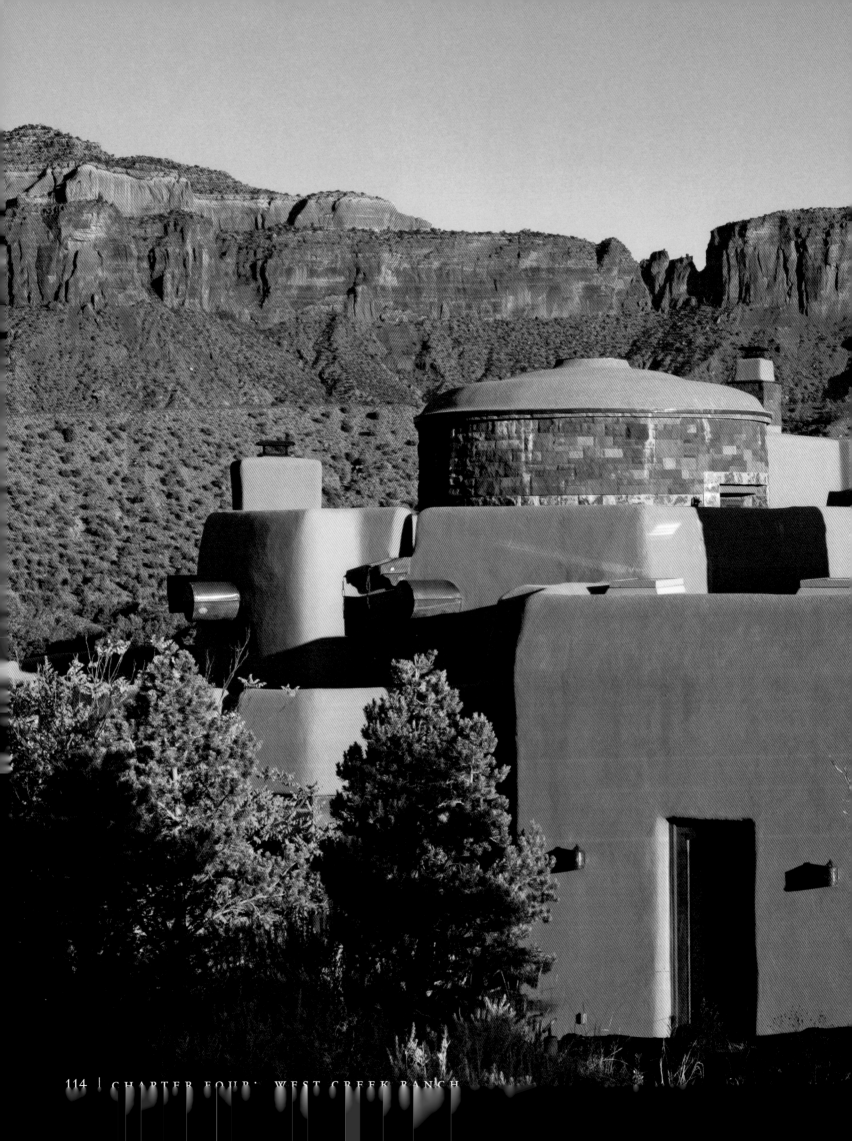

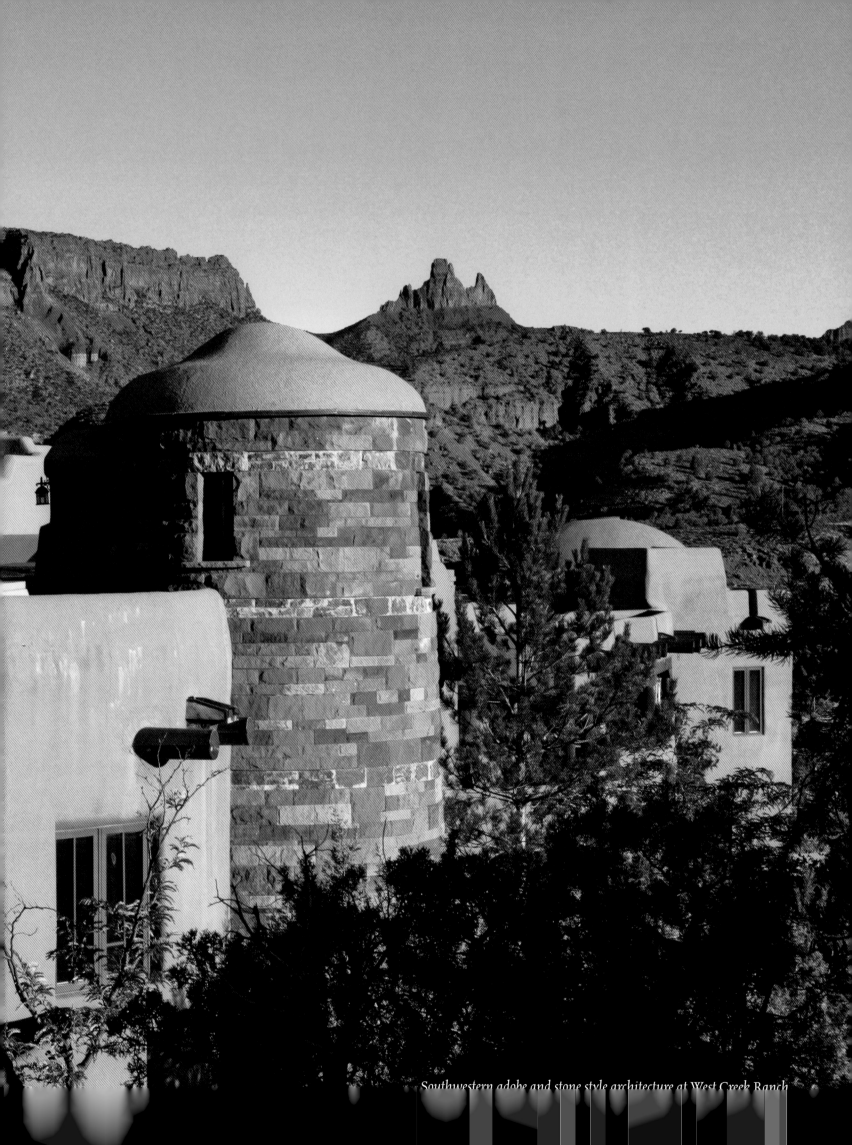

Southwestern adobe and stone style architecture at West Creek Ranch

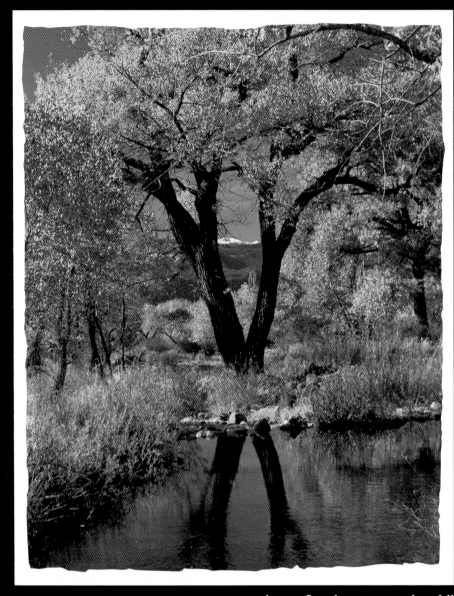

Cottonwood tree reflected on West Creek in fall

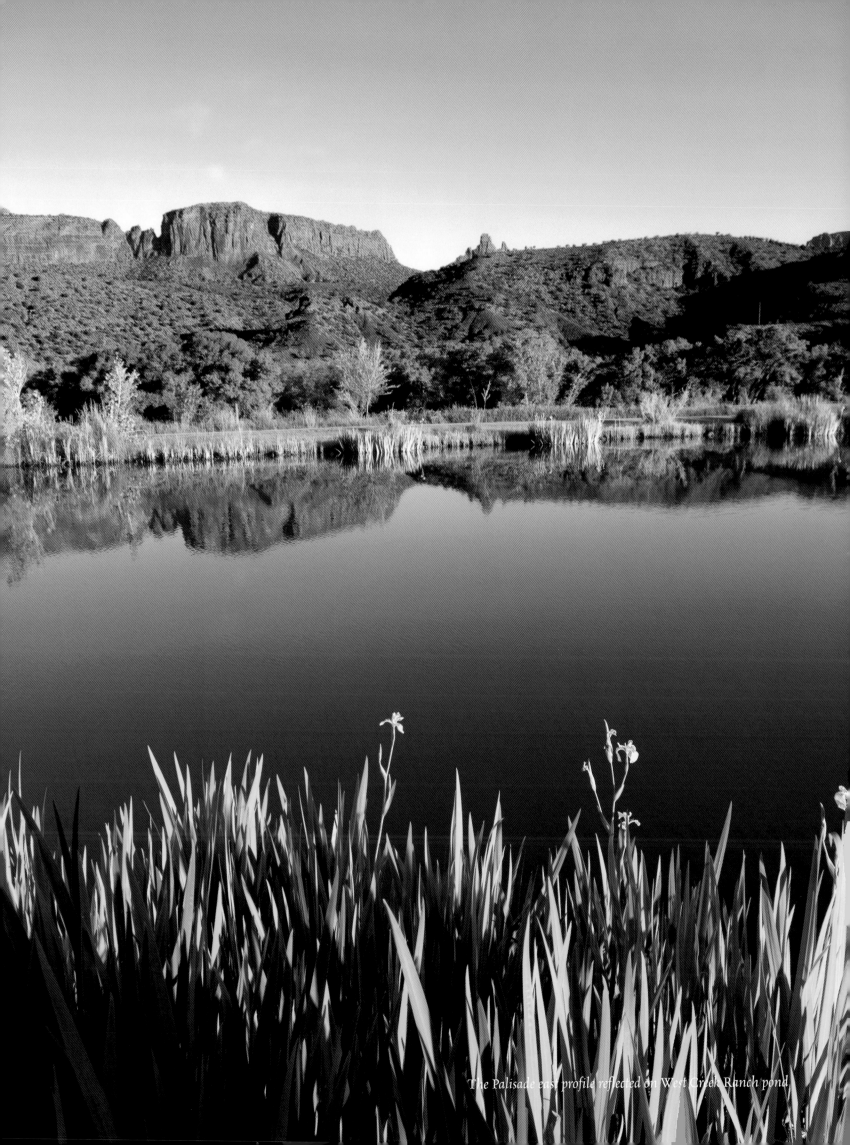

The Palisade east profile reflected on West Creek Ranch pond

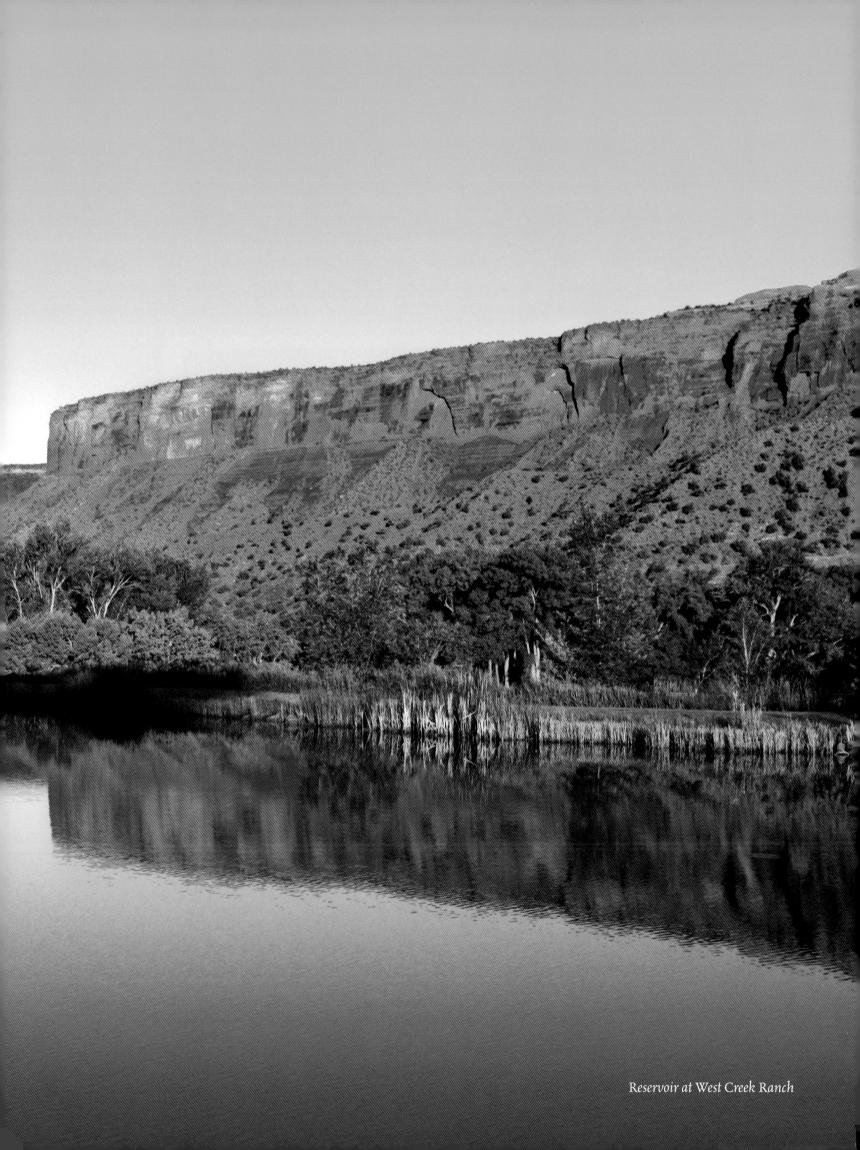

Reservoir at West Creek Ranch

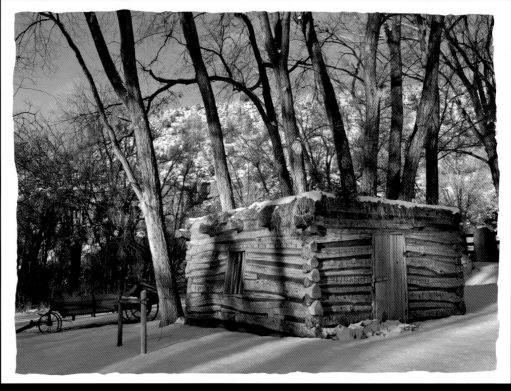

Homestead cabin at West Creek Ranch

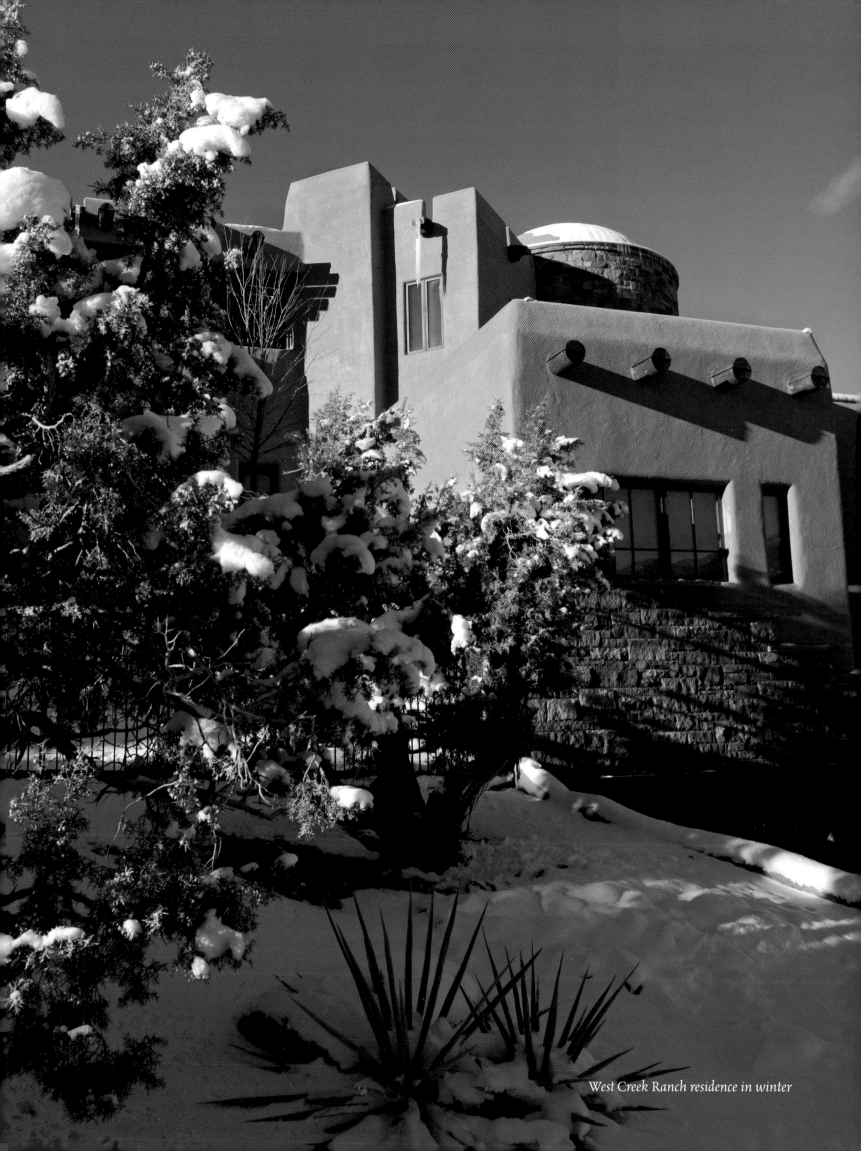

West Creek Ranch residence in winter

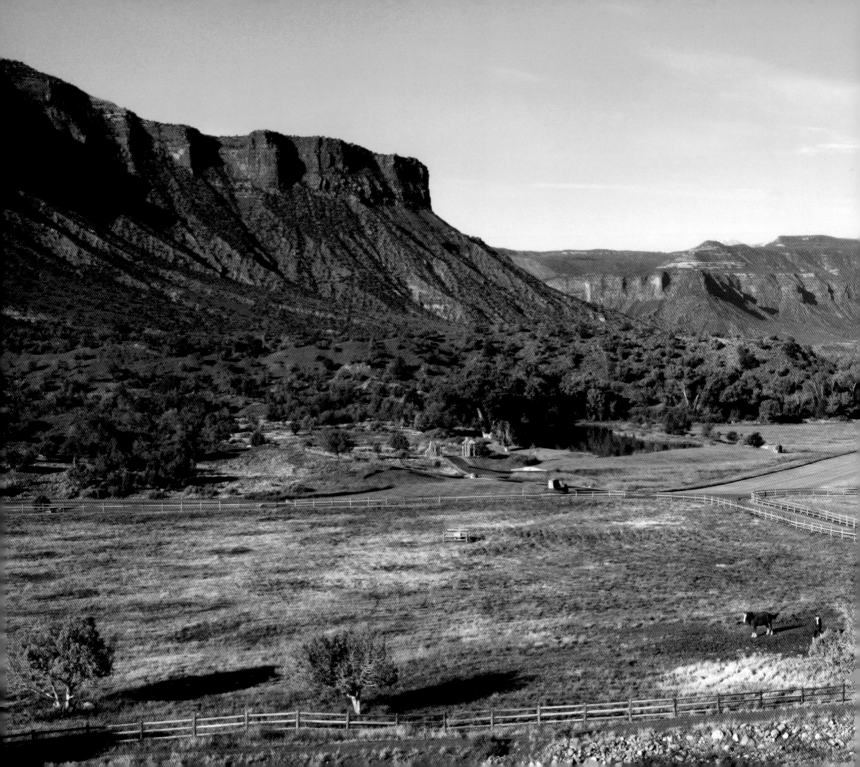

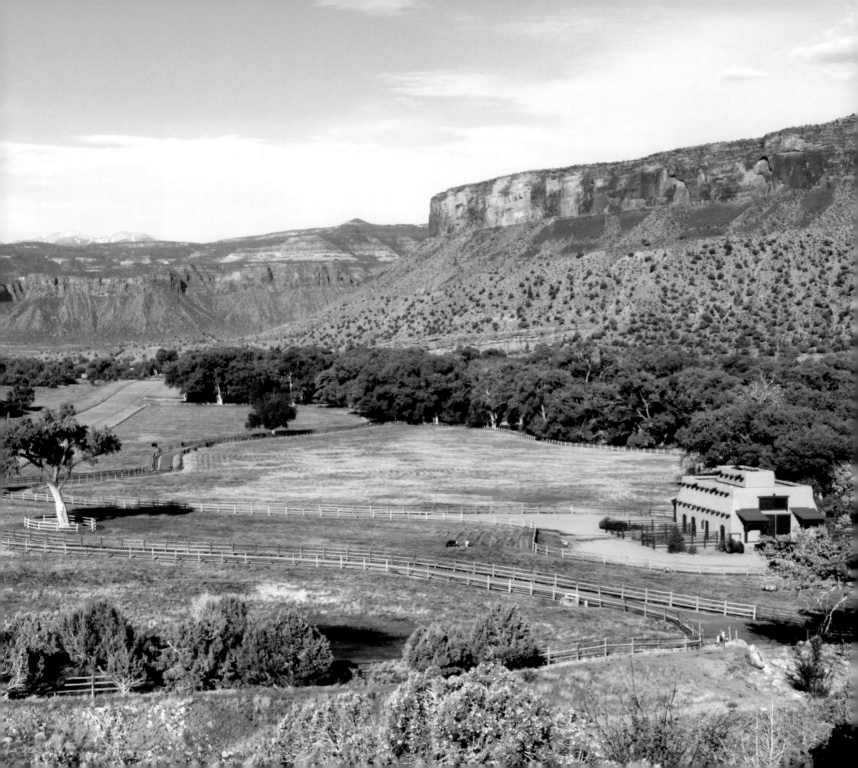

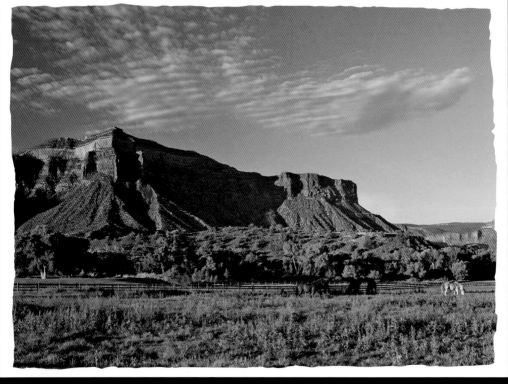

Horses in West Creek pasture

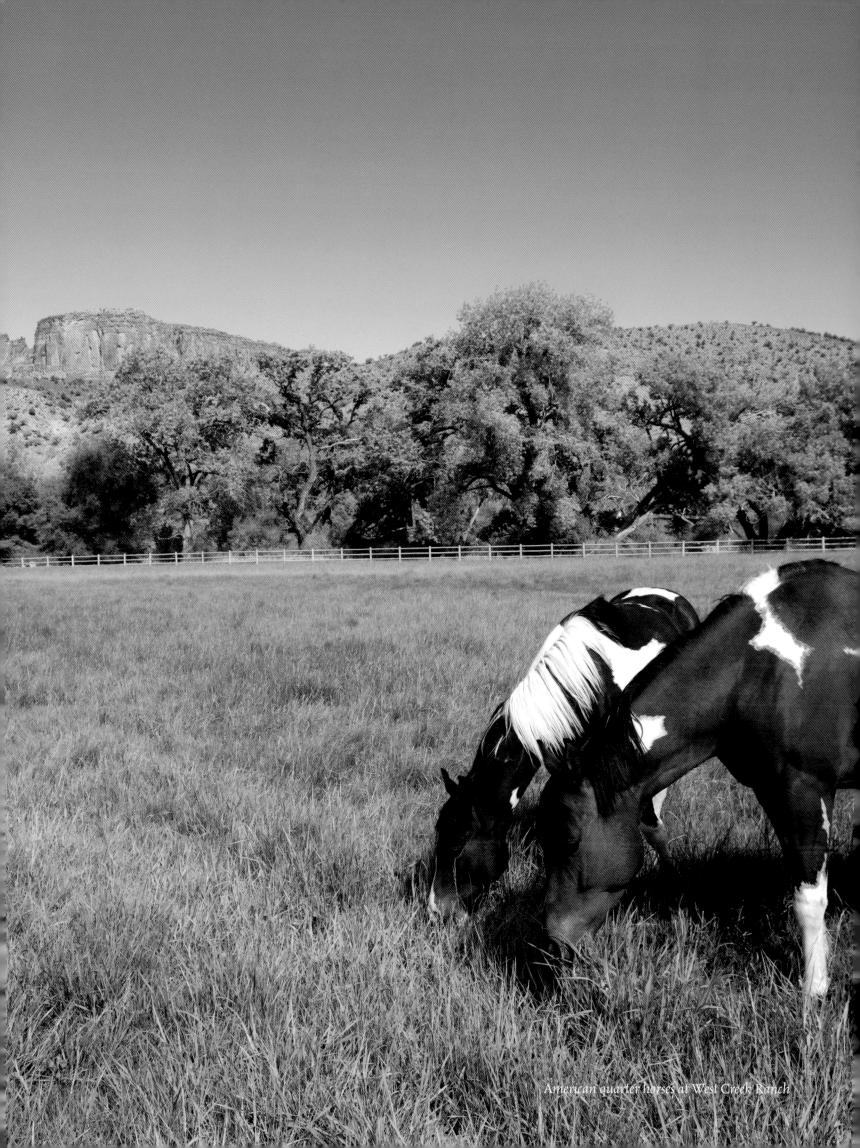

American quarter horses at West Creek Ranch

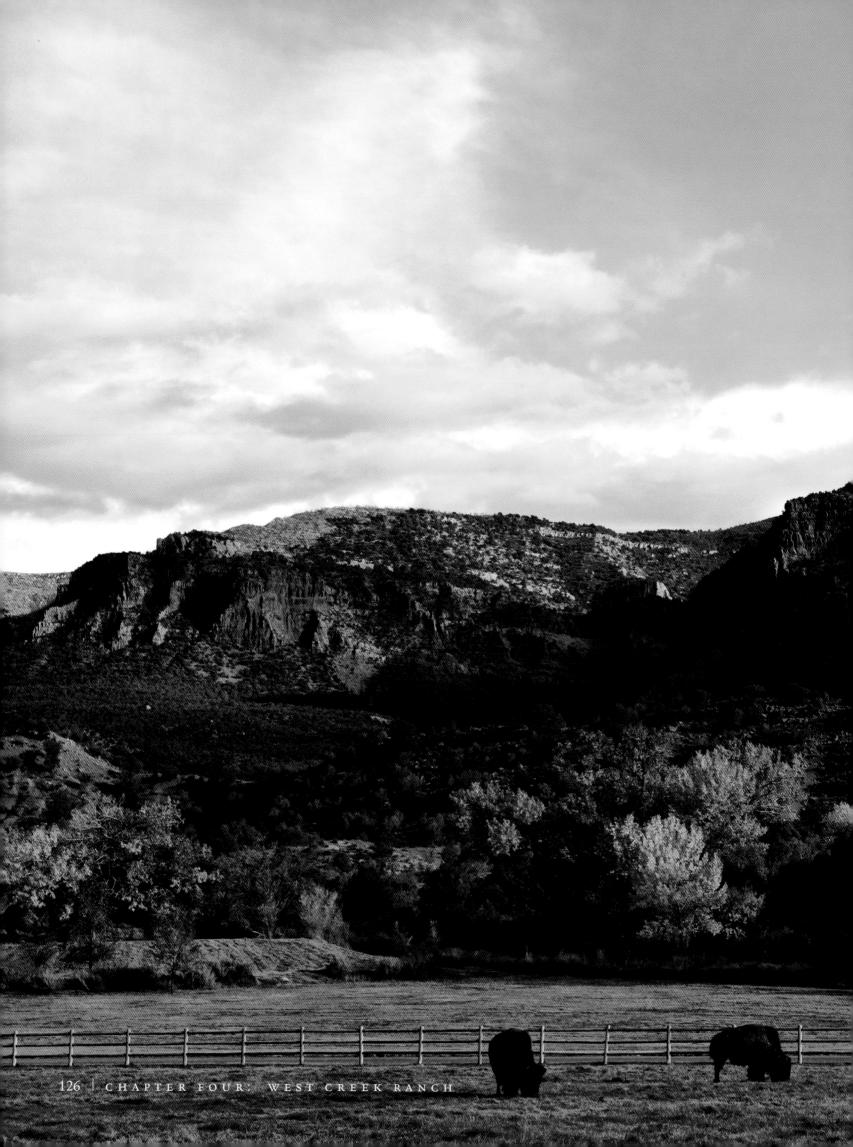

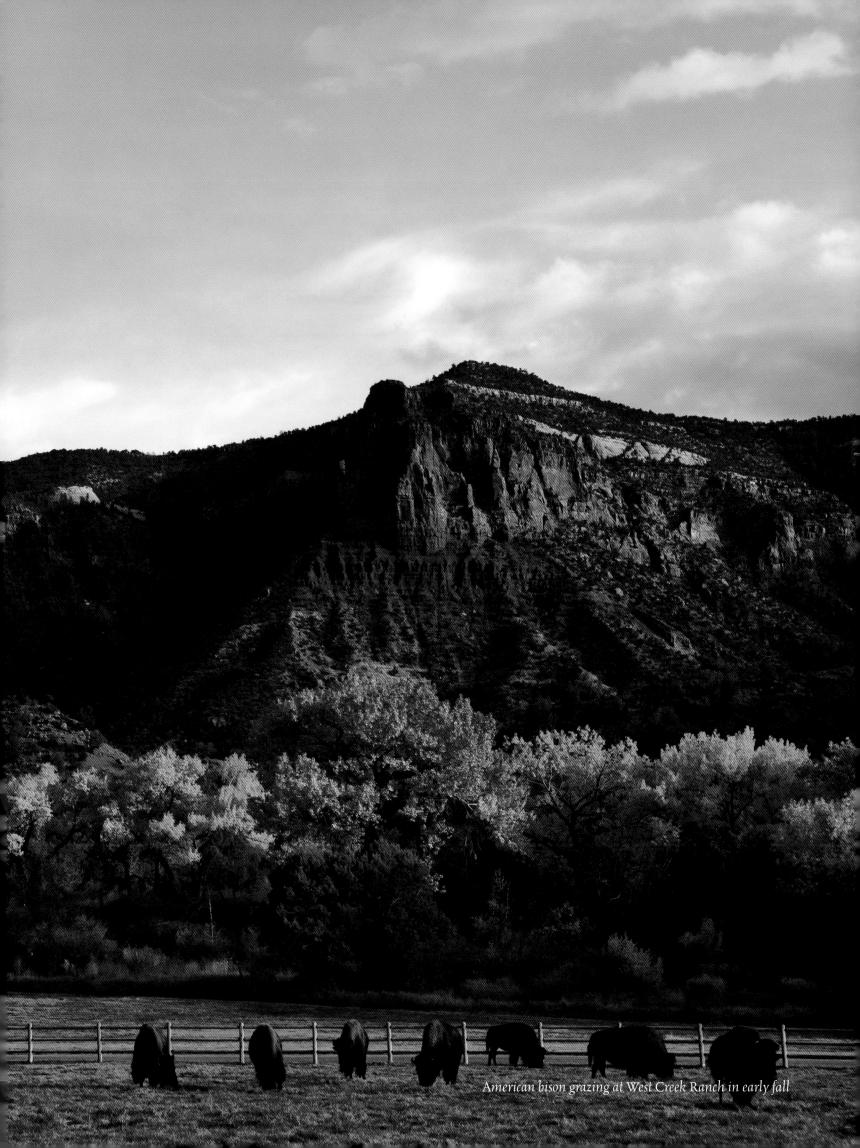

American bison grazing at West Creek Ranch in early fall

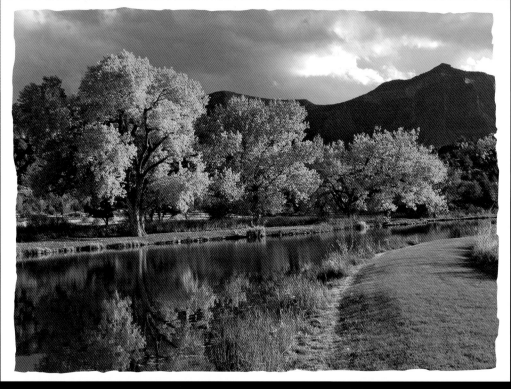

Cottonwood trees in fall at West Creek Ranch pond

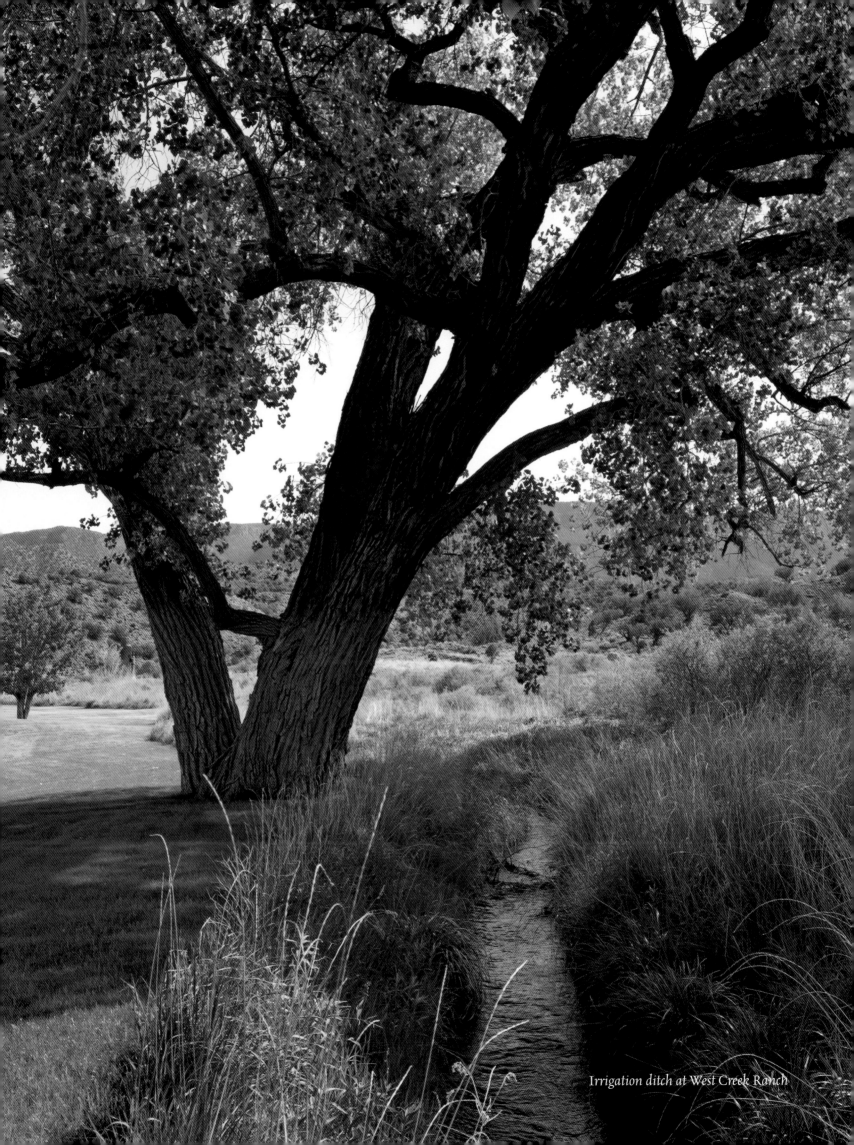

Irrigation ditch at West Creek Ranch

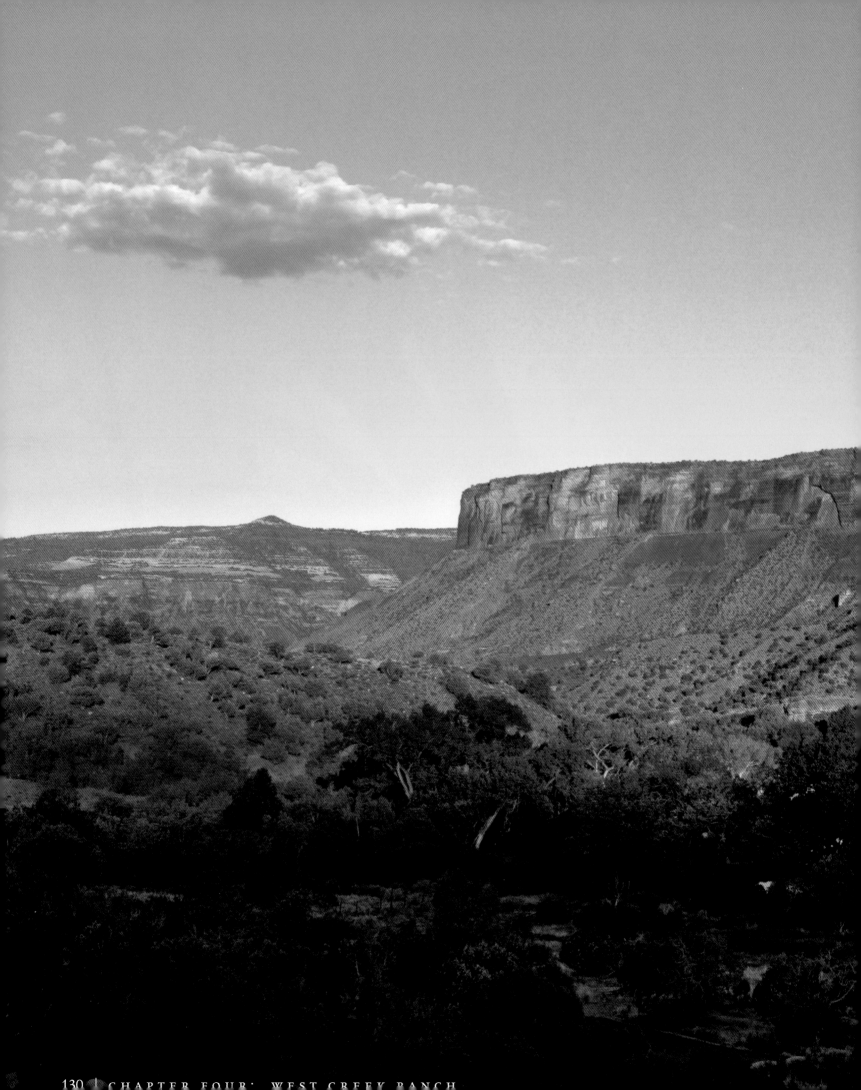

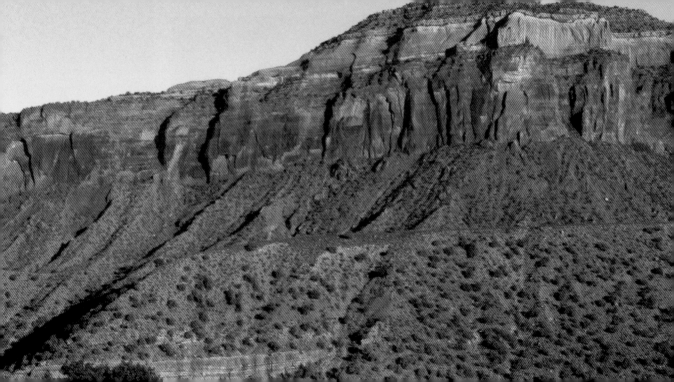

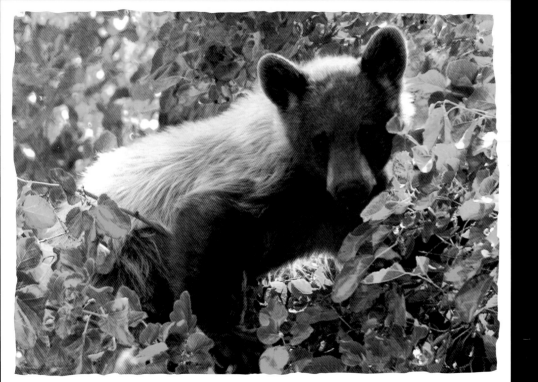

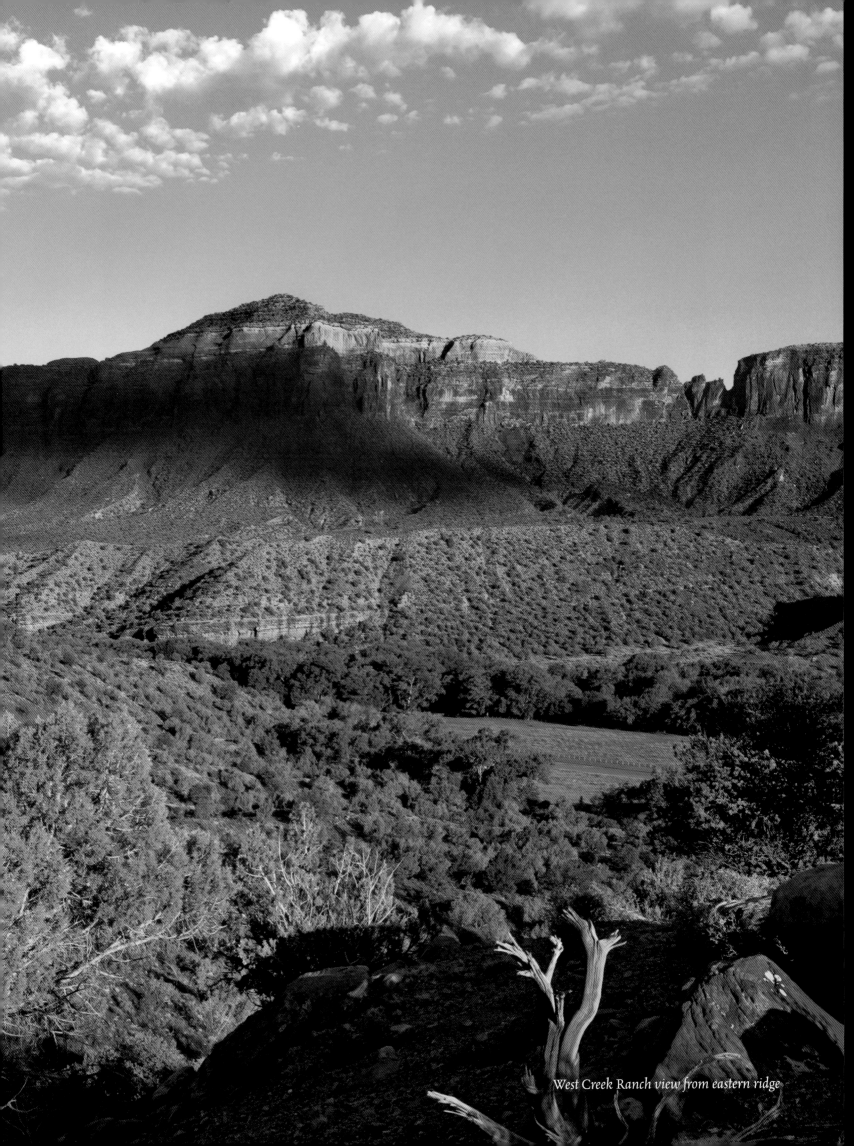

West Creek Ranch view from eastern ridge

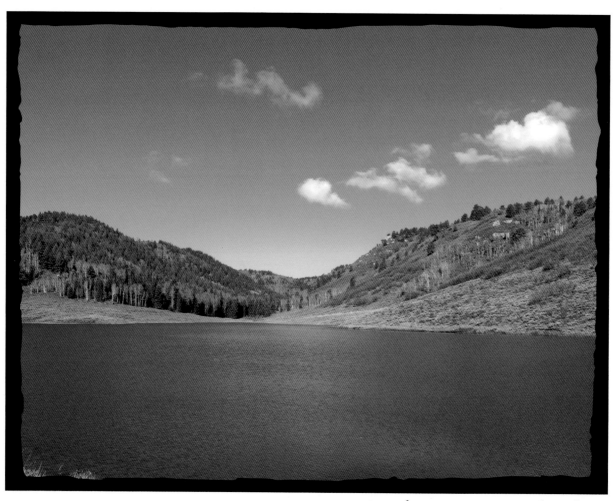

Big Creek Reservoir on Uncompahgre Plateau

MESAS IN THE SKY

Within a short drive, up either Divide Road or John Brown Canyon Road, lie the lush ponderosa pine forests of the Uncompahgre Plateau. Overlooking the high-desert landscape of the red canyon country below, these forests that once welcomed the dinosaurs, now are filled with elk, black bear, and mountain lions. It's a land of many contrasts as piñon pines and juniper trees dot the canyon floors at elevations from 4,800 to 7,000 feet. Venture higher still to the mesa tops, above 8,000 feet in elevation, and you'll find flatter, cooler and wetter land with heavy snowfall in winter. This high mesa snowpack fills the creeks which irrigate the lands below during the late spring runoff.

A spectacular 20-minute drive up John Brown Canyon Road leads to Sky Mesa Ranch. With the Colorado-Utah border as its western fence line, Sky Mesa Ranch overlooks the expansive Sinbad Valley, formed through what geologists speculate must have been a cataclysmic collapse of an enormous underground salt dome. Utah's snow-capped La Sal Mountains stand in full view, the summit of Mount Peale soaring to 13,100 feet.

Unaweep Canyon's Divide Road leads to the high plateau country of the Uncompahgre National Forest. This is cattle-grazing country with grand open skies and inspiring sunsets. Big Creek Reservoir and Casto Reservoir, both located on the Uncompahgre Plateau, store water for irrigating the pastures of Unaweep Canyon, as well as pastures in the Dolores River Canyon, some 20 miles away.

Meander in just about any direction and you're likely to come upon a view that you'd swear no one else has seen, well at least not in the last several hundred years. So rare is it to see another human in this part of the world that it is easy to get lost in imaginary pasts.

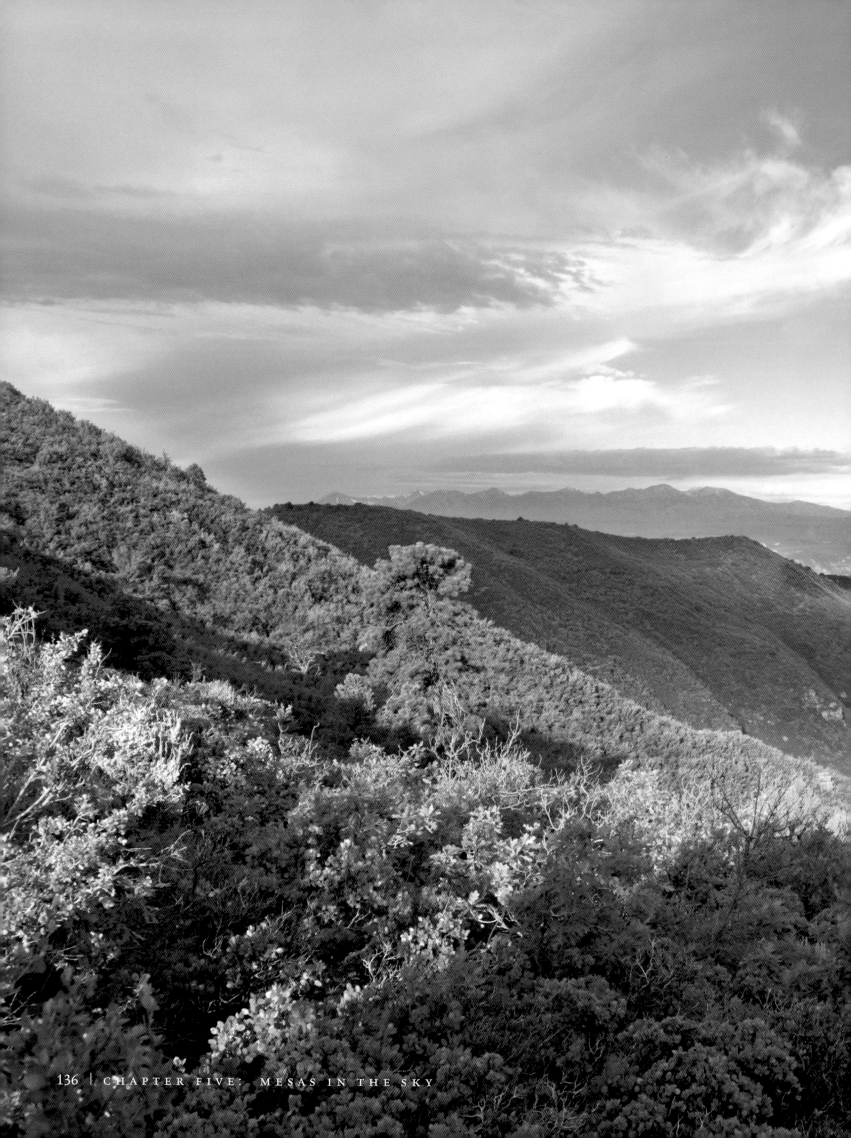

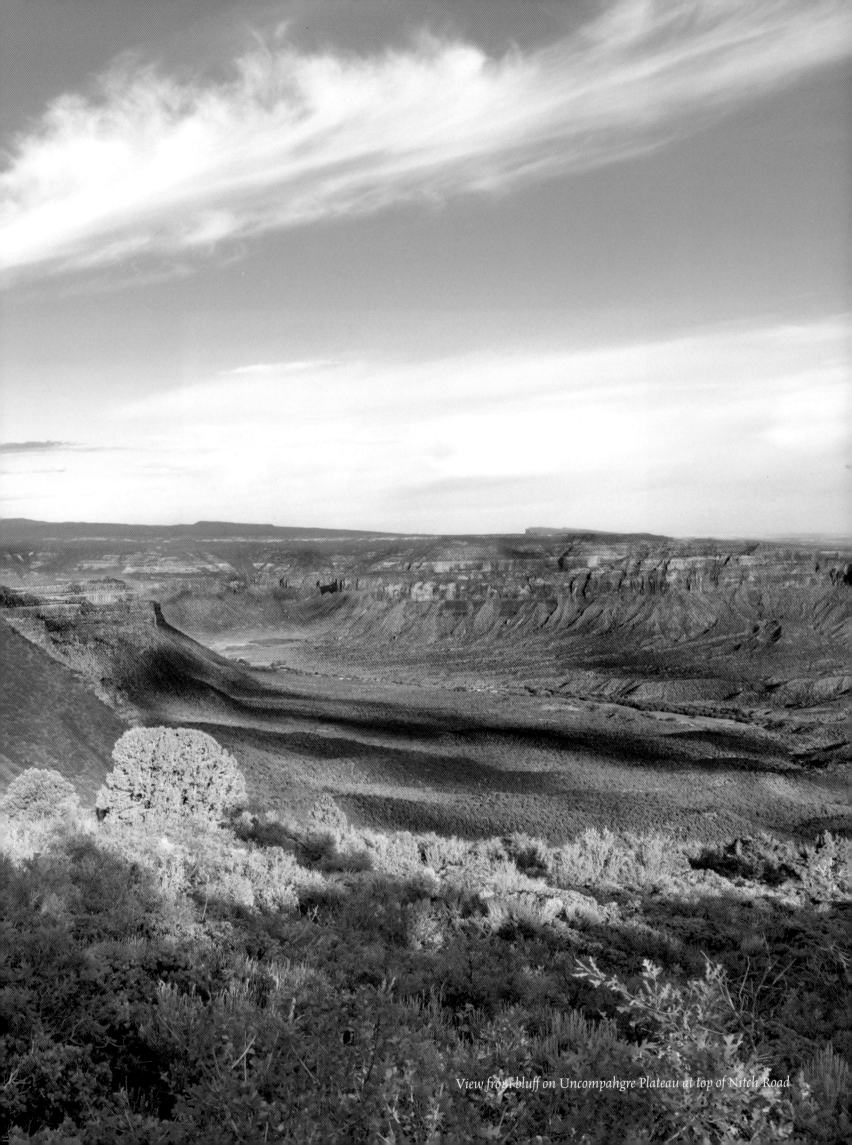

View from bluff on Uncompahgre Plateau at top of Nitch Road

Cabin at Sky Mesa western overlook

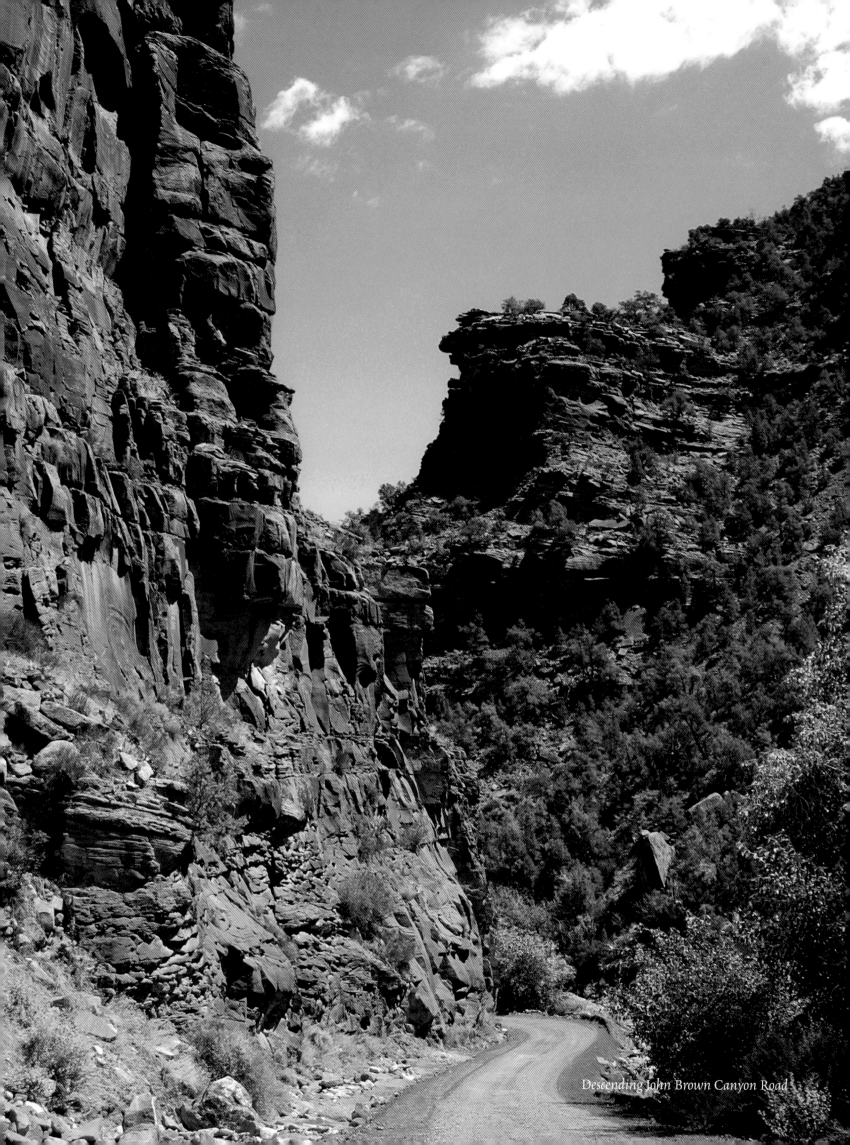

Descending John Brown Canyon Road

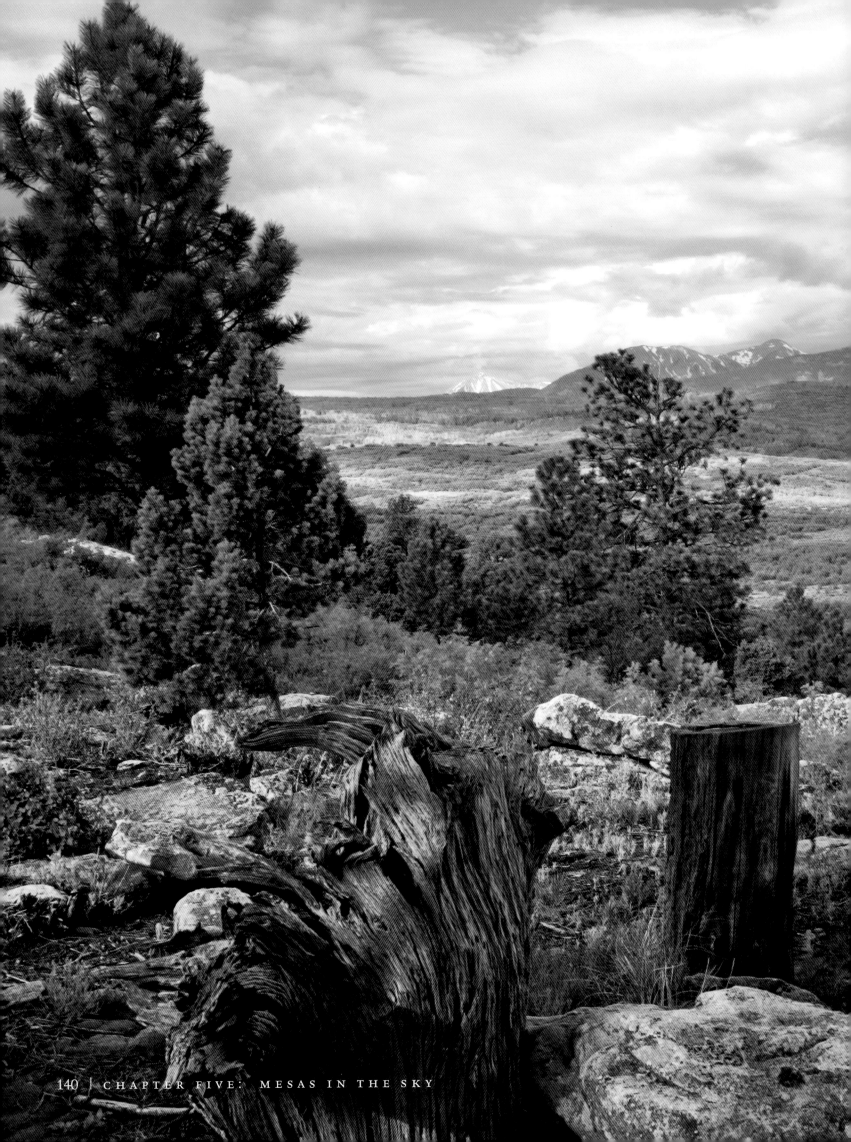

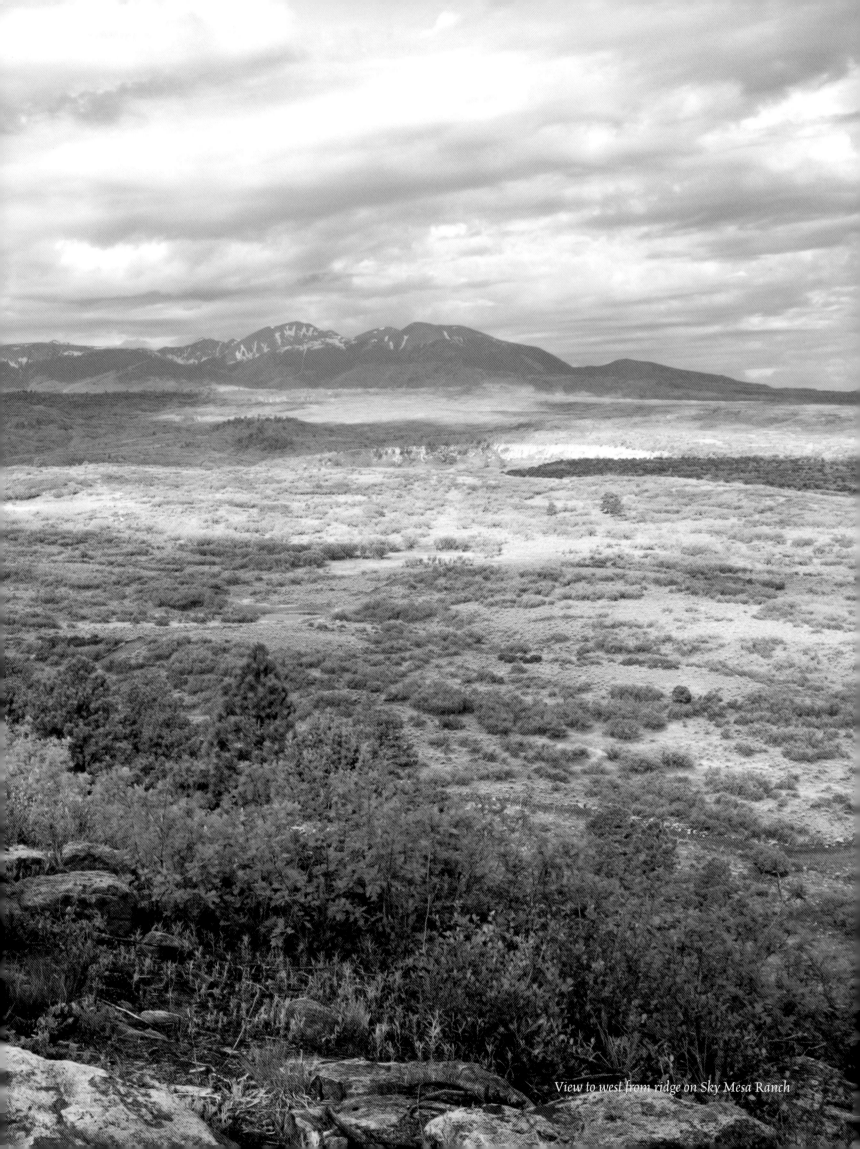

View to west from ridge on Sky Mesa Ranch

Wildflowers on Uncompahgre Plateau

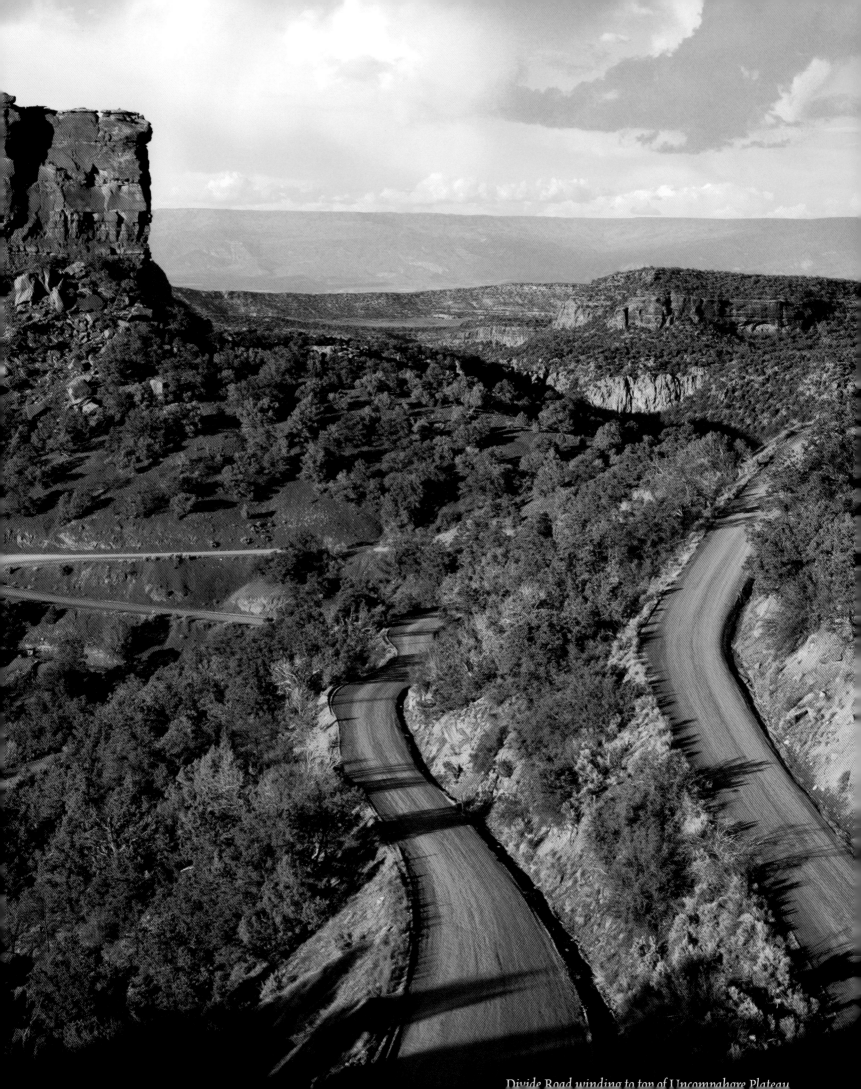

Divide Road winding to top of Uncompahgre Plateau

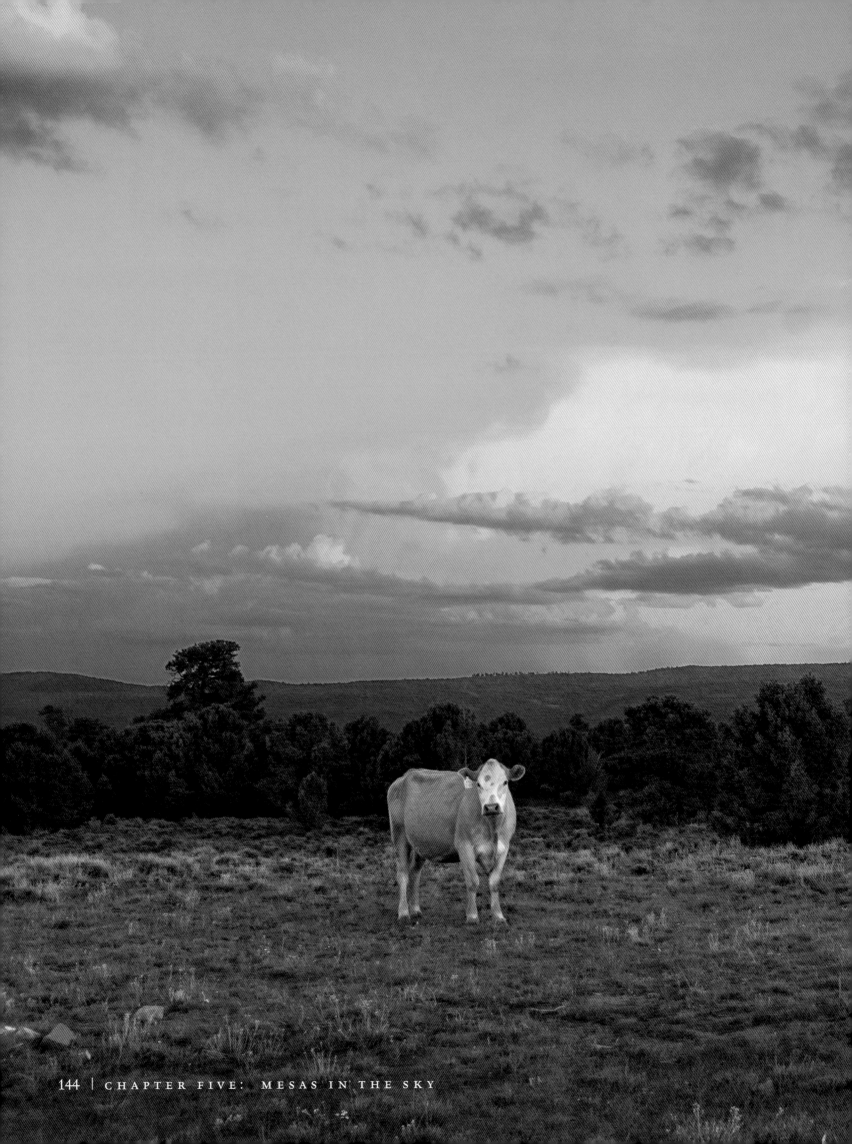

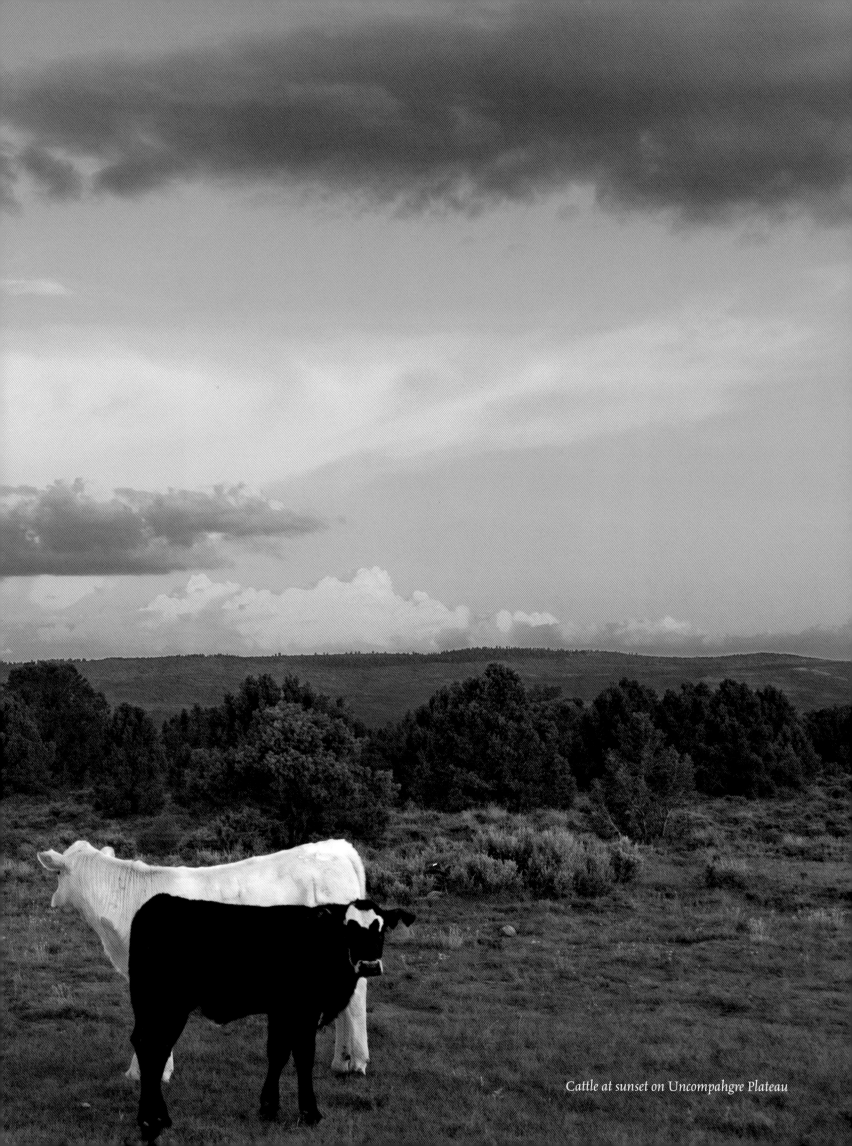

Cattle at sunset on Uncompahgre Plateau

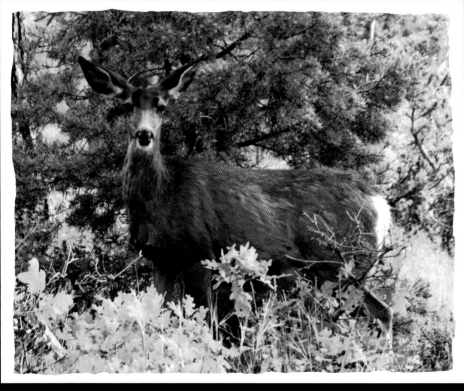

Deer on Sky Mesa Ranch

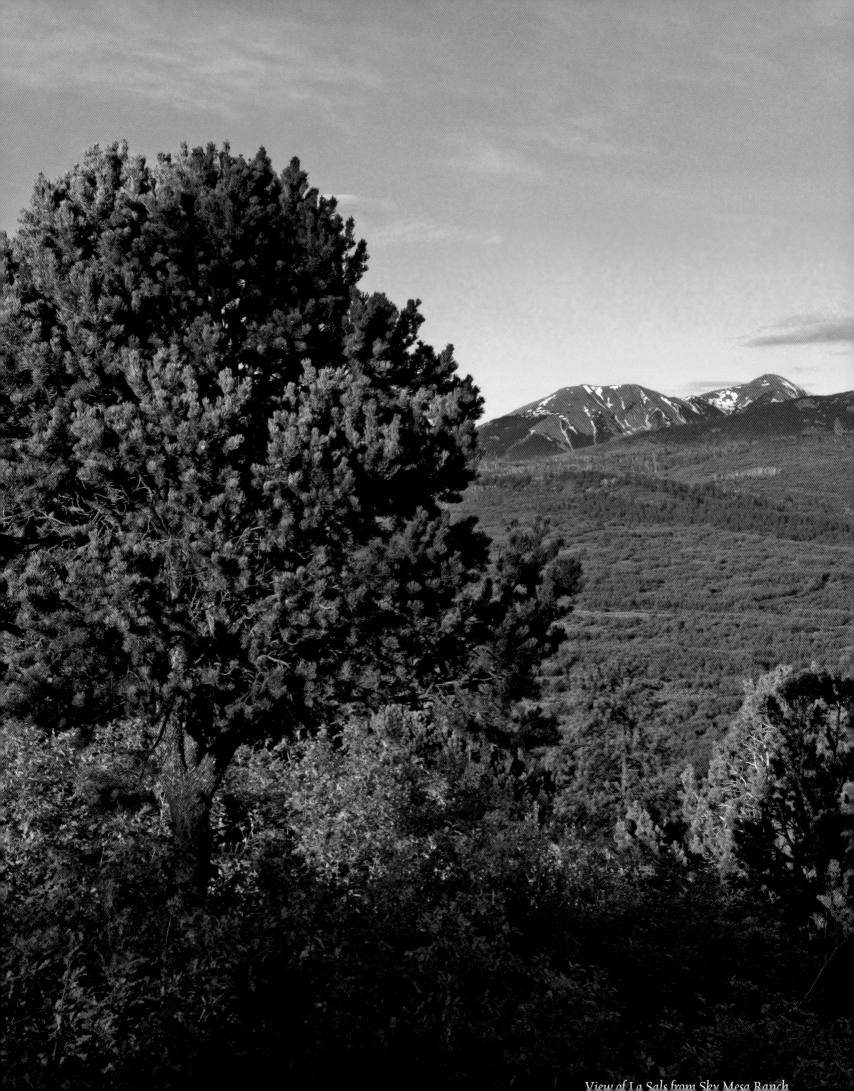

View of La Sals from Sky Mesa Ranch

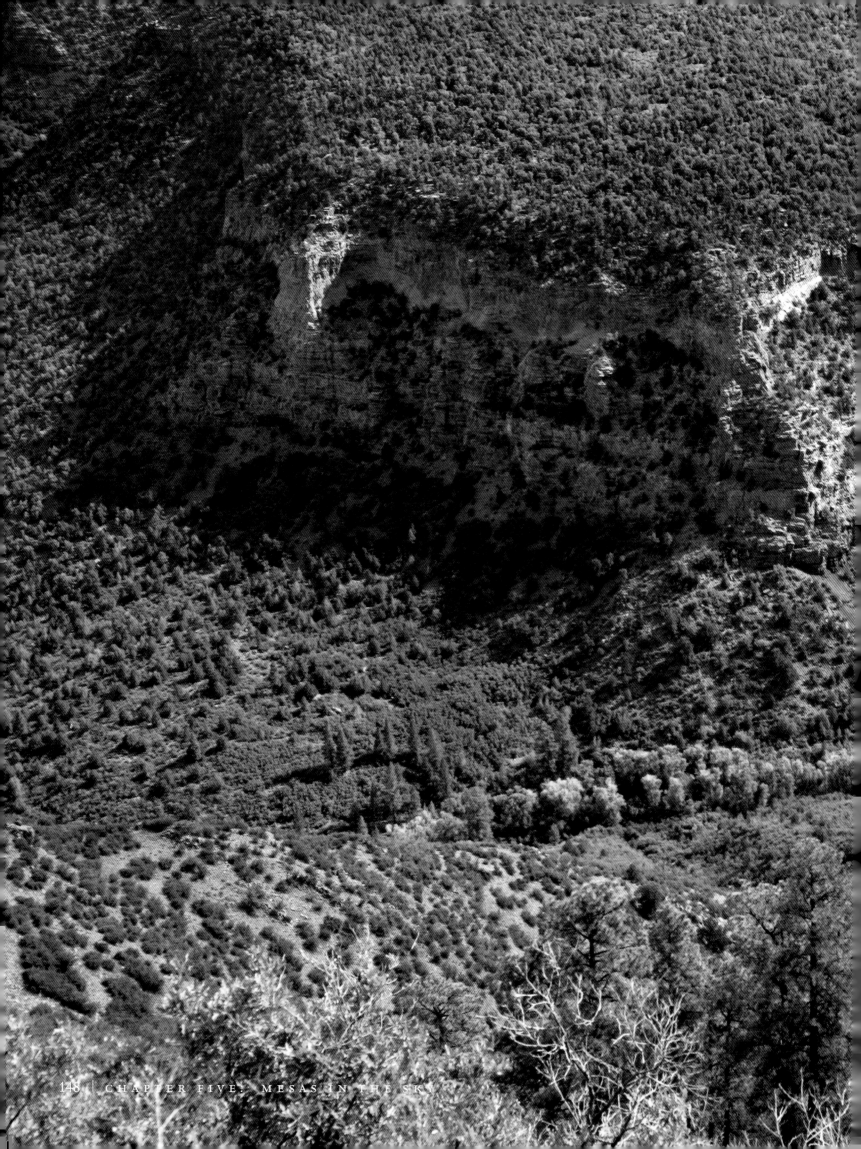

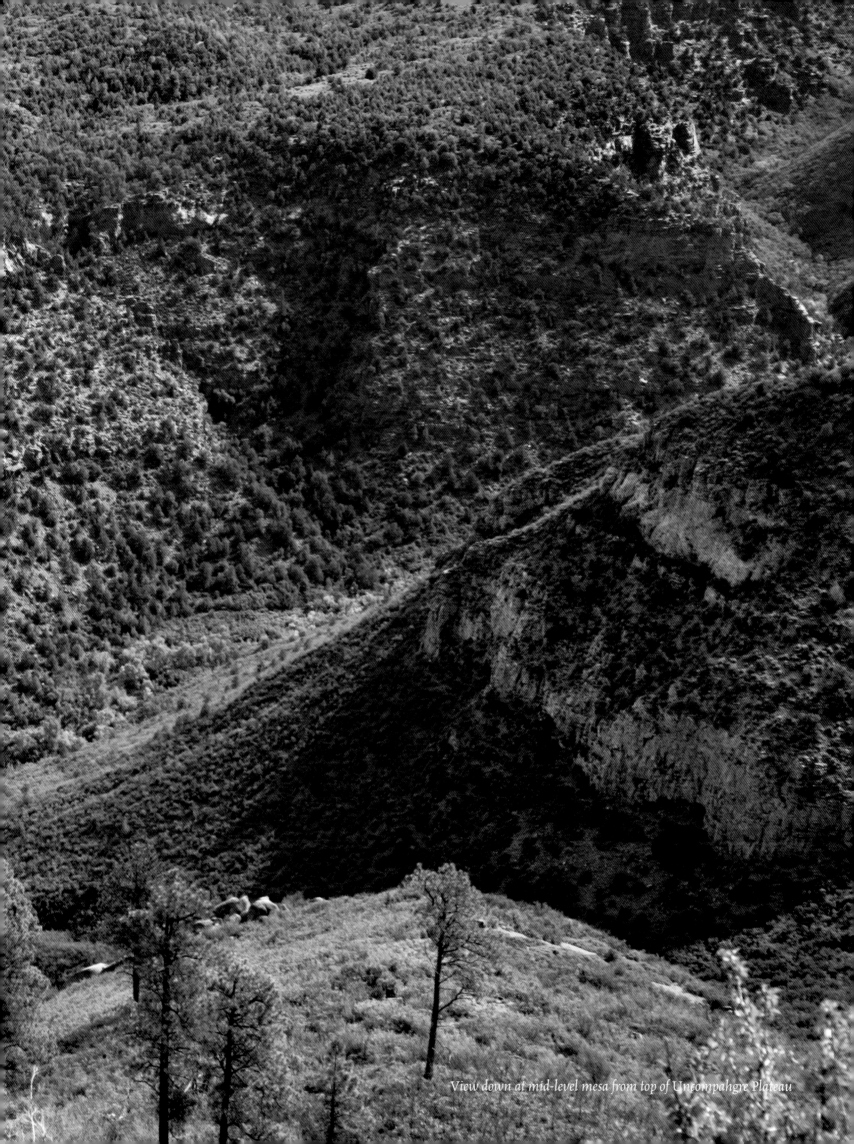

View down at mid-level mesa from top of Uncompahgre Plateau

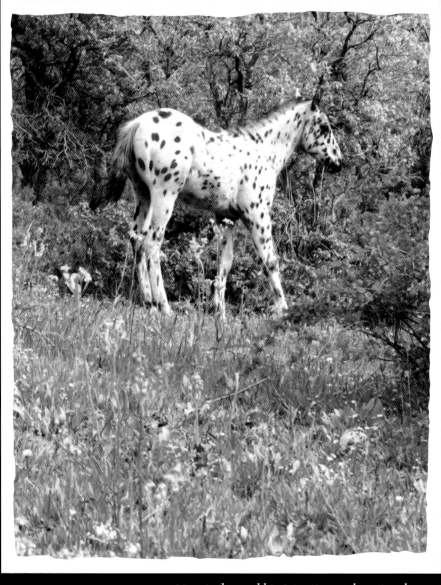

New to the world in Manti-La Sal National Forest

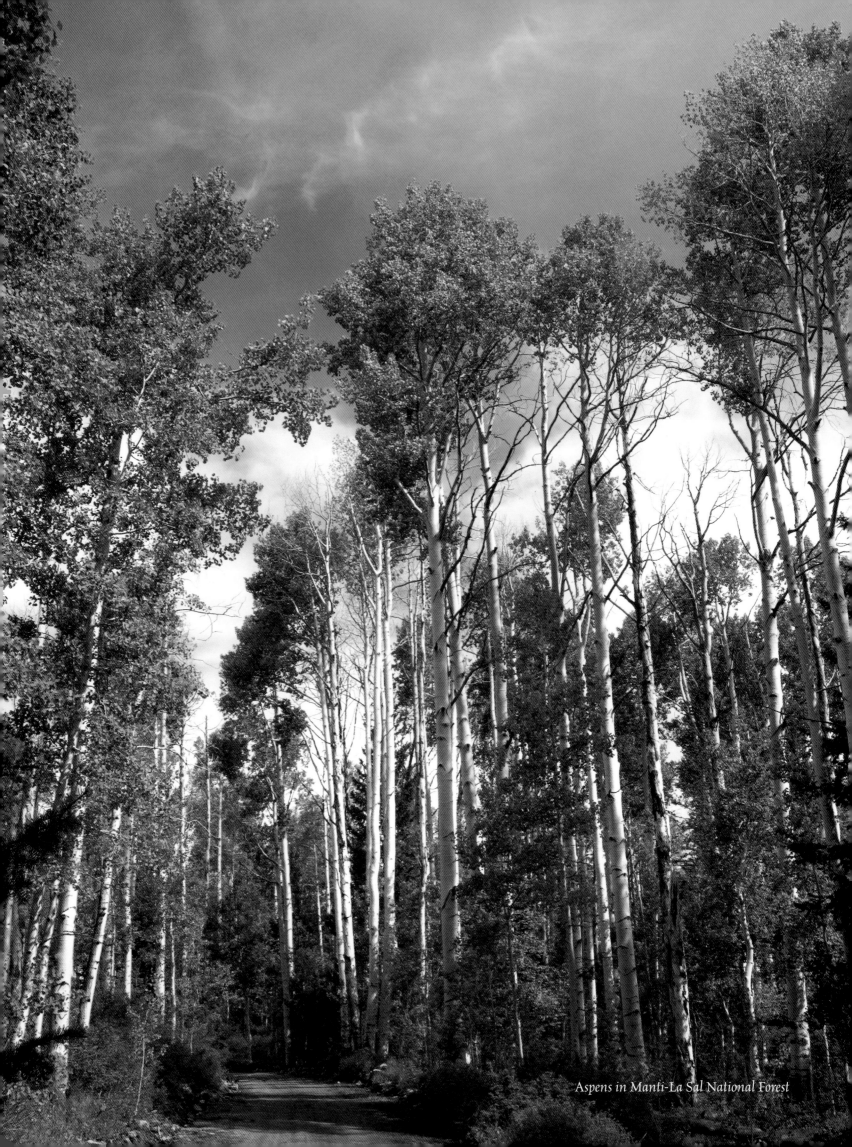

Aspens in Manti-La Sal National Forest

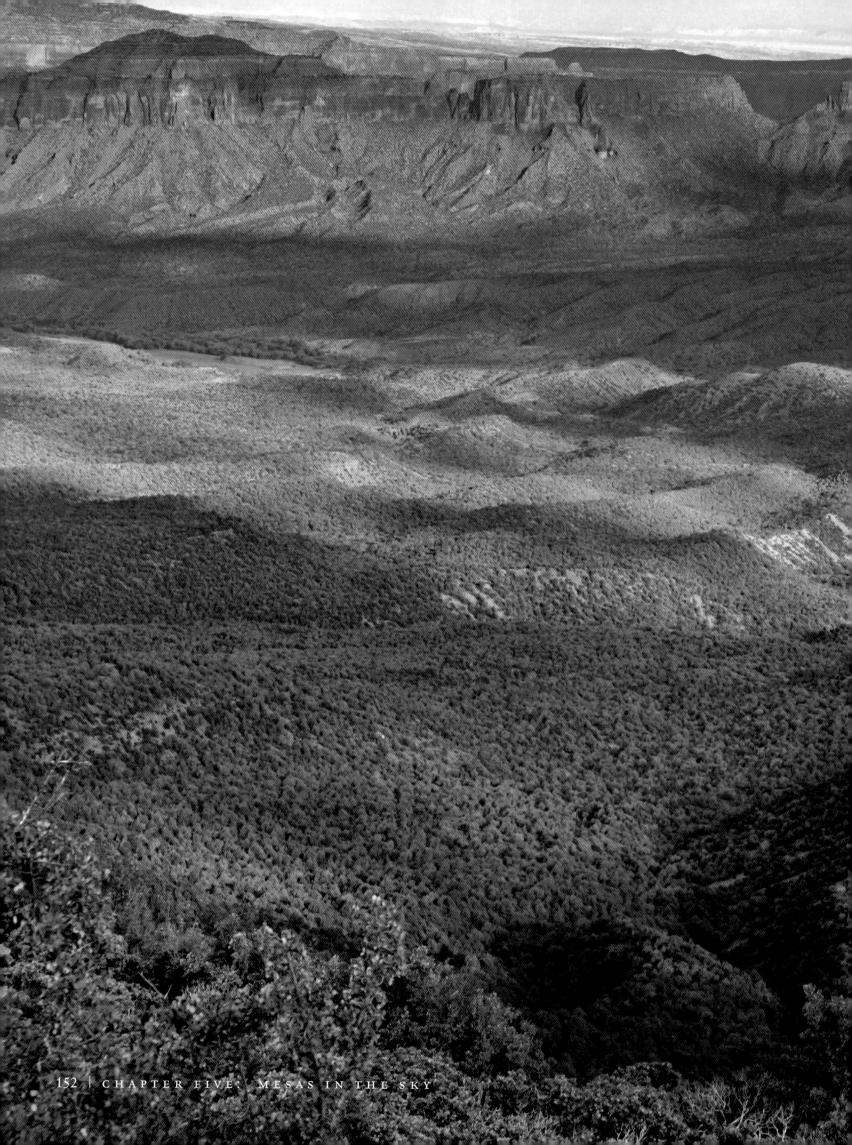

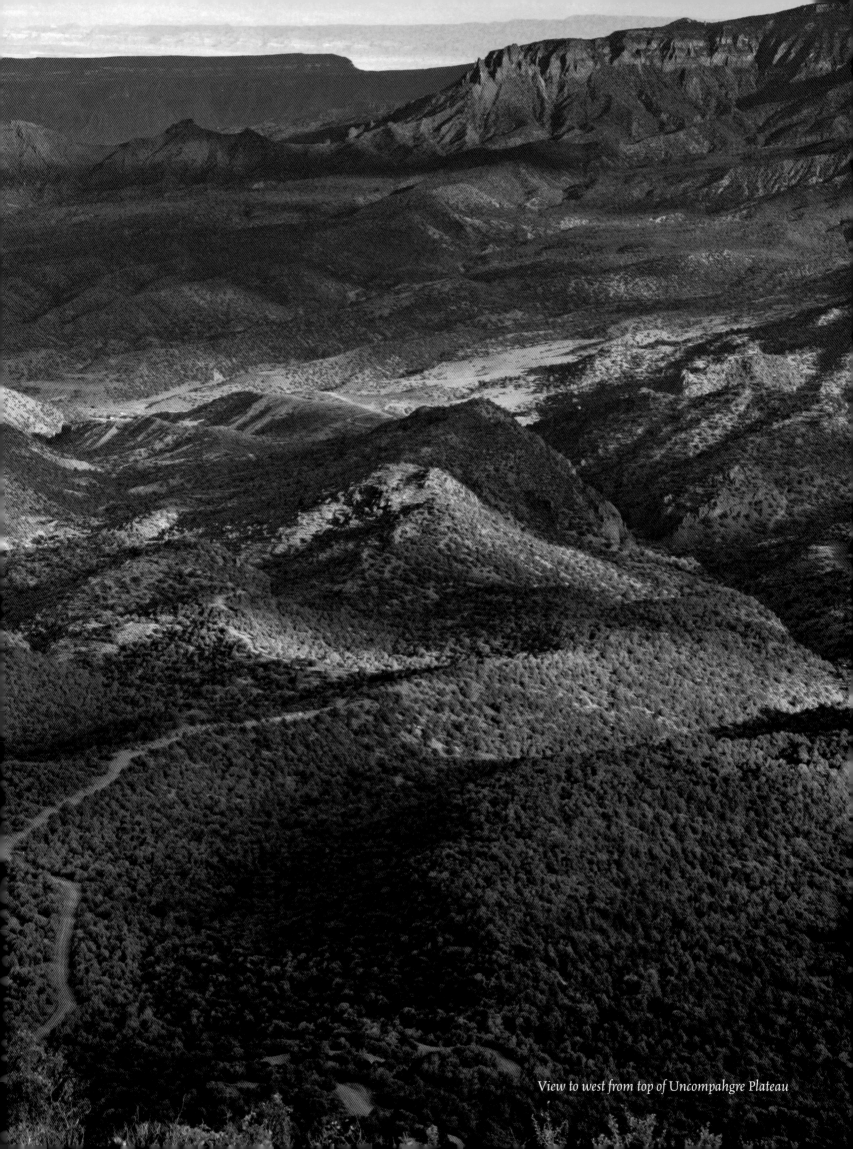

View to west from top of Uncompahgre Plateau

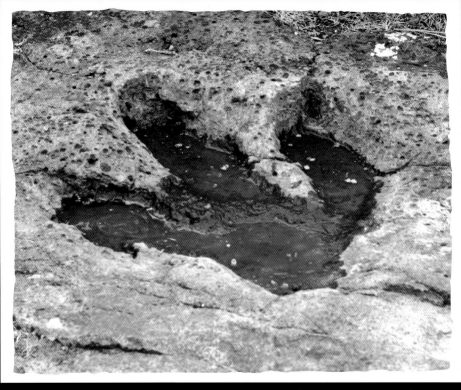

Dinosaur track on mesa top west of Gateway

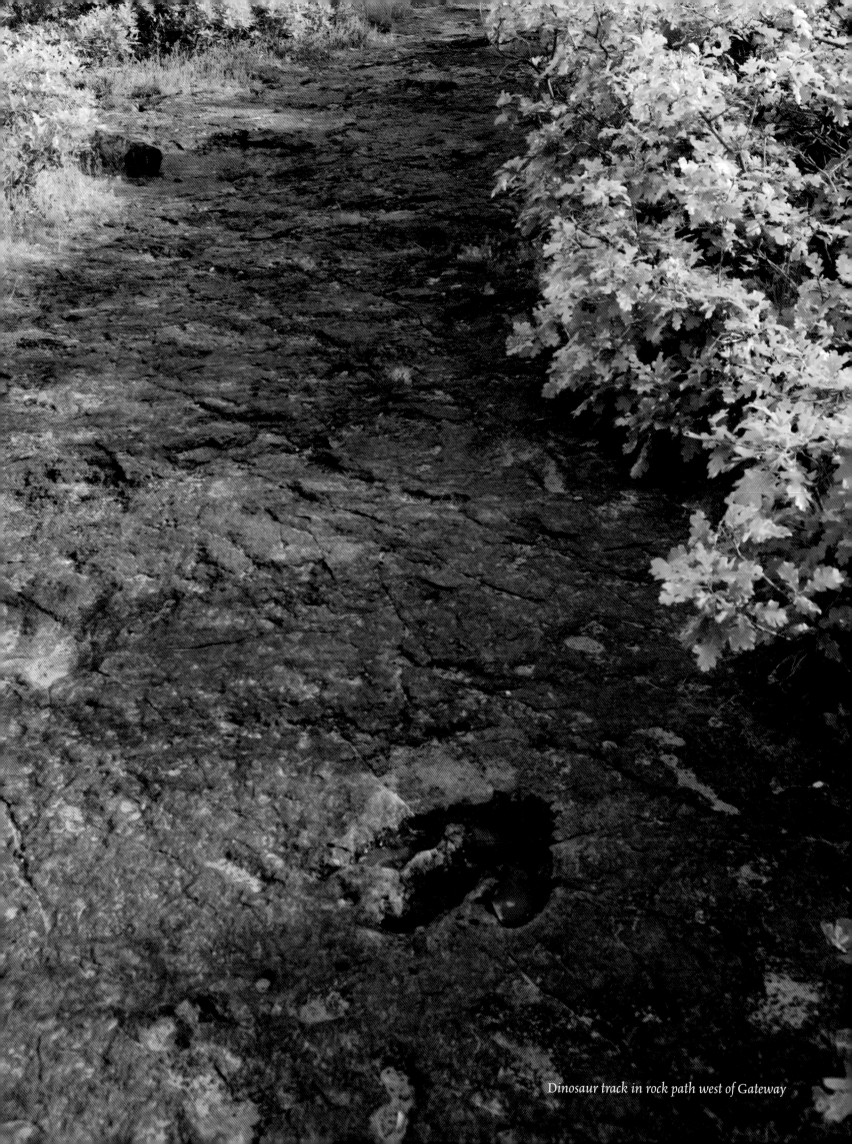

Dinosaur track in rock path west of Gateway

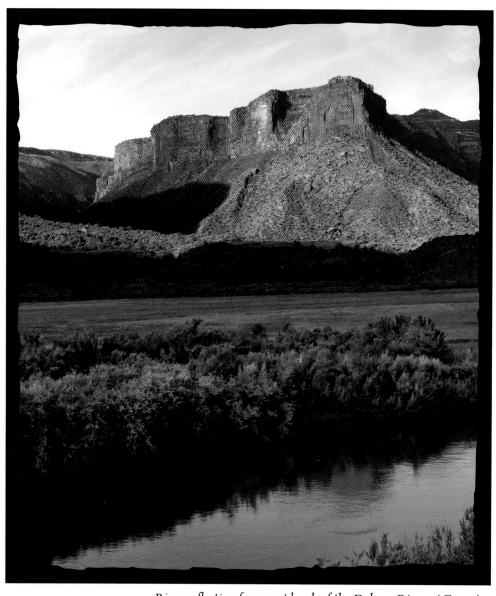

River reflection from east bank of the Dolores River at Experius

LAND OF EXPERIUS

Imagine the gradual building of a small mining town. A place to water the horse, maybe settle in for the night. A general store offering essentials like twine, tin cups, fabric, and maybe a special treat or two. Soon, as the population builds, so does the desire for connecting with others, bringing entertainment, adventure, and places to share stories. The history of Gateway Canyons plays out much like that of many early Colorado towns – a compelling destination attracting adventurers...evoking a desire to call the place home, for however long.

As the Hendricks family sets aside several thousands of acres for preservation, generations of visitors will continually enjoy the opportunity to repeat the "discovery" of this remarkable land. With the additions of Experius Academy and Experius Community, visitors will find a natural, welcoming home for their questions and inspirations.

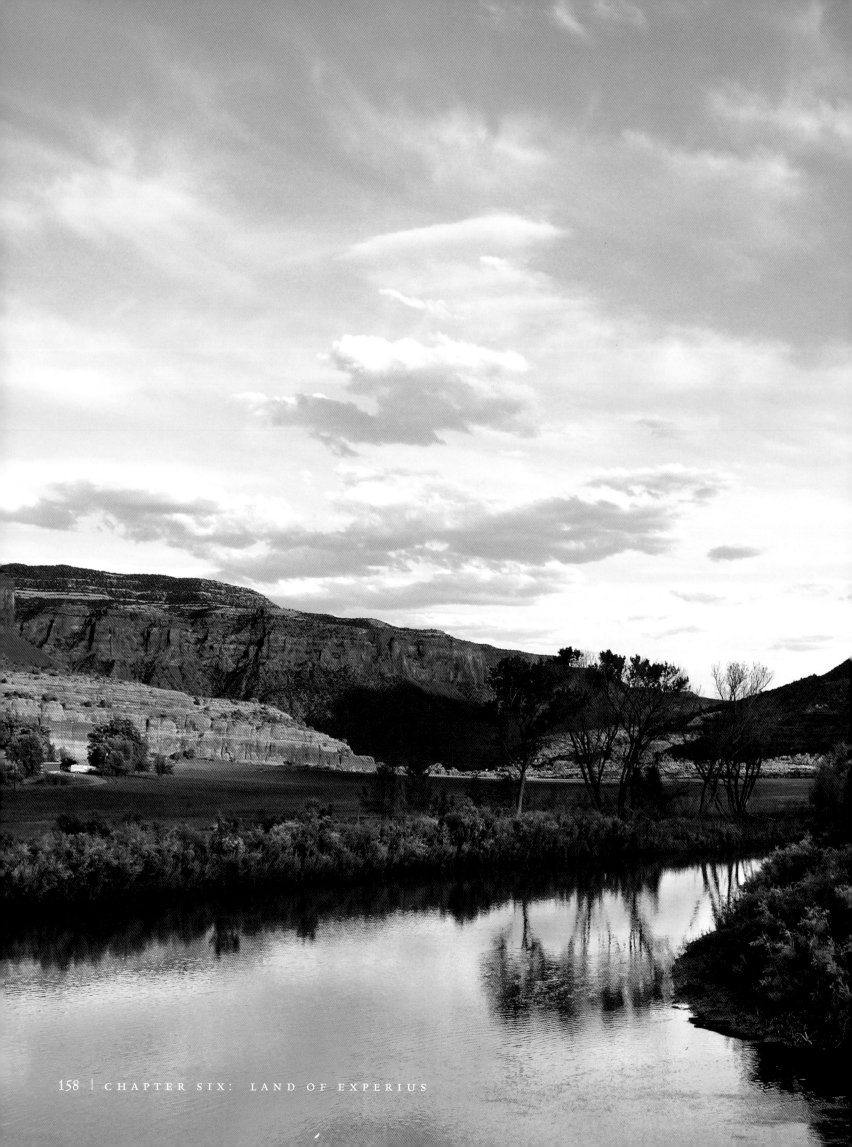

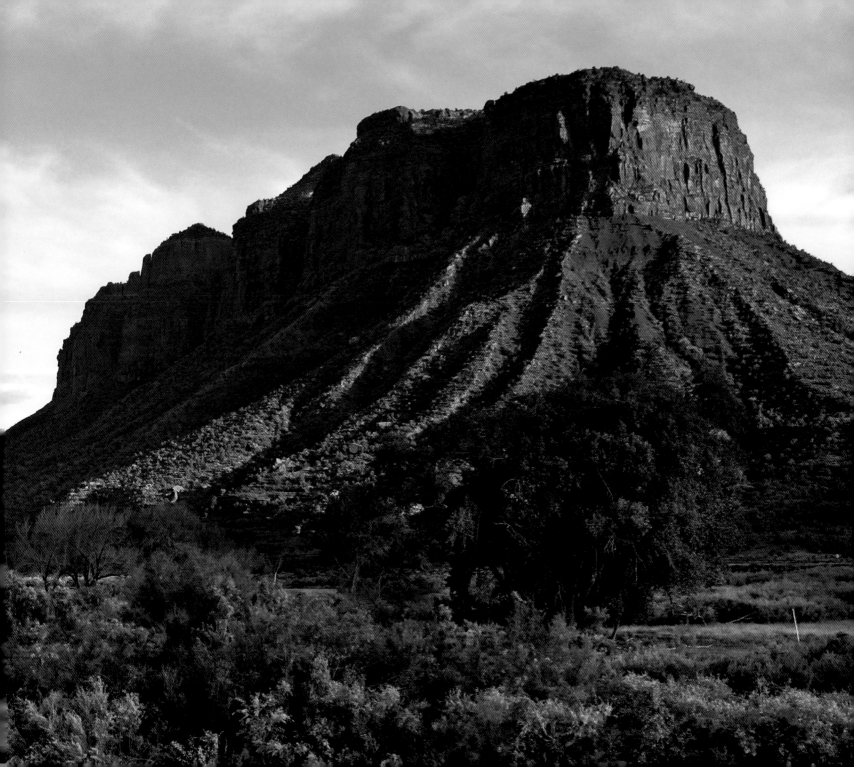

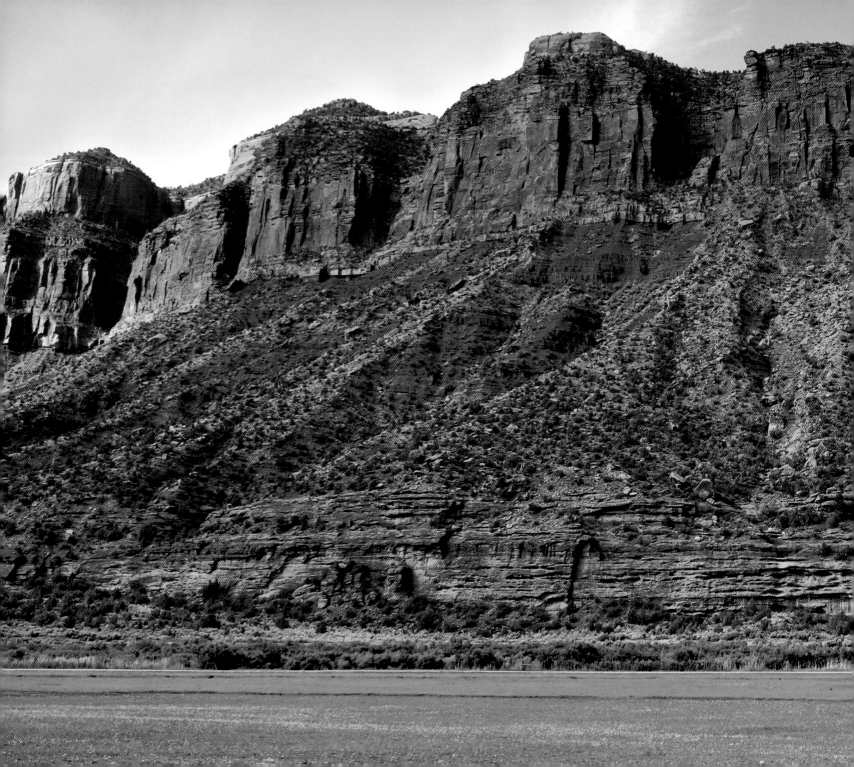

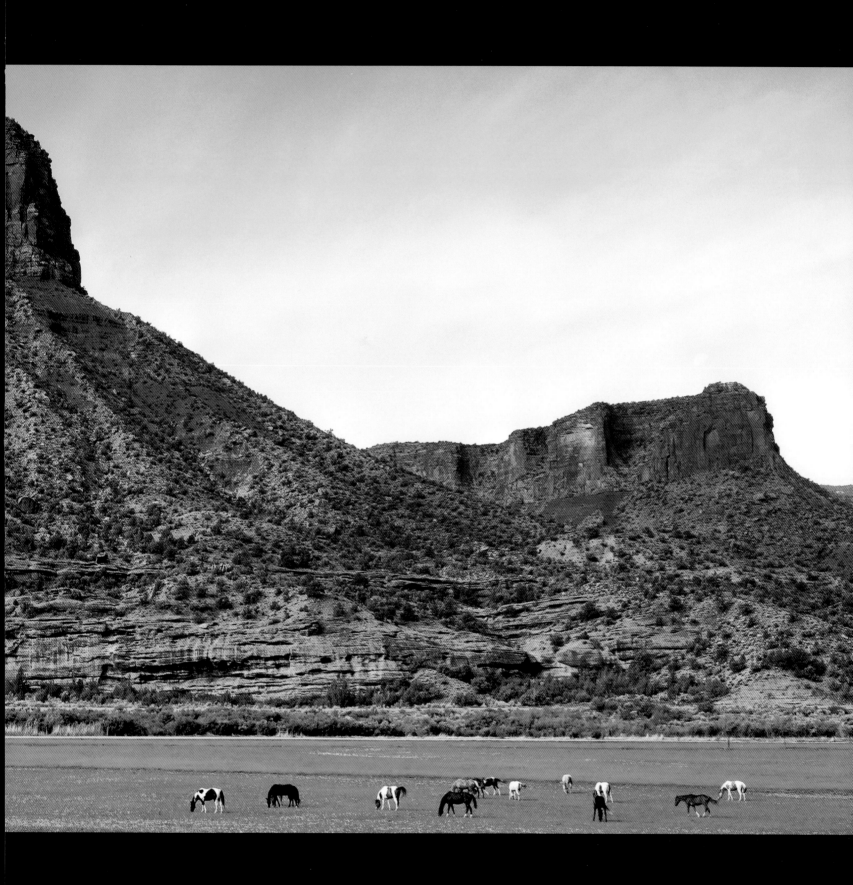

Horses grazing under cliffs at Experius

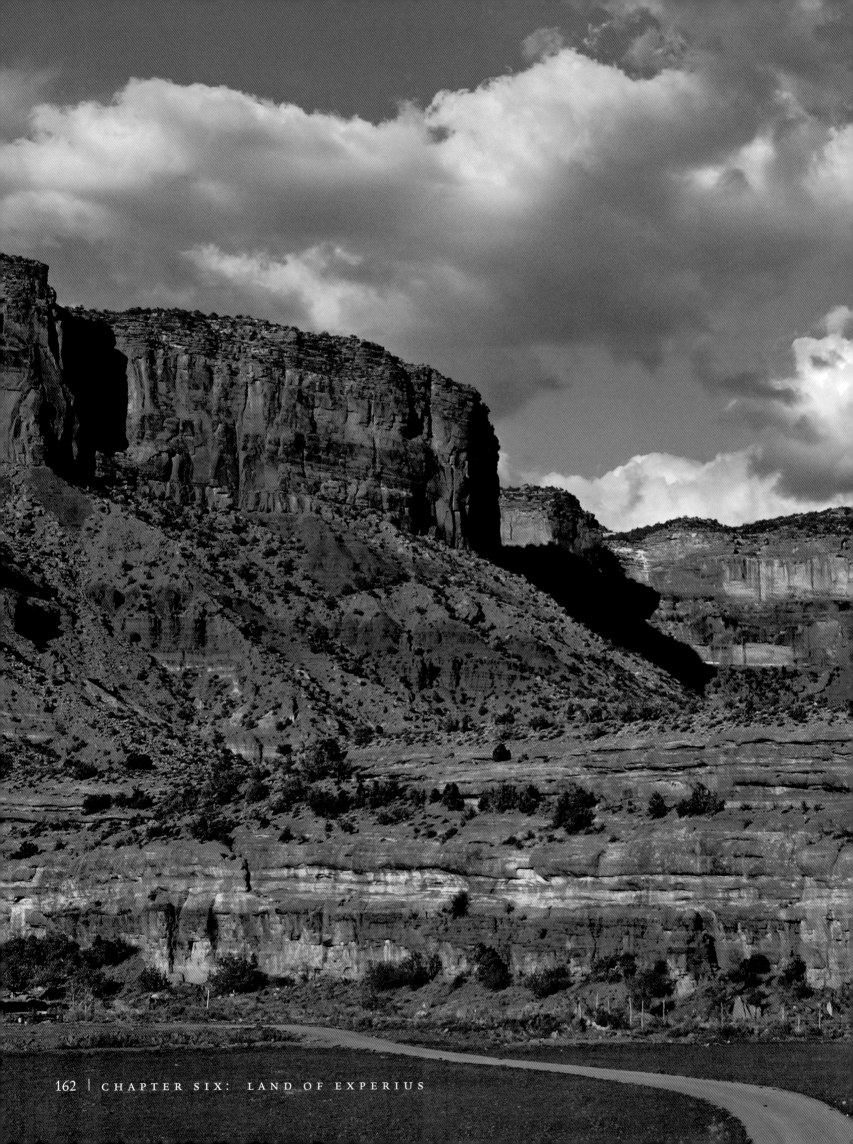

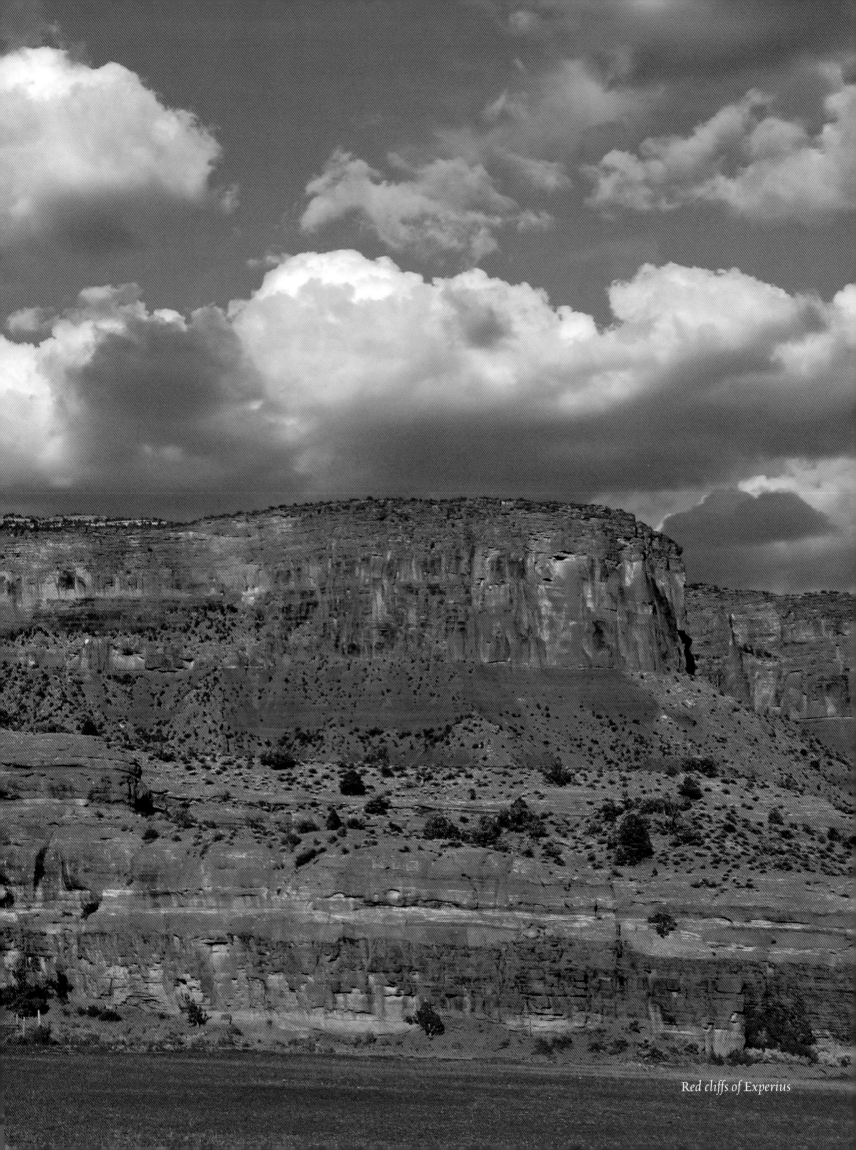
Red cliffs of Experius

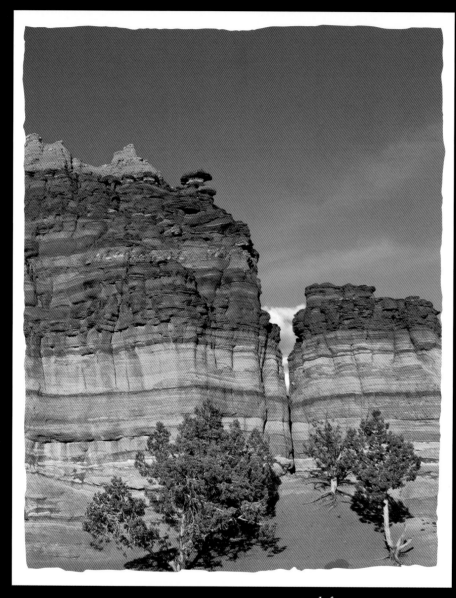

Rock formations at Experius

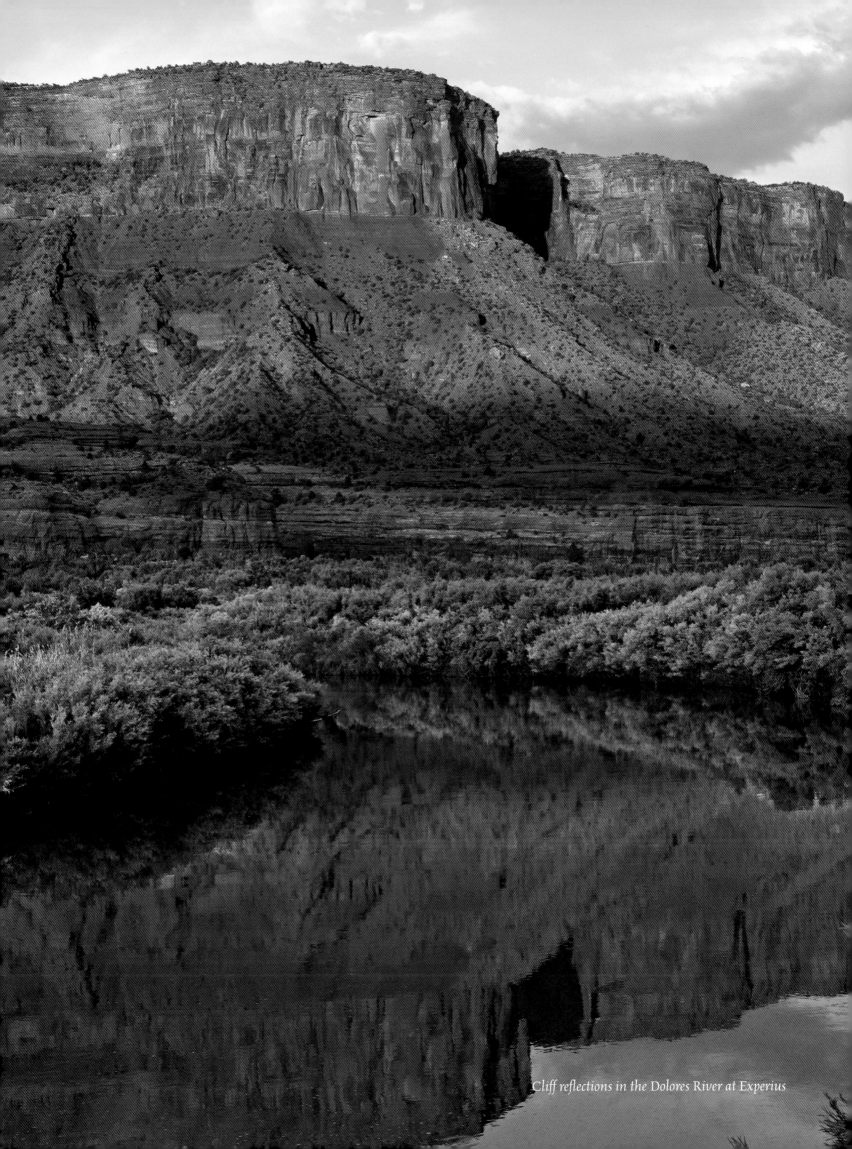

Cliff reflections in the Dolores River at Experius

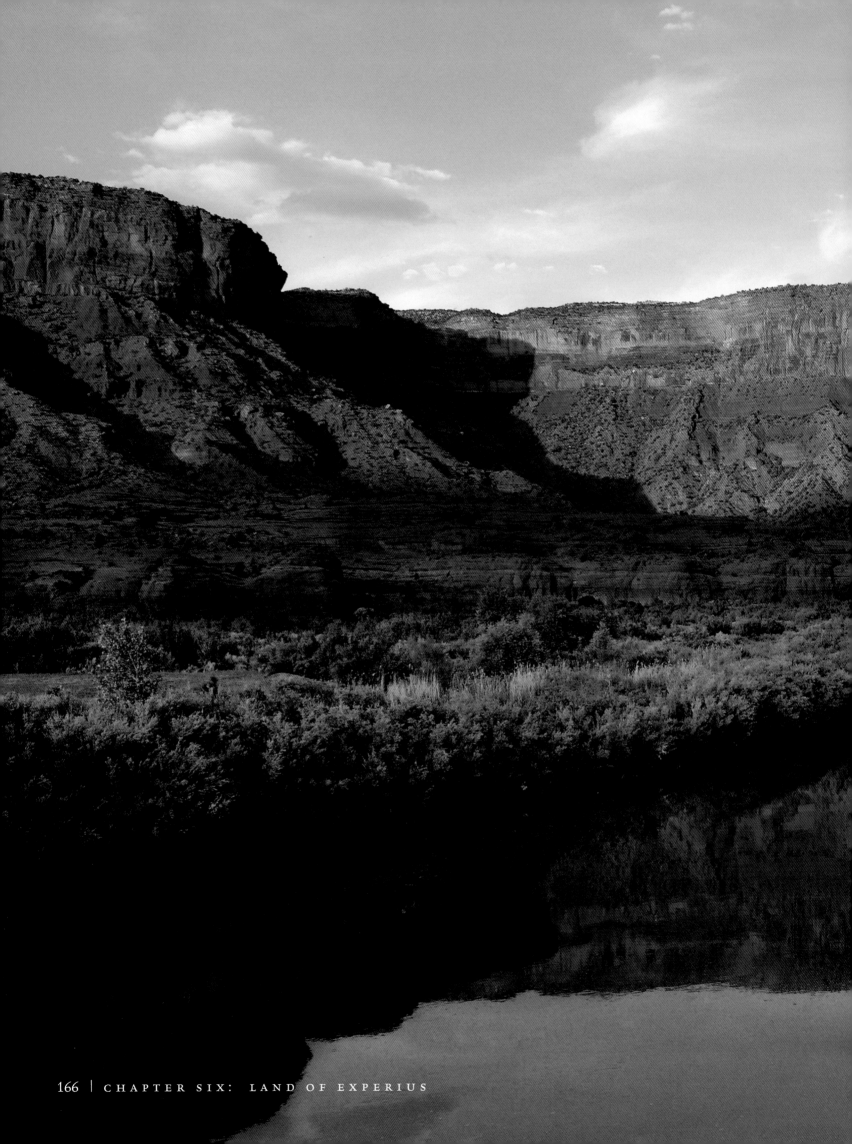

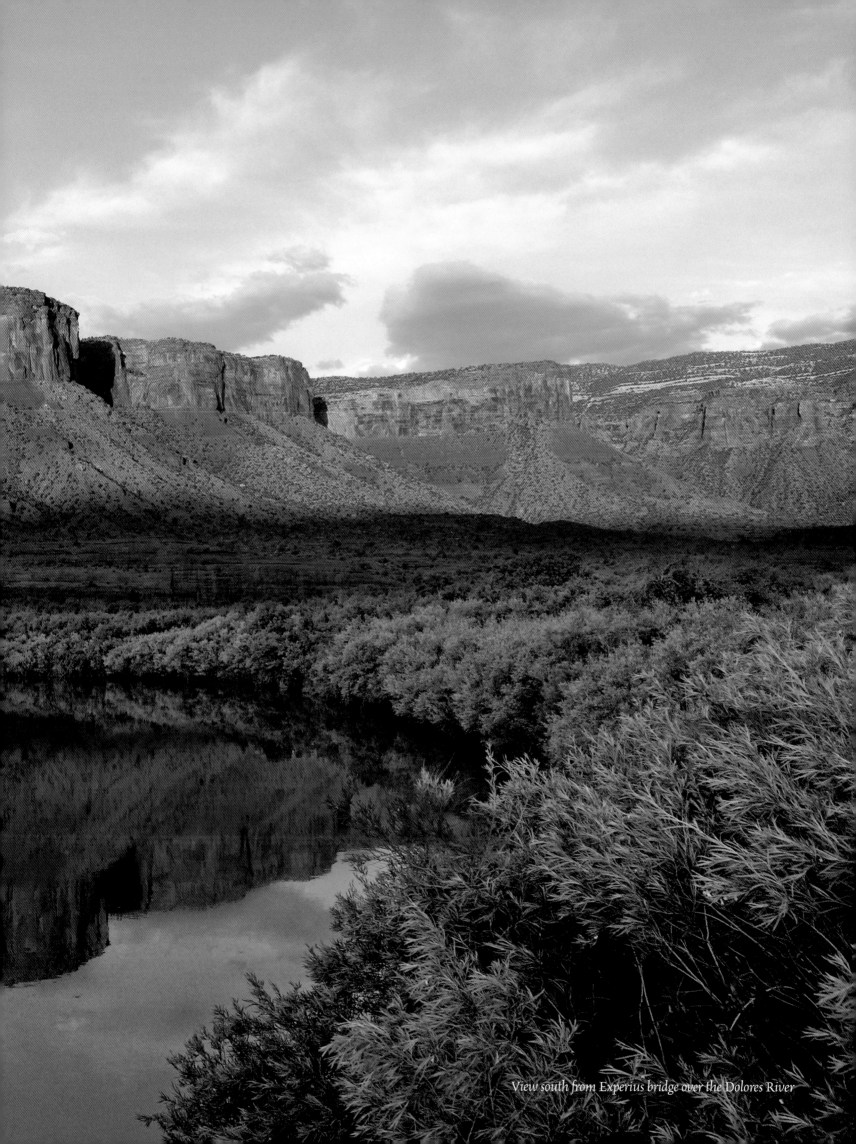

View south from Experius bridge over the Dolores River

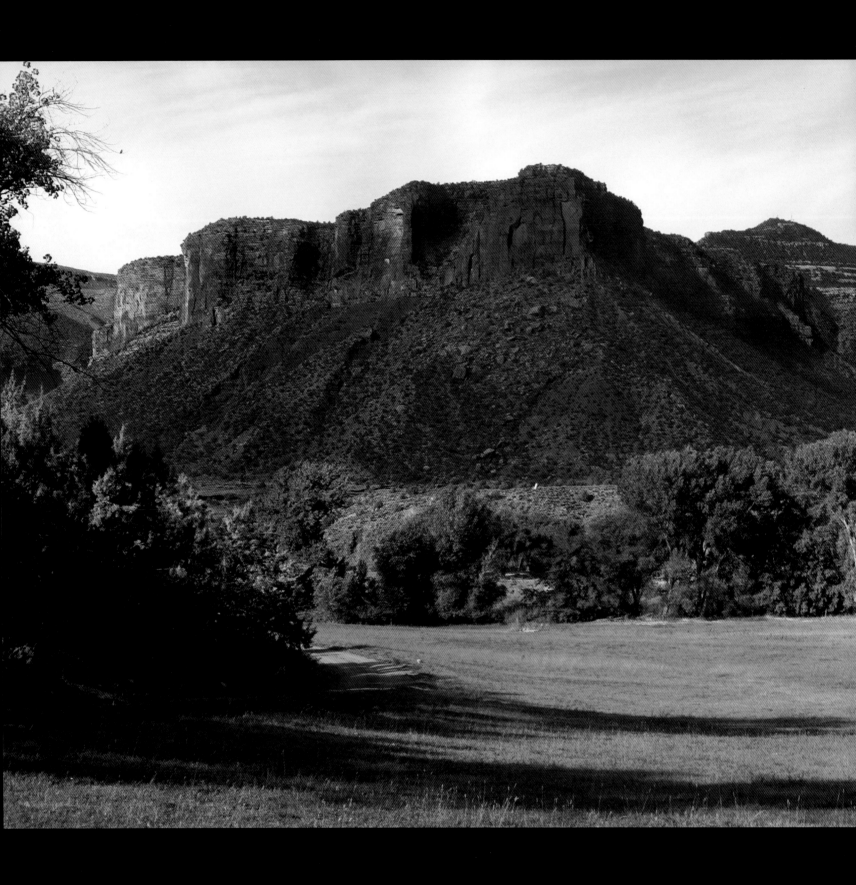

Green fields by West Creek at Experius

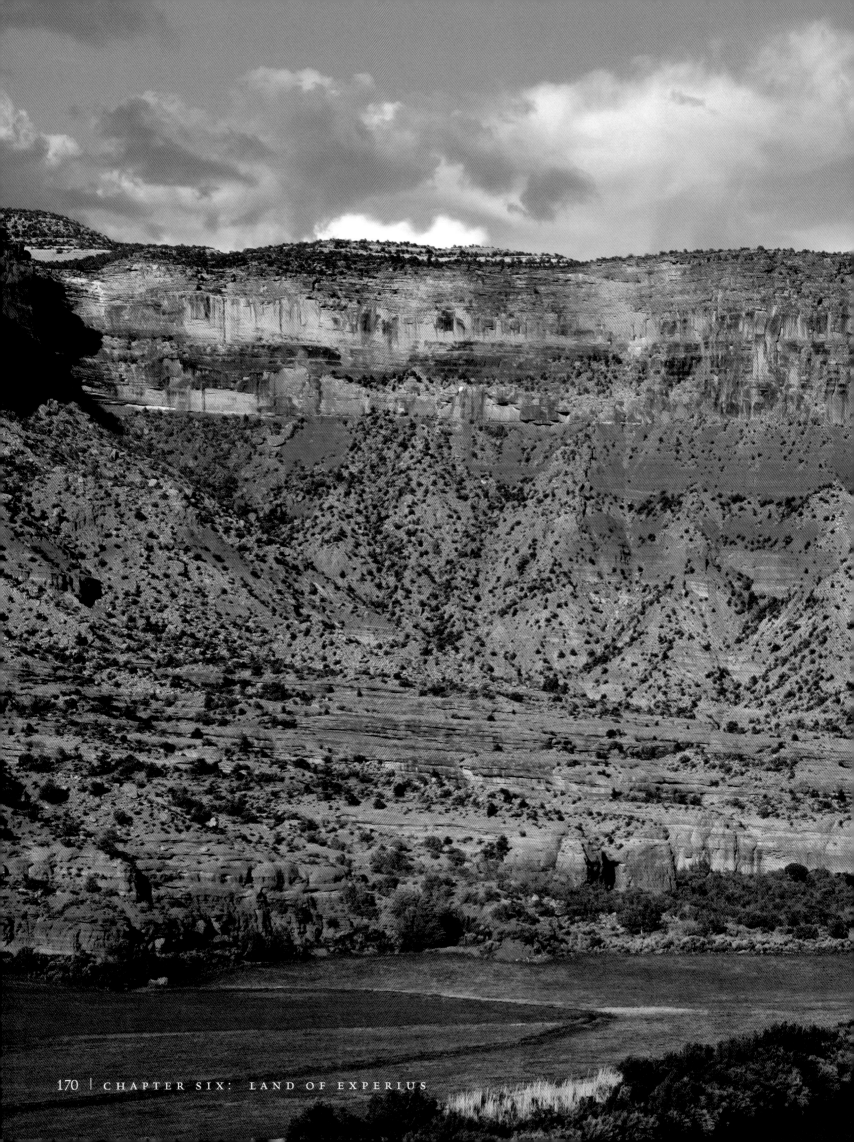

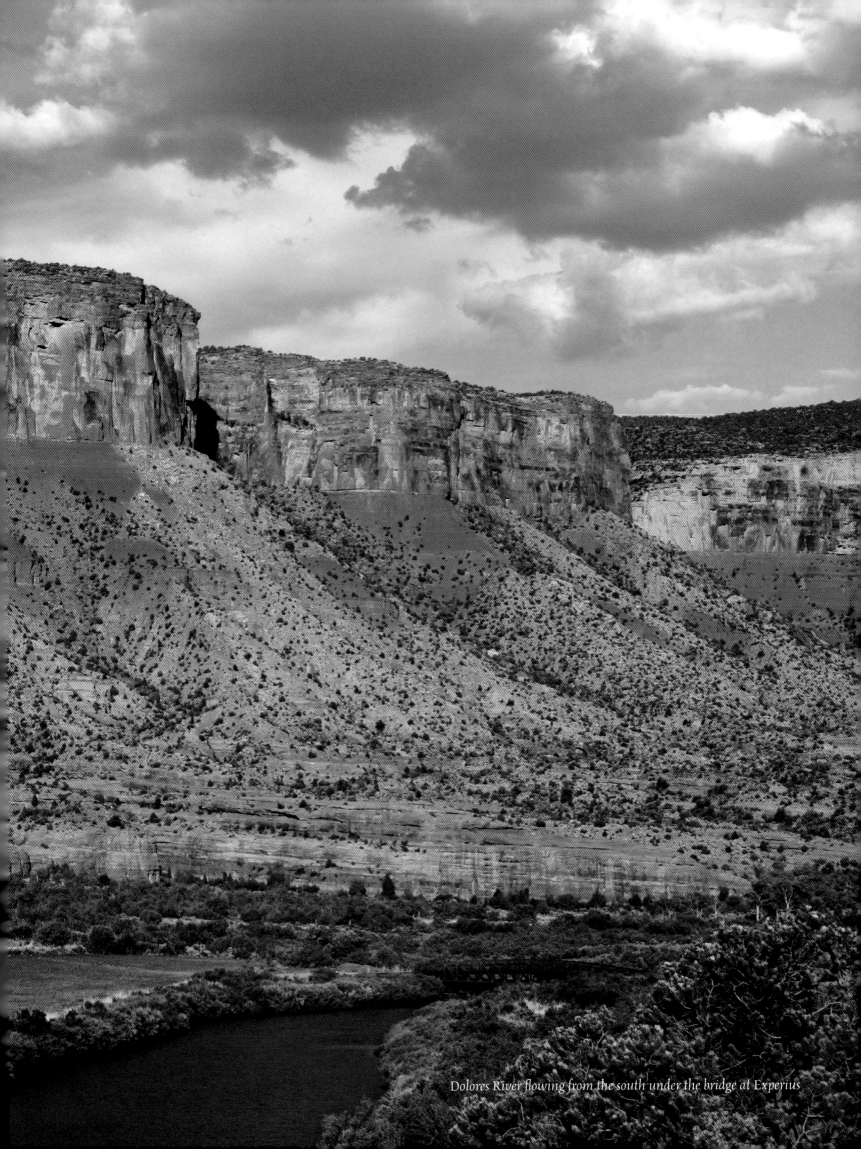

Dolores River flowing from the south under the bridge at Experius

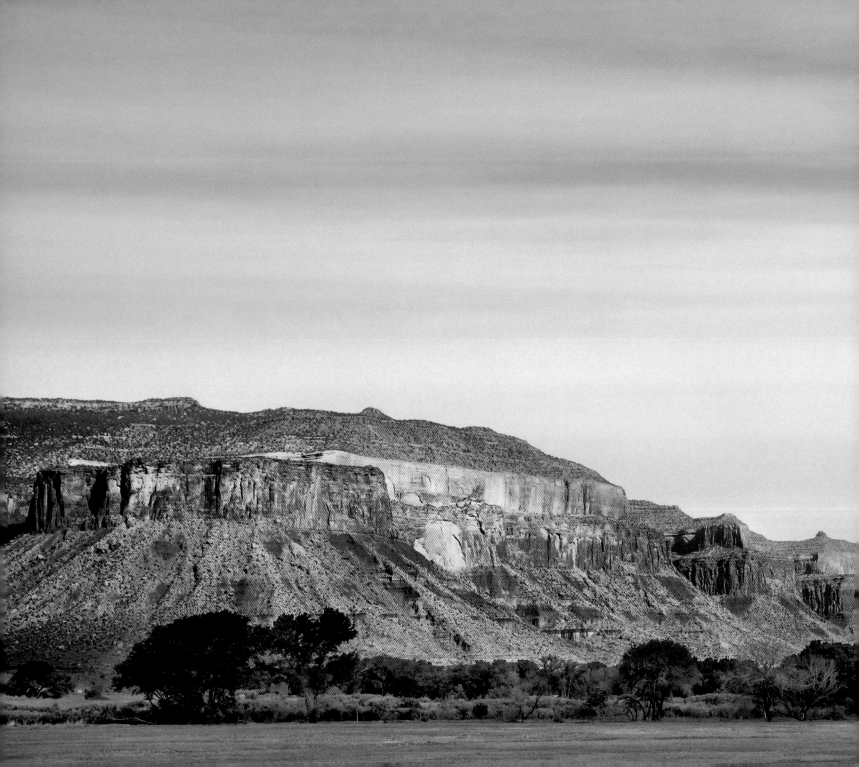

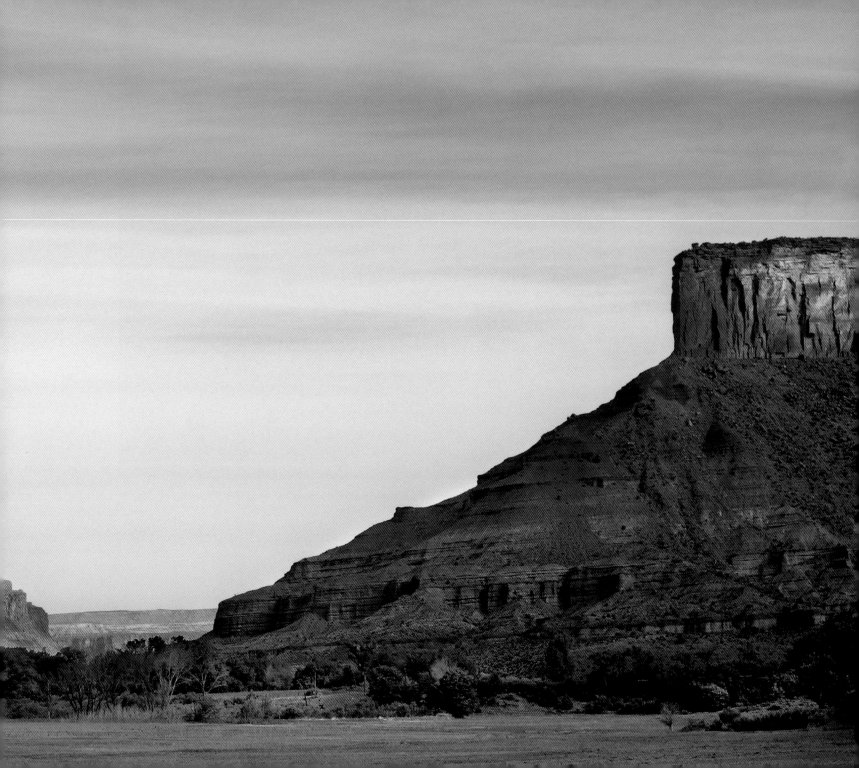

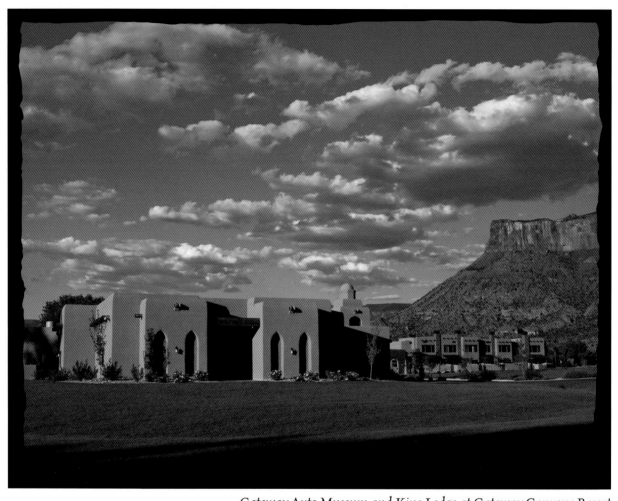

Gateway Auto Museum and Kiva Lodge at Gateway Canyons Resort

GATEWAY CANYONS RESORT

Sitting at the base of the Palisade, where West Creek meets the Dolores River, Gateway Canyons Resort offers visitors a rare opportunity to explore, at leisure, the canyons of Gateway. Unlike the early Colorado settlements, Gateway Canyons Resort provides casually elegant accommodations and dining choices that range from the Entrada Restaurant and Paradox Grille to the well-stocked grocery store, and a few options in between. The resort is home to the Gateway Colorado Auto Museum, a "celebration of the American Automobile" with more than 45 classic cars on display. The newly opened Mission Bell Amphitheater and Palisade Event Center are both beautiful, modern versions of the Anasazi gathering spots depicted on the nearby canyon walls. Like those meeting places of old, these venues, too, will witness celebration, performance, instruction, and discussion. No doubt that the Ancients, and later, the miners and pioneers, had a means of relaxing. Today's inhabitants enjoy luxuries like the spa, the HD theater, access to outdoor adventure guides, and leisurely hours to tinker with a camera to capture the place, as perfectly as possible, for memory's sake.

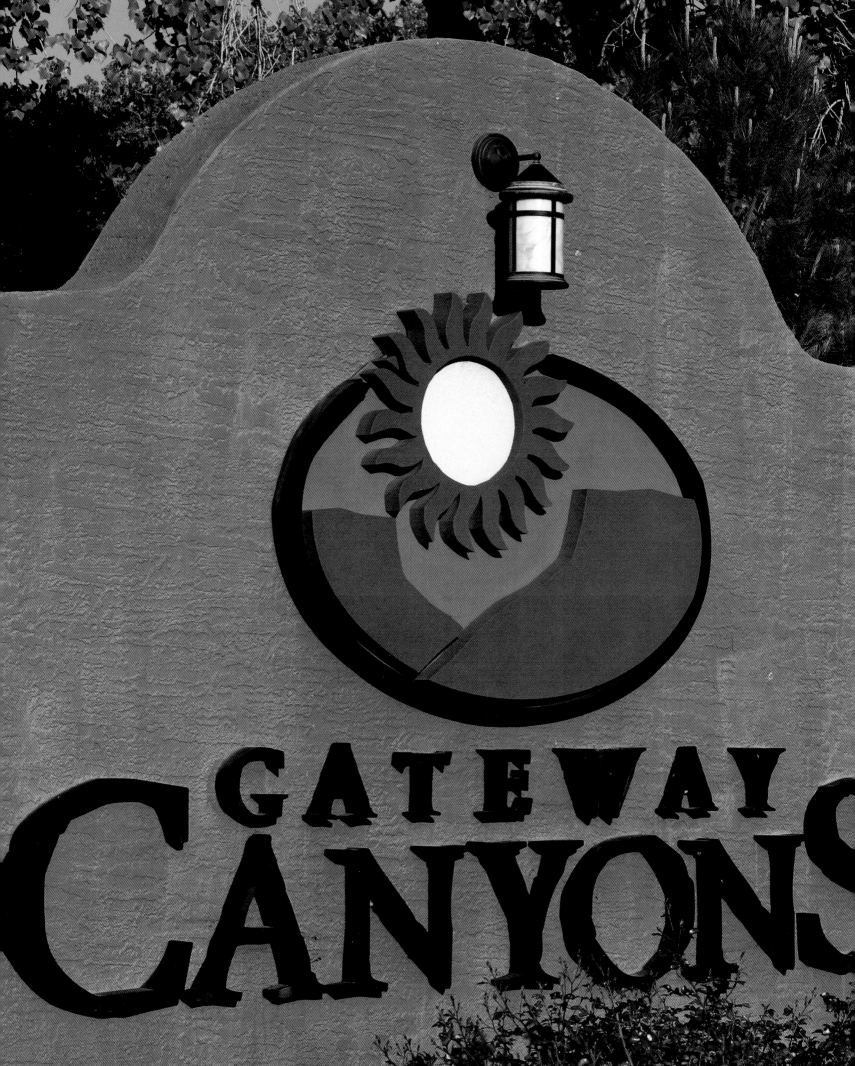

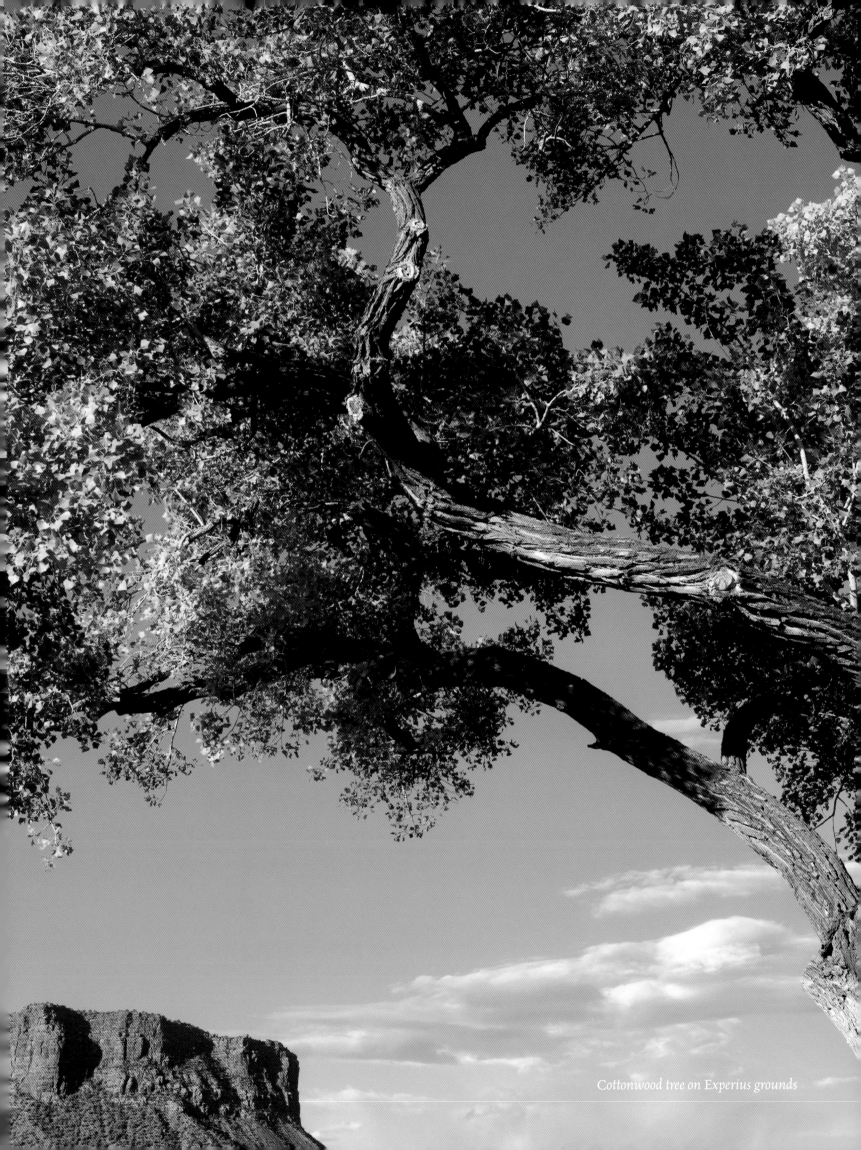

Cottonwood tree on Experius grounds

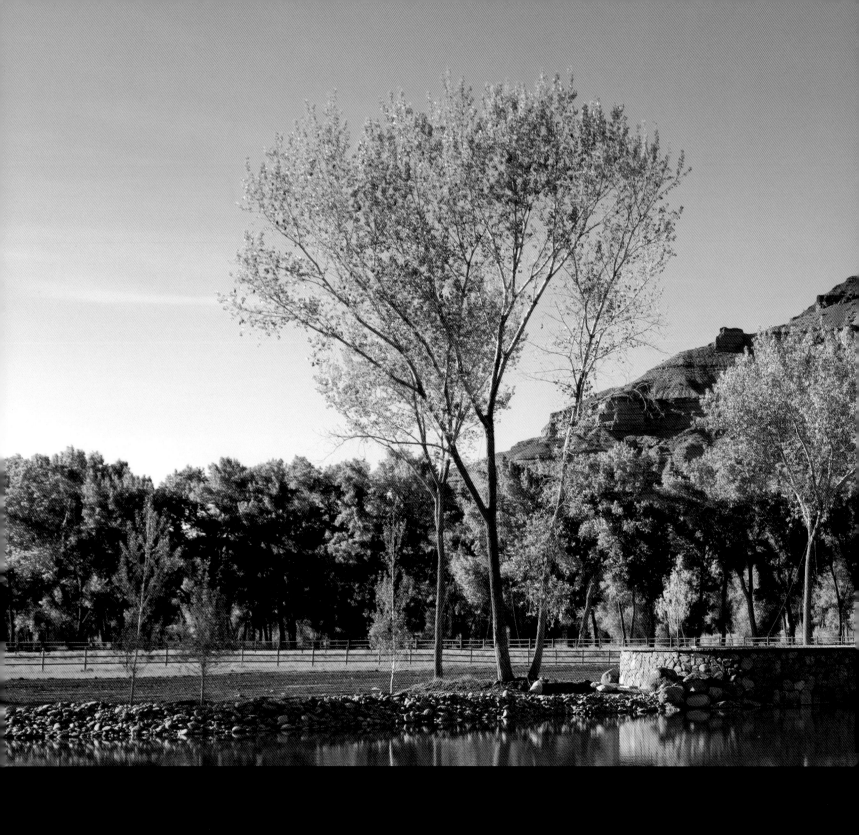

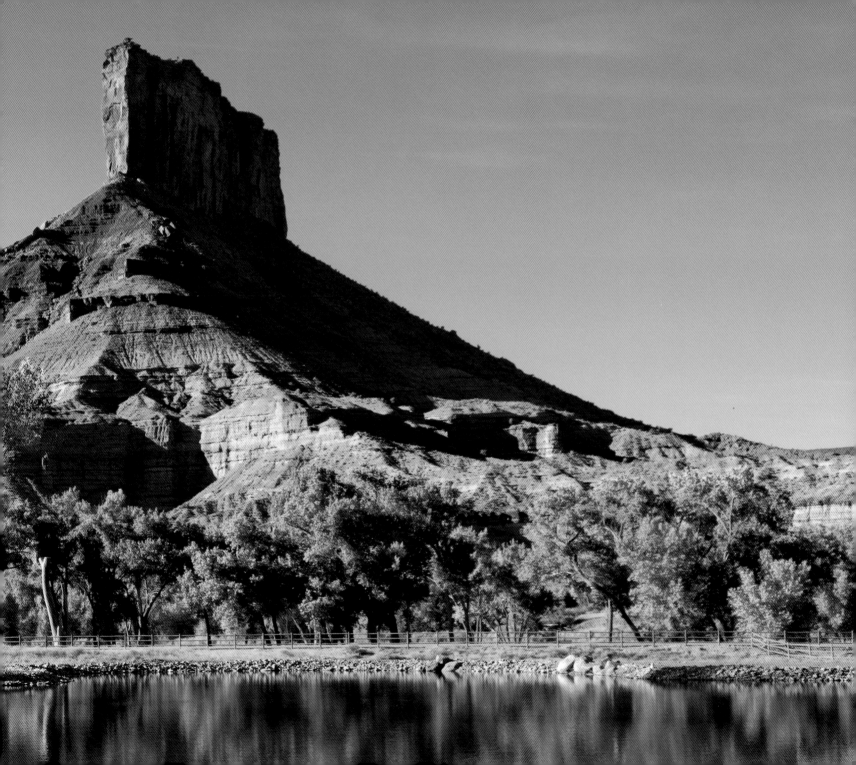

View of Experius Academy through Mission Bell Amphitheater

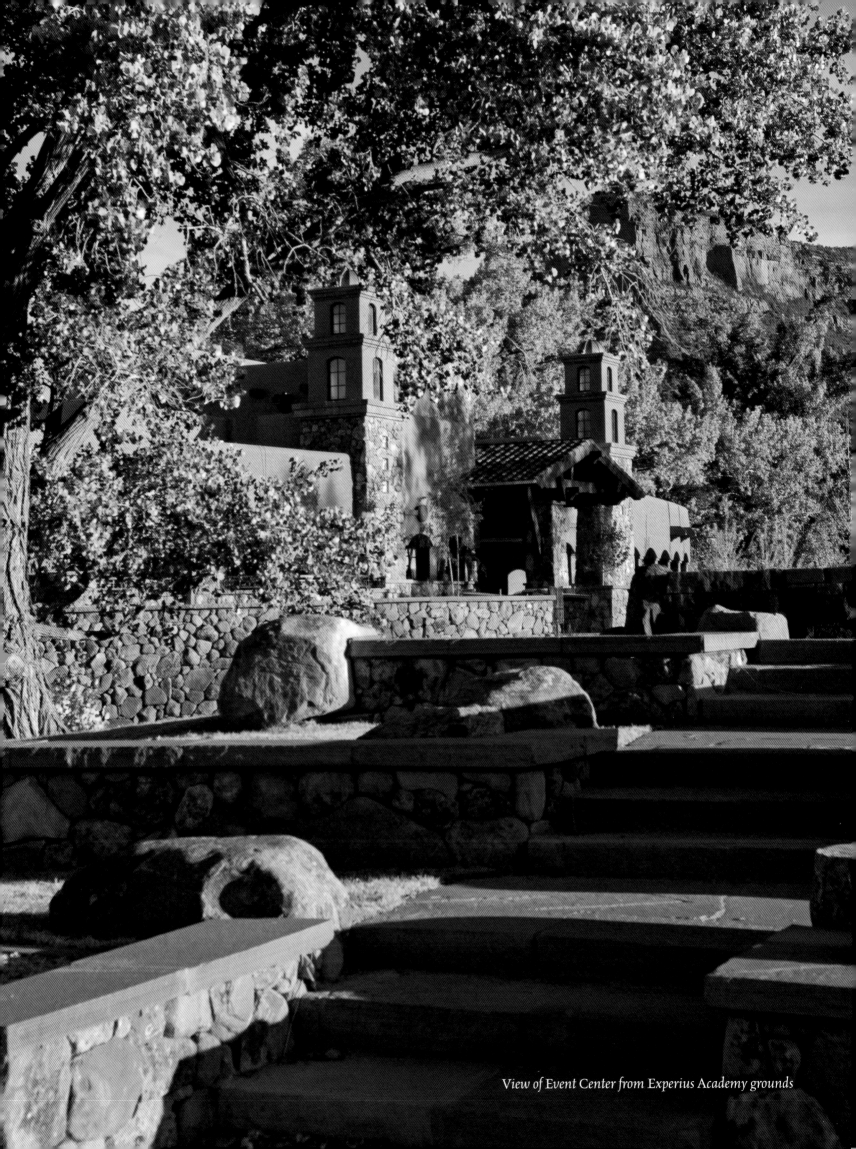

View of Event Center from Experius Academy grounds

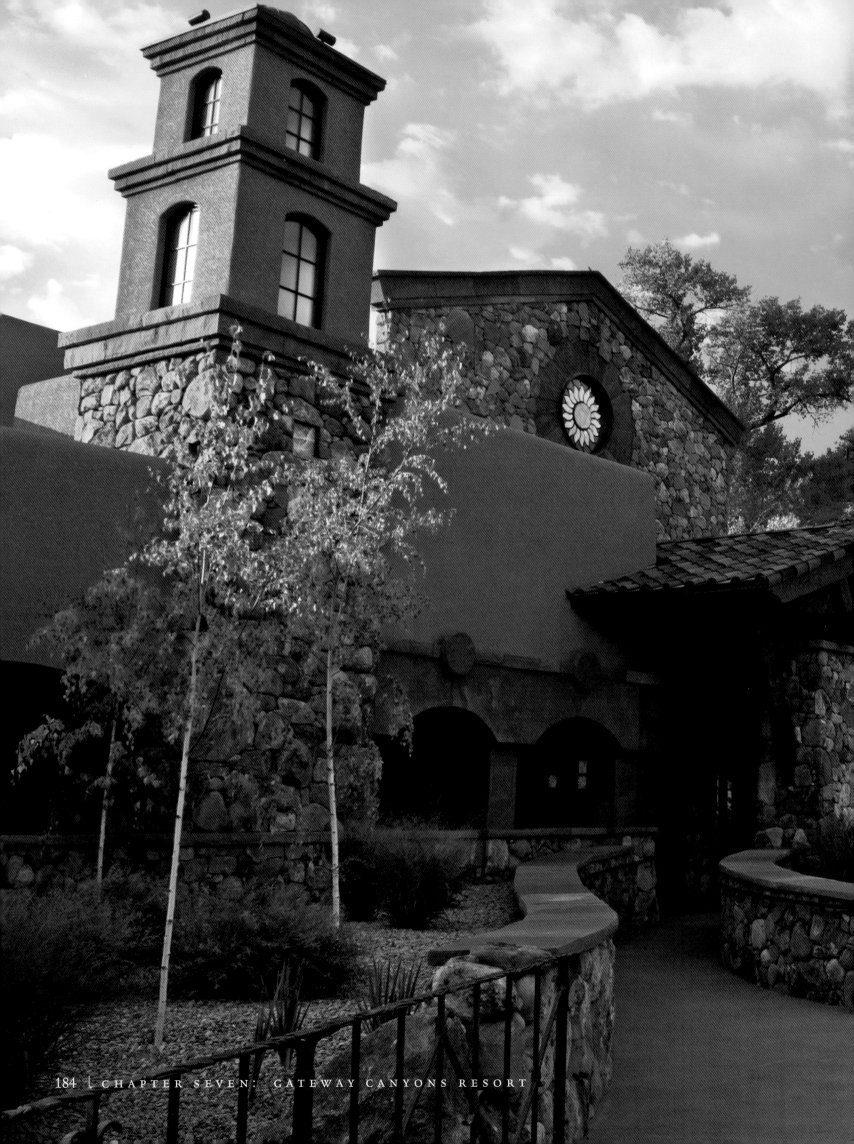

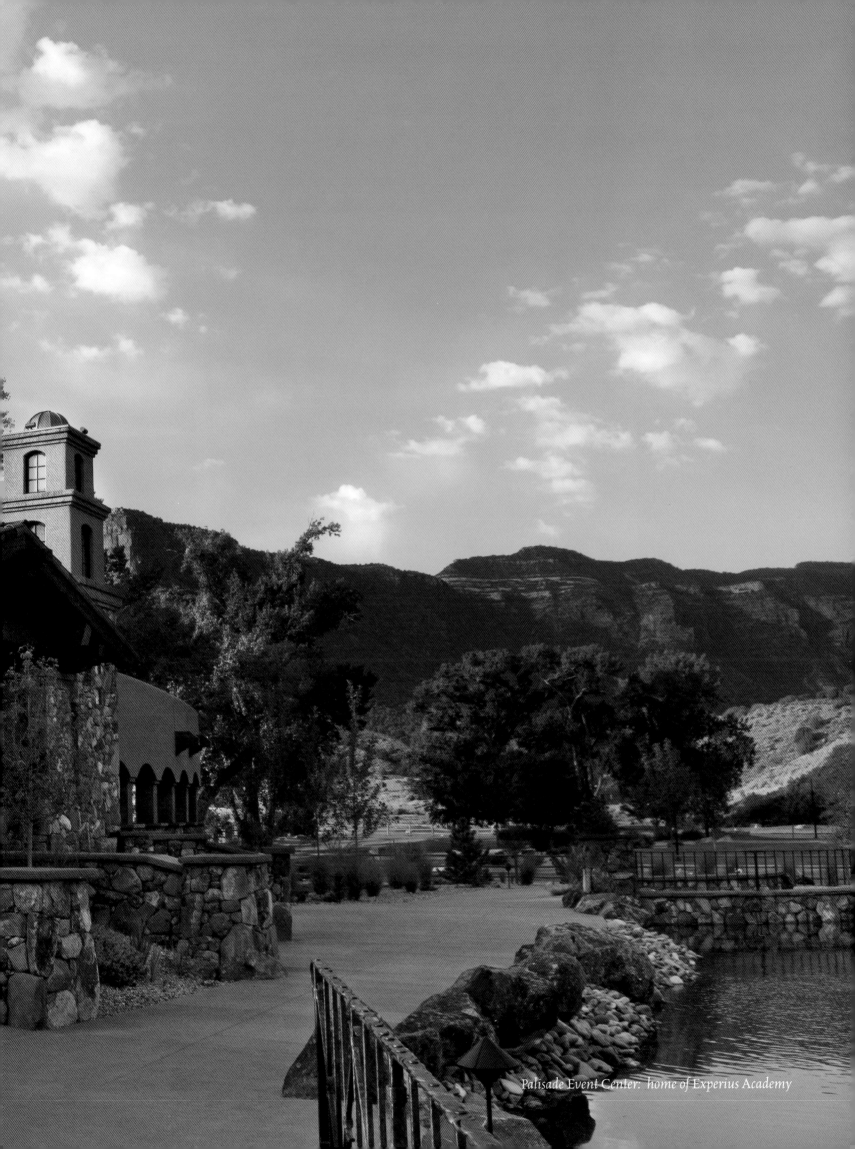

Mission Bell Amphitheater

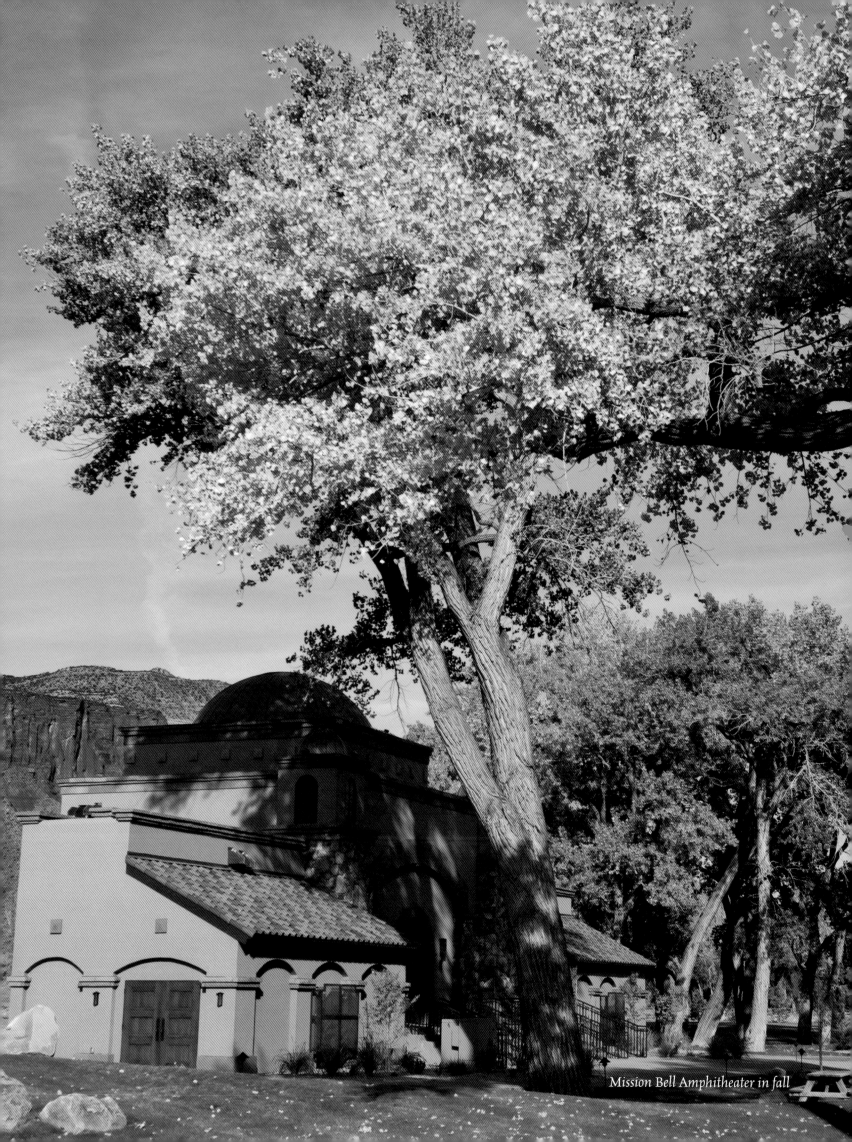

Mission Bell Amphitheater in fall

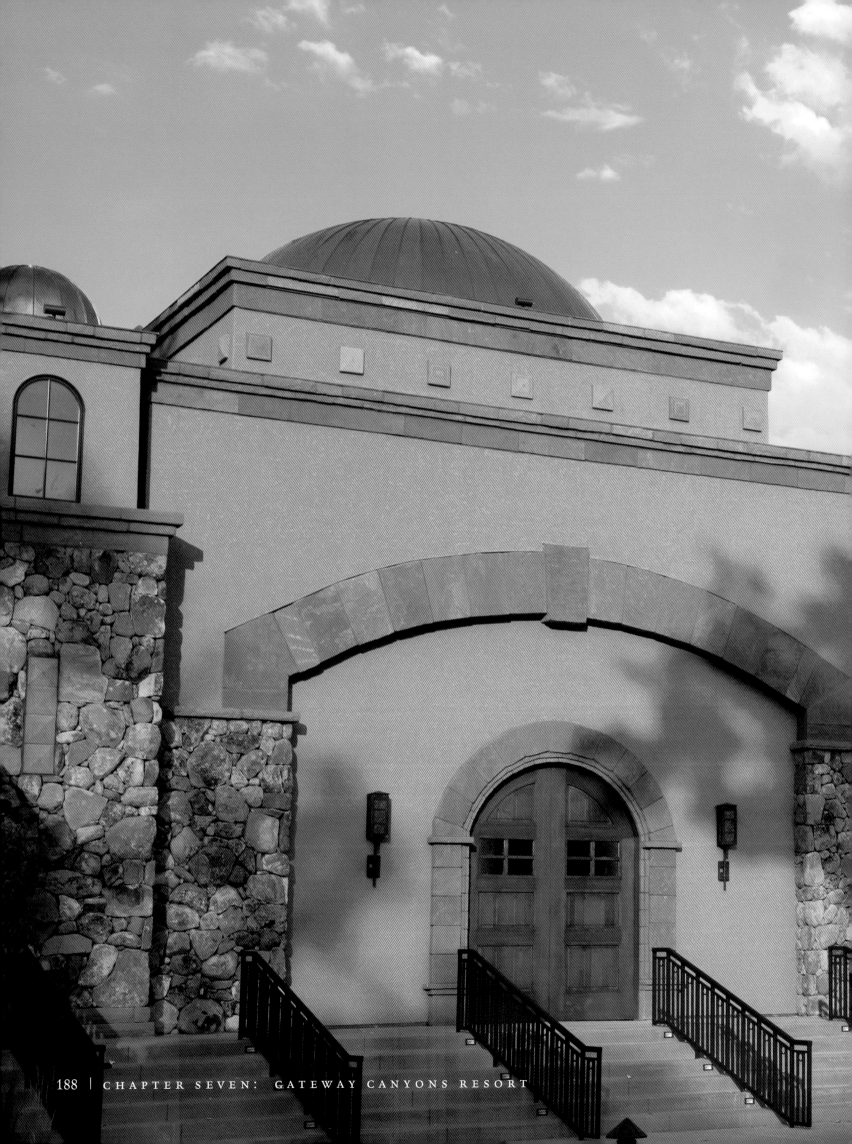

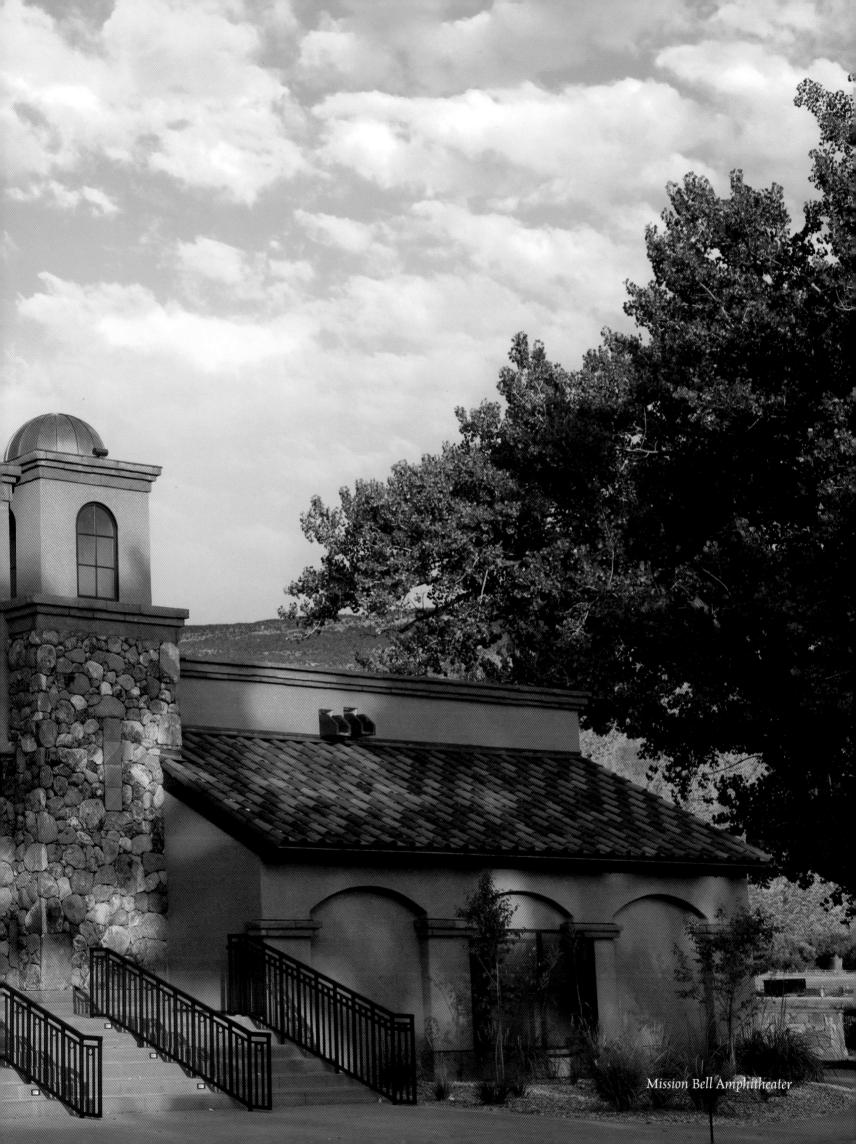

Mission Bell Amphitheater

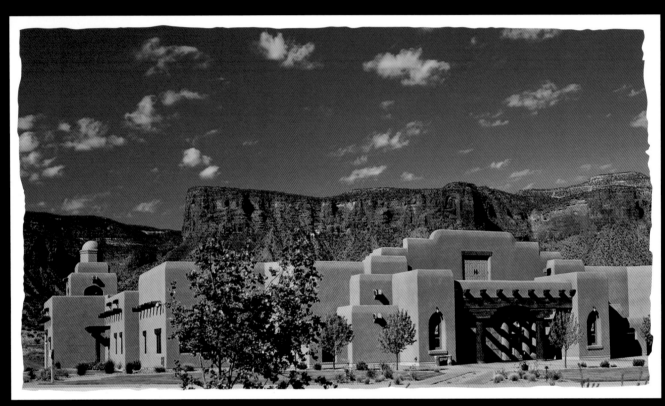

Gateway Auto Museum at Gateway Canyons Resort

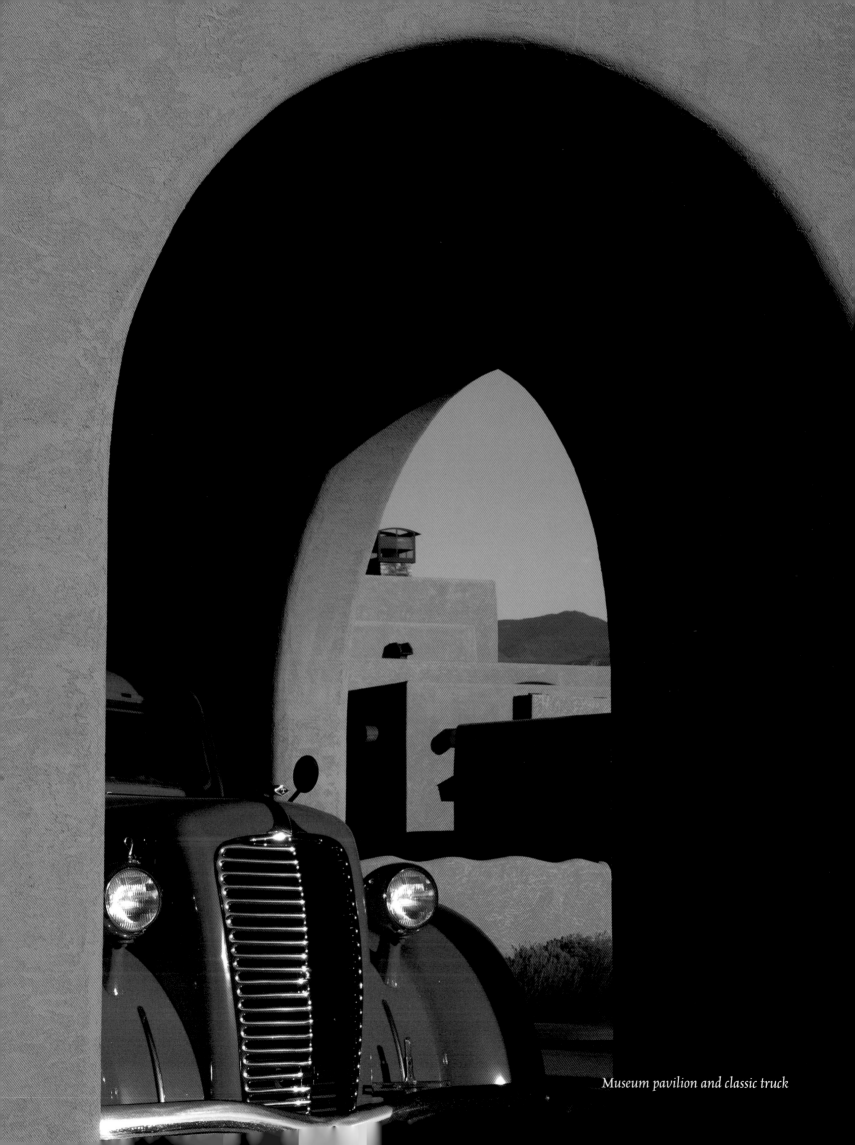

Museum pavilion and classic truck

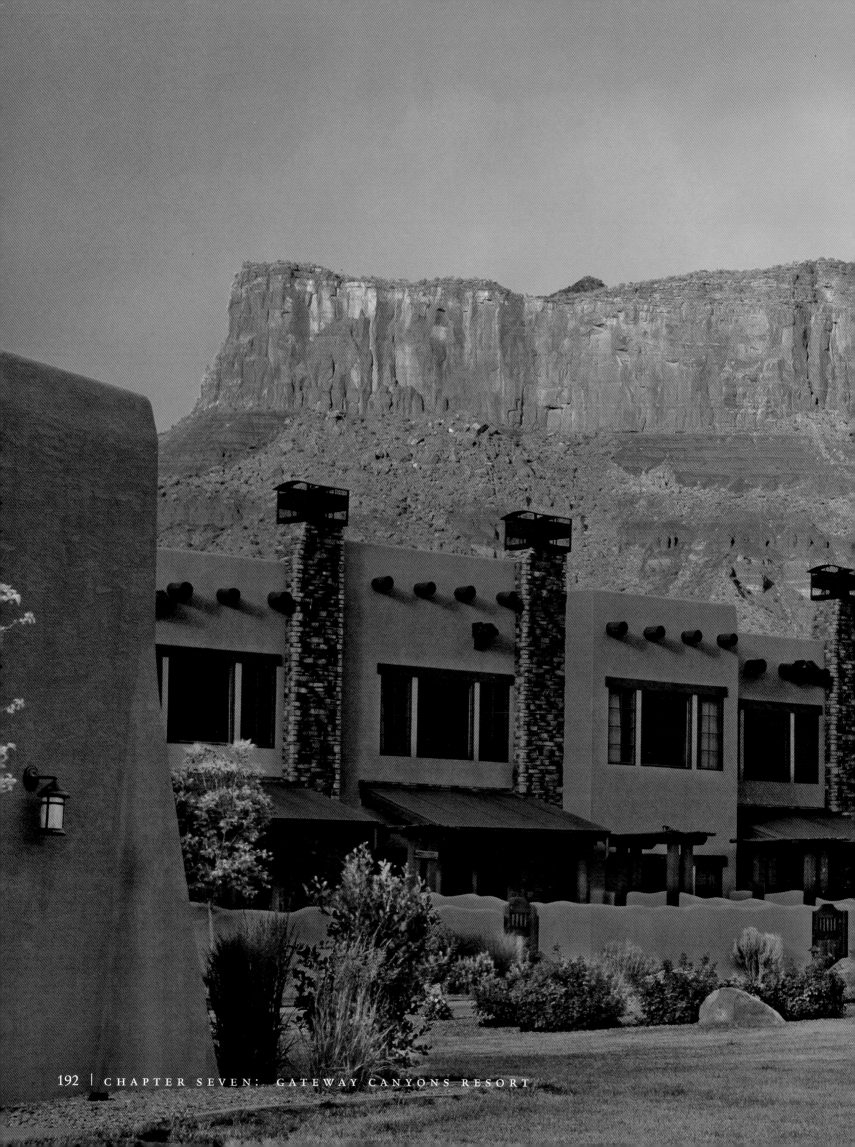

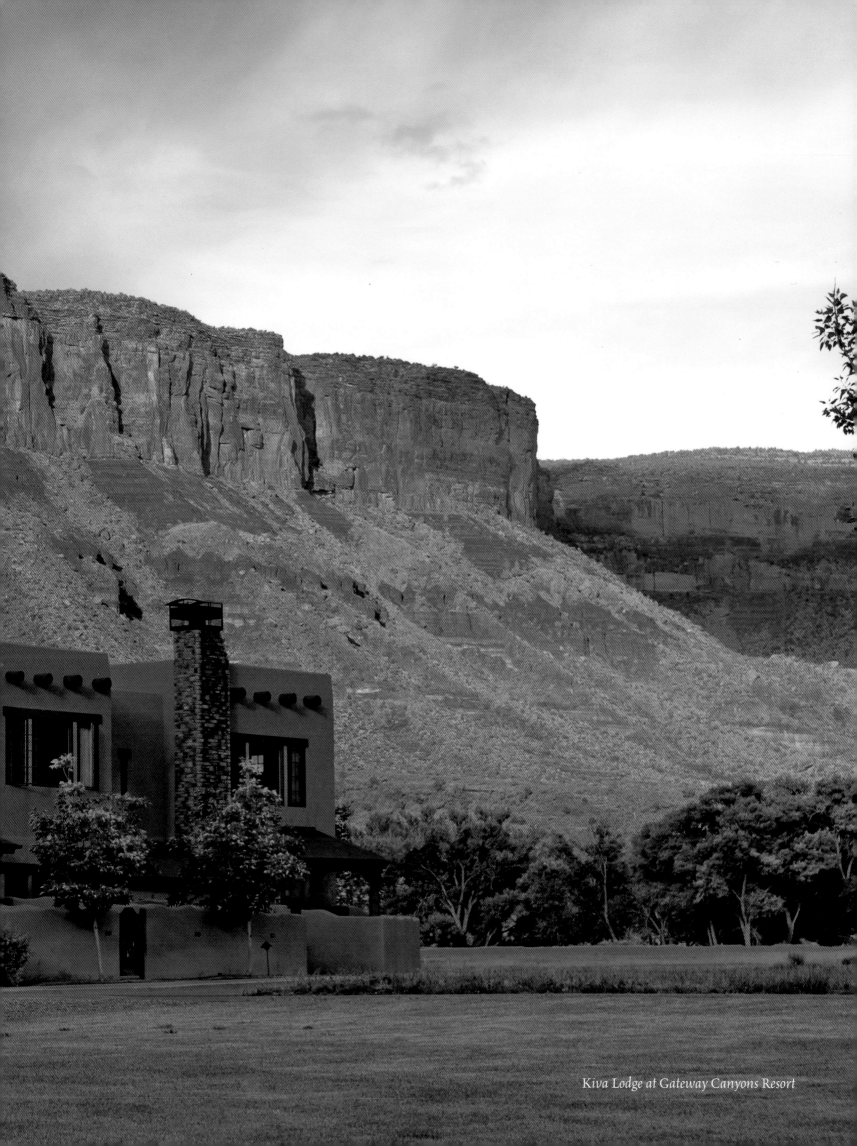

Kiva Lodge at Gateway Canyons Resort

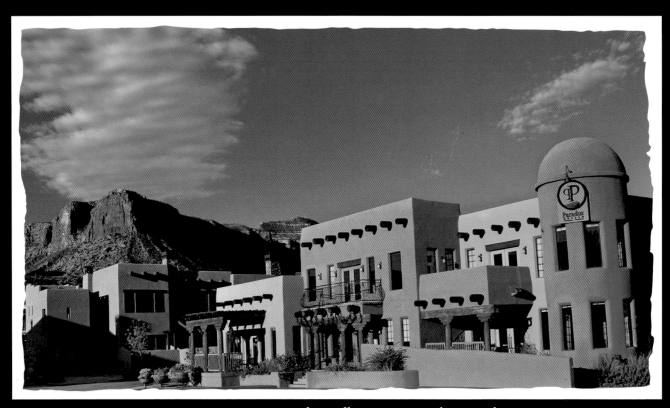

Paradox Grille Restaurant and Kiva Lodge at Gateway Canyons Resort

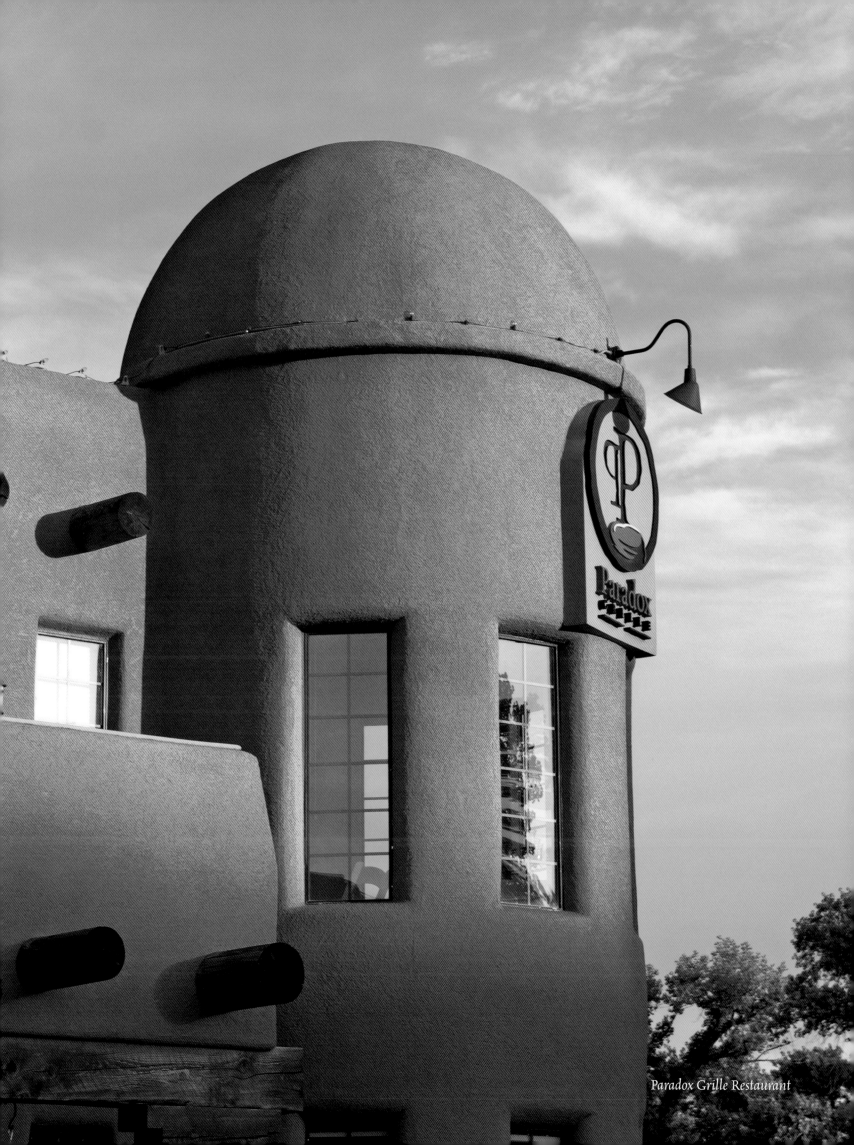

Paradox Grille Restaurant

Sunset view from West Creek Ranch

SUNDOWN

There are small windows of time, near dawn and dusk, when the sun bathes the canyon skies in ever-changing colors. The surprising regularity of spectacular sunsets in this area prompted me to ask some questions of John Hendricks as I shared one of his evening photography sessions at West Creek Ranch. As a private pilot, John knows a good bit about meteorology and he speculates that there is a combination of factors that contributes to the "perfect storm of colors" at sunset in Gateway. He observes: "It appears that the afternoon winds in eastern Utah add just the right amount of atmospheric dust to redden the evening sky at sunset. This dust is generally accompanied by a late afternoon build-up of cumulus clouds from water vapor that condenses from the air mass moving steadily from the southwest up and over the LaSal Mountains toward Gateway. Remarkable sunsets generally result from low-angle light of the setting sun reaching under cloud layers, which is uniquely enabled at Gateway. Western sunlight reaches this area at low angles after passing, without obstruction, through the dry atmosphere of the desert country of Moab and Canyonlands National Park. This strong, low-angle, dust-reddened sunlight penetrates the Gateway canyon country with ease, illuminating cliffs, and providing the late evening rainbow of glow that dances in the wispy world of the clouds."

John Hendricks has captured the sun at play – on cliff walls, in pond reflections, and in the majestic sky itself – from its first stretches across the land to its final good night, over the canyons of Gateway.

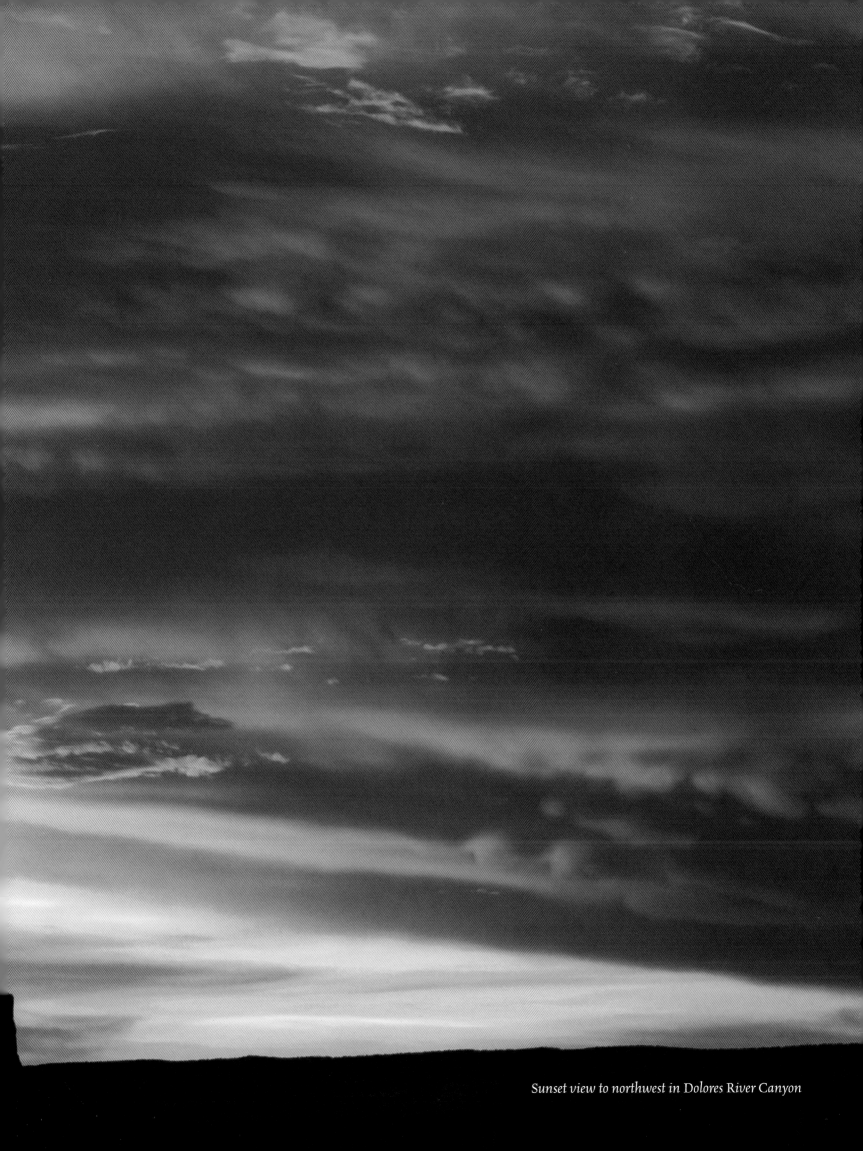

Sunset view to northwest in Dolores River Canyon

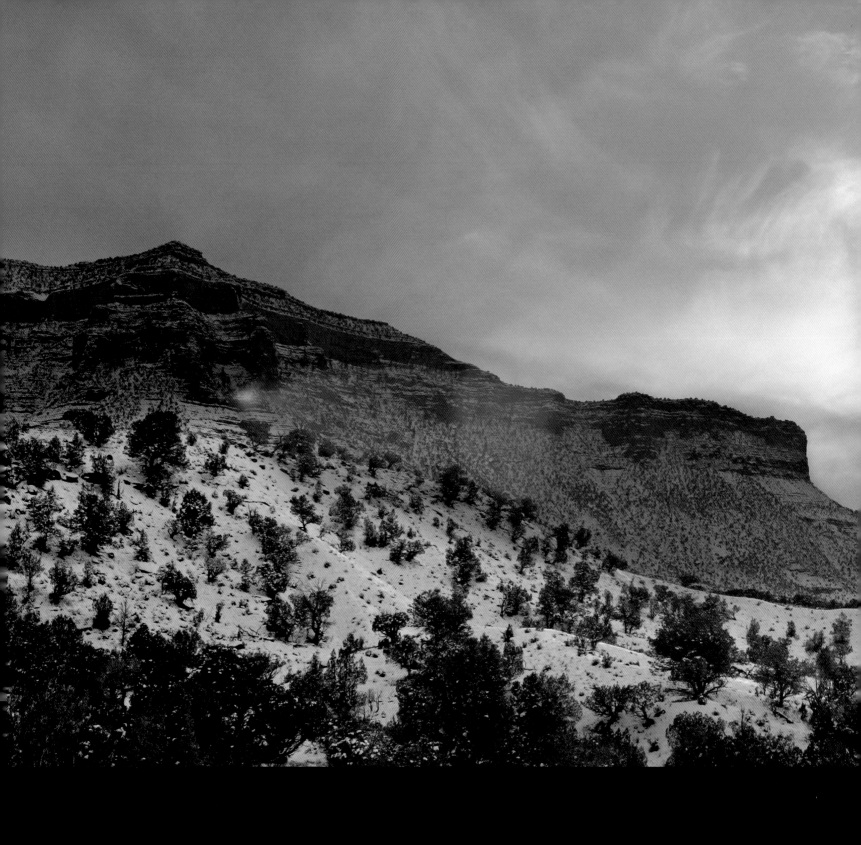

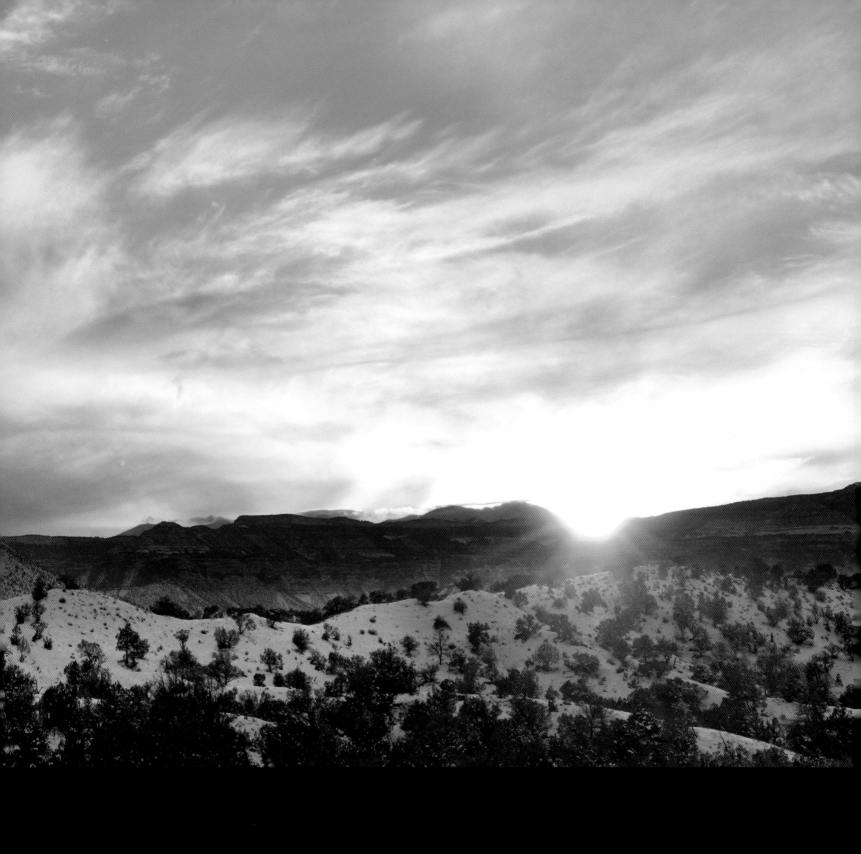

Winter sunset at West Creek Ranch

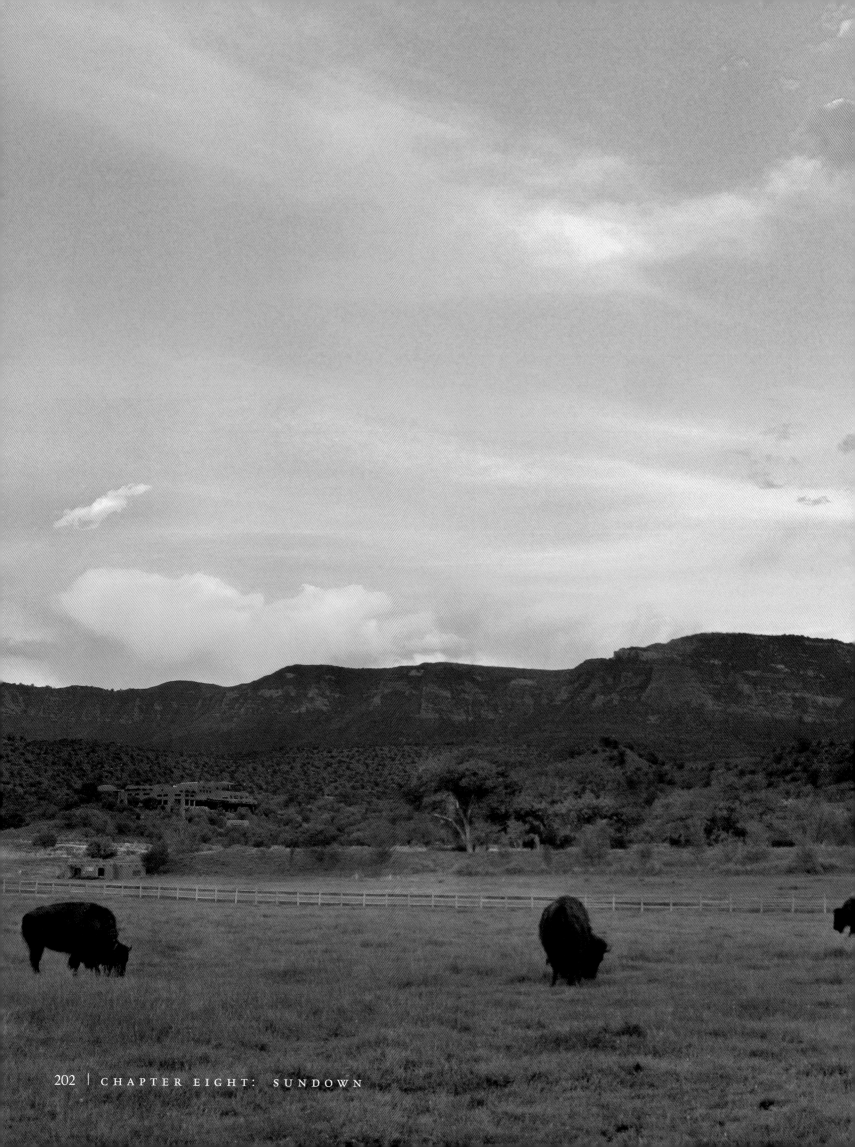

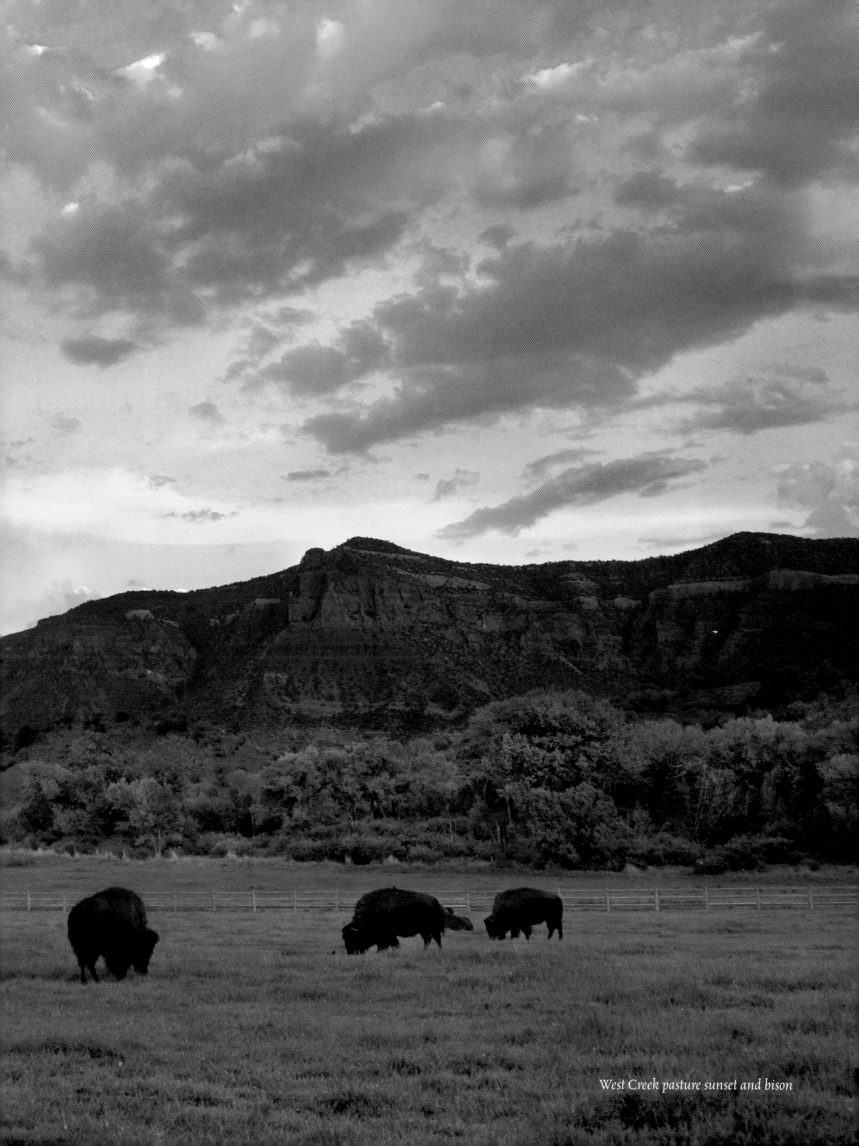

West Creek pasture sunset and bison

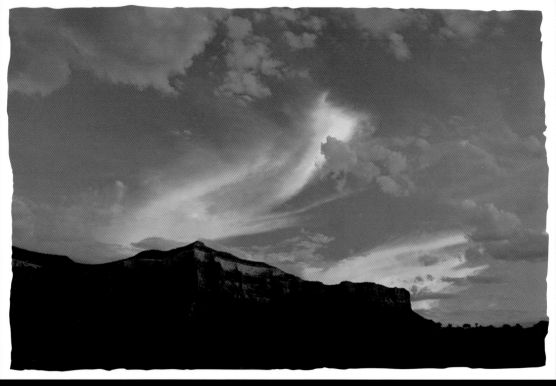

Sunset flame over Tenderfoot Mesa

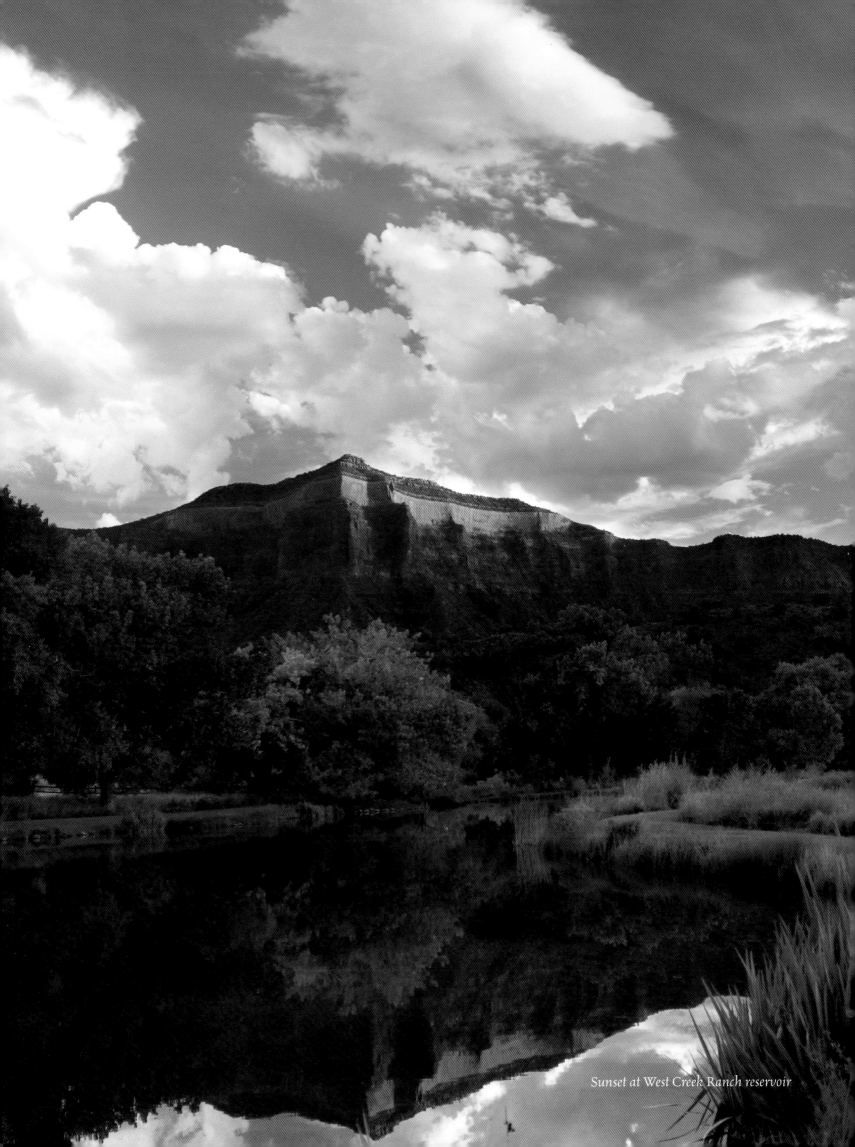

Sunset at West Creek Ranch reservoir

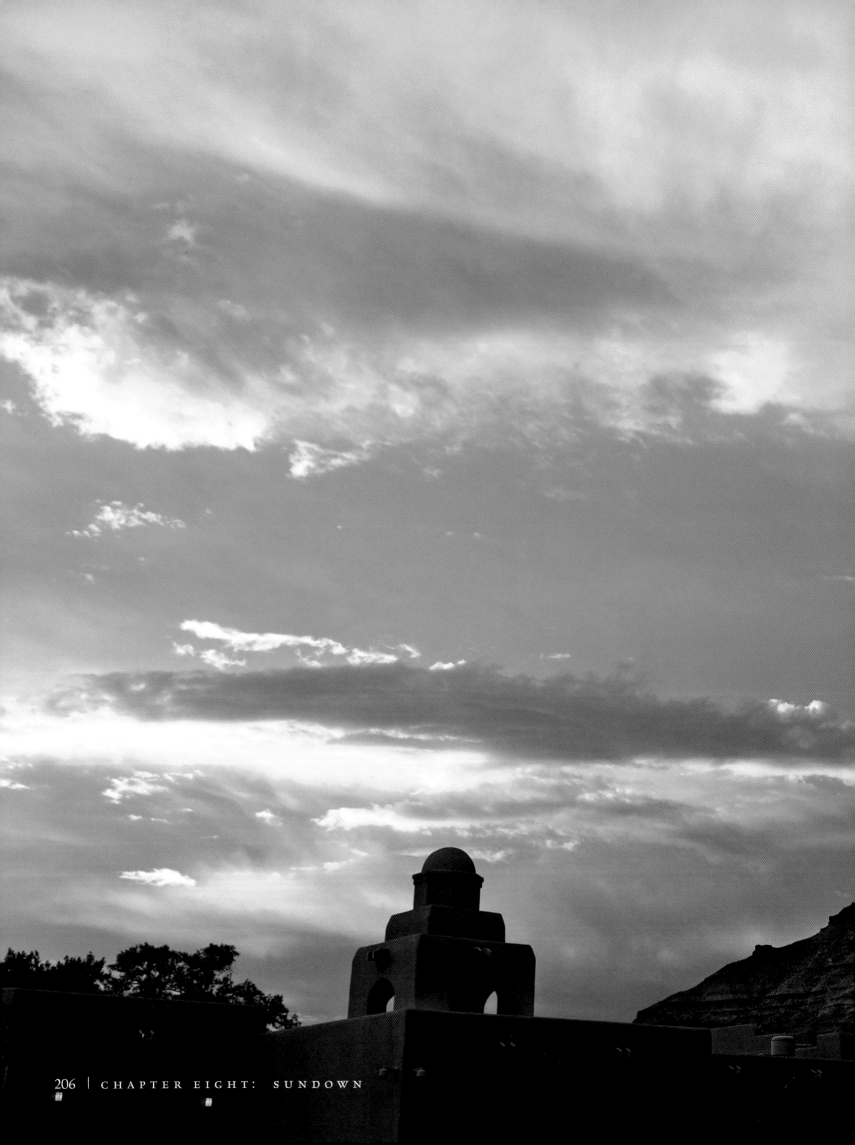

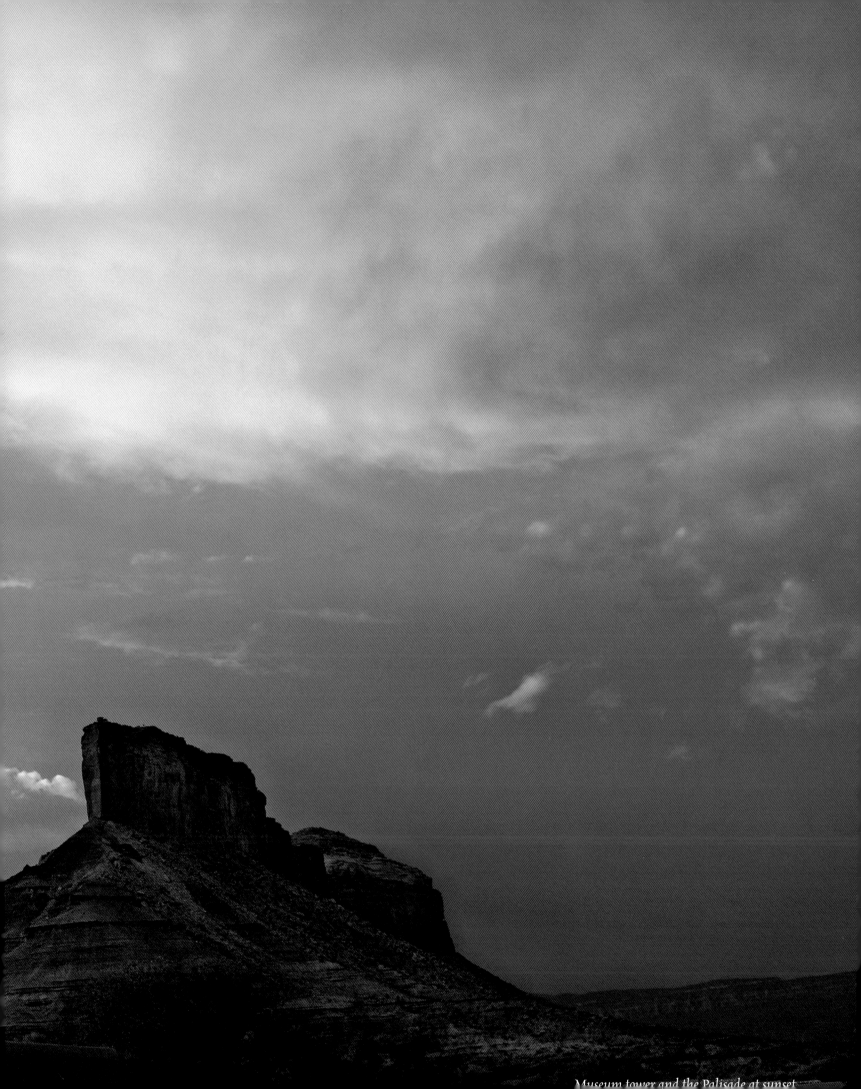

Museum tower and the Palisade at sunset

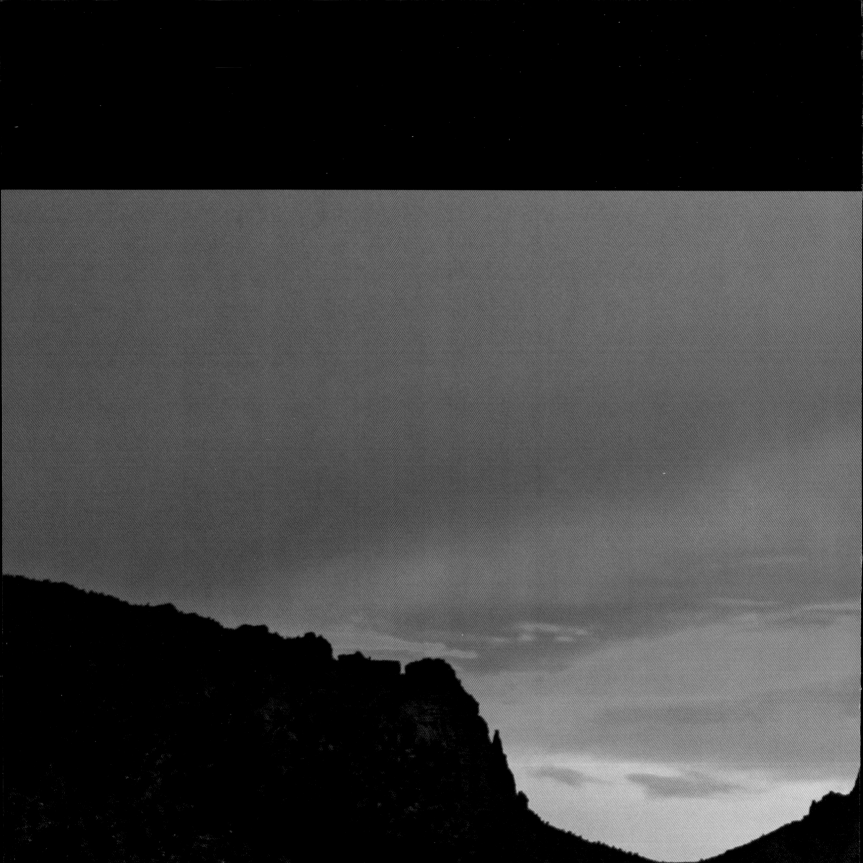

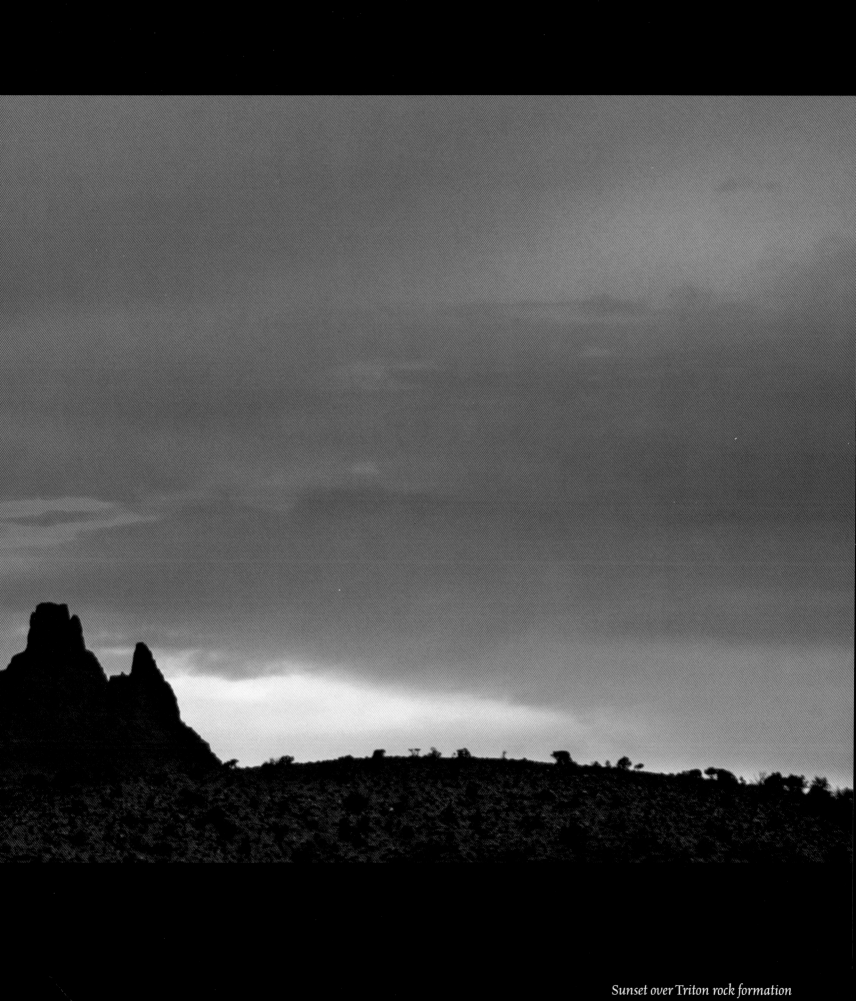

Sunset over Triton rock formation

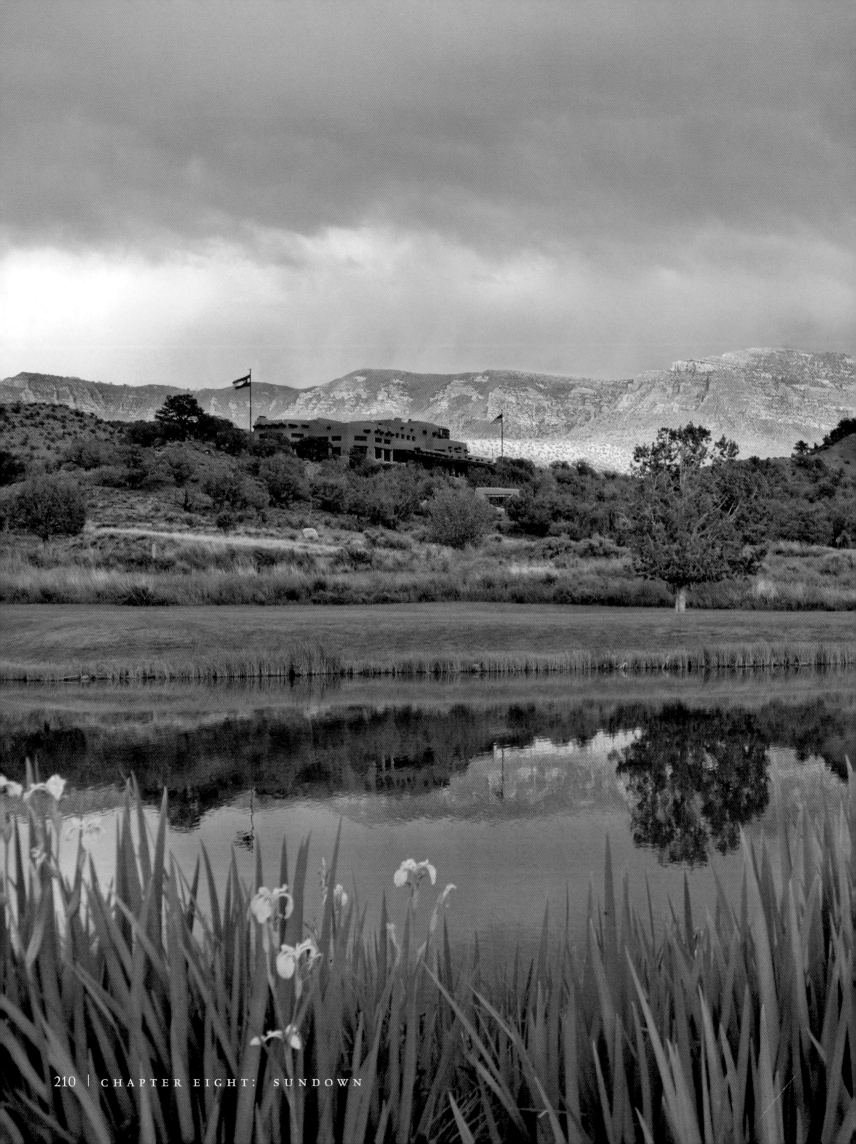

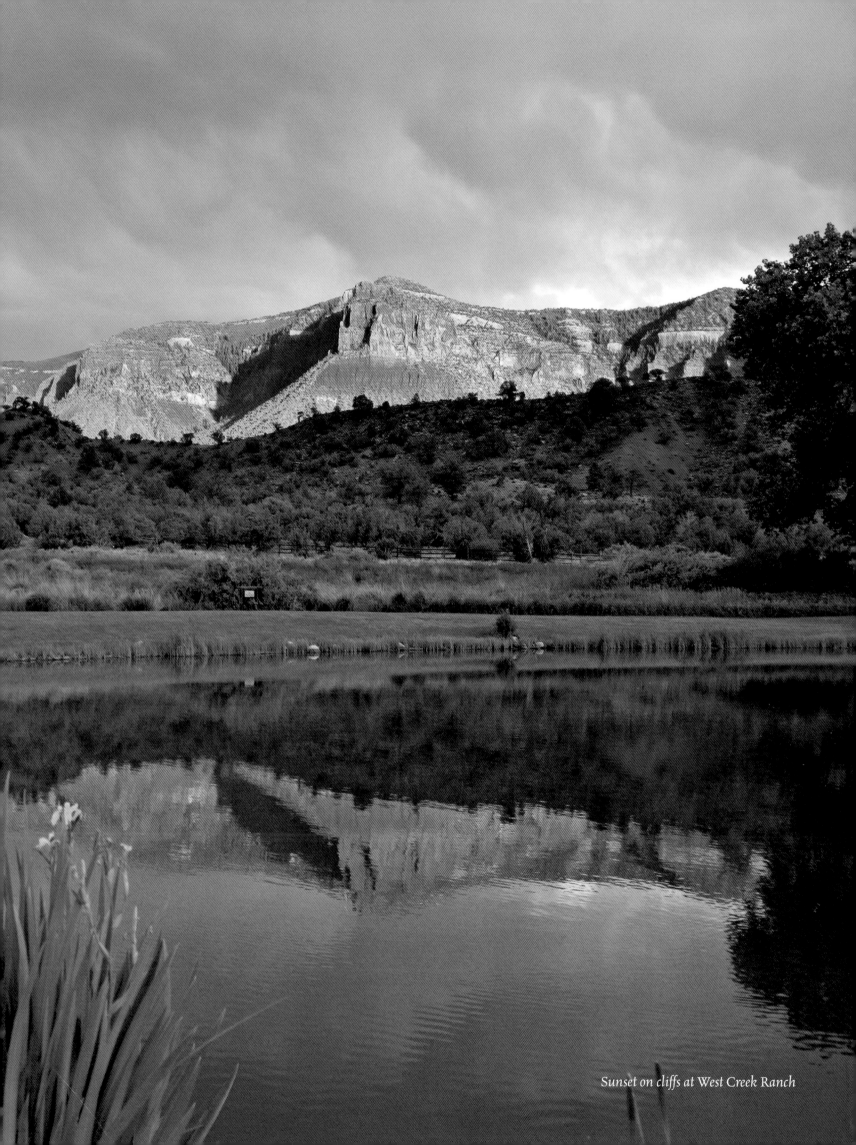

Sunset on cliffs at West Creek Ranch

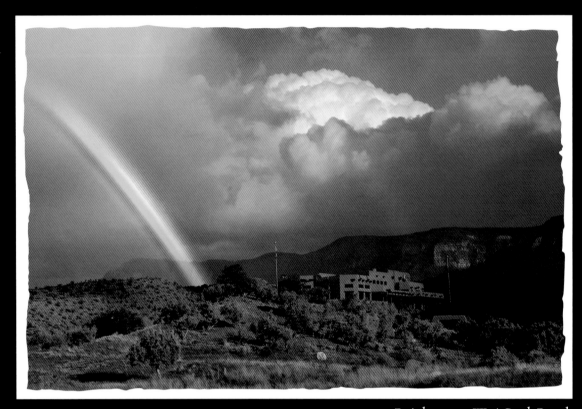

Rainbow over West Creek Ranch

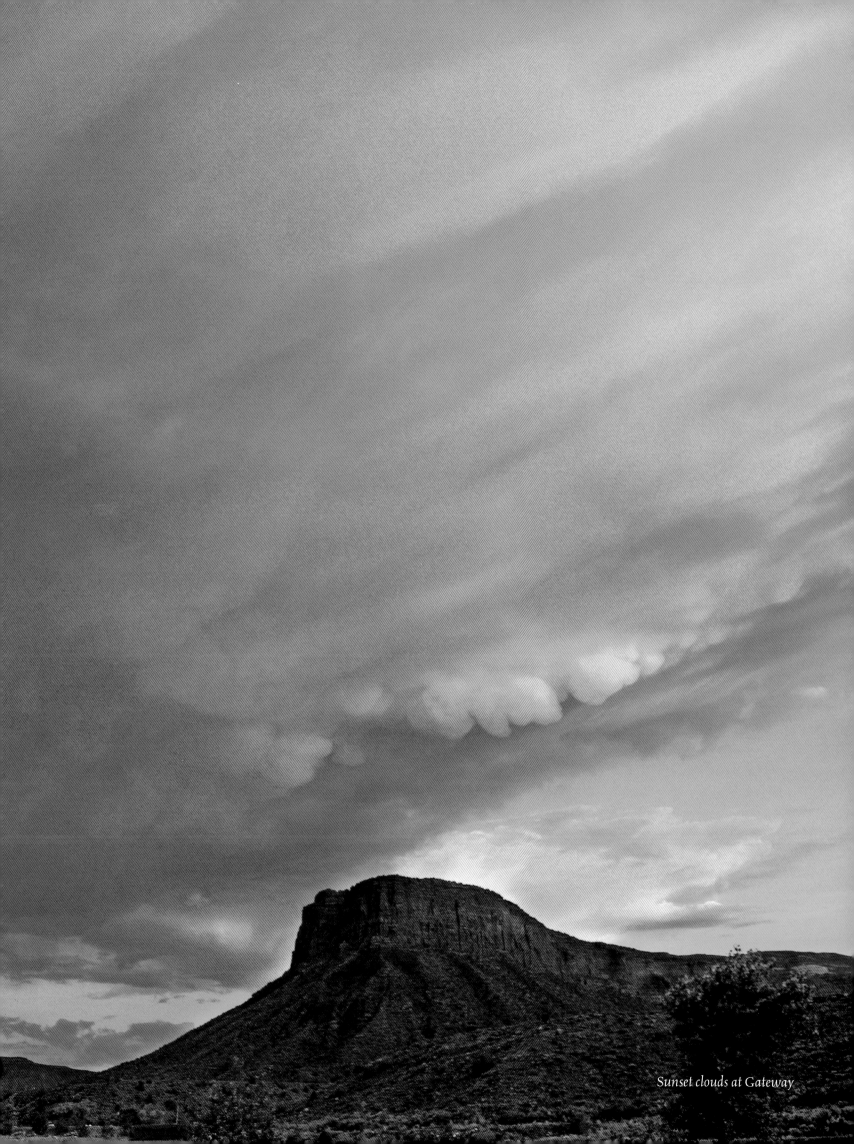

Sunset clouds at Gateway

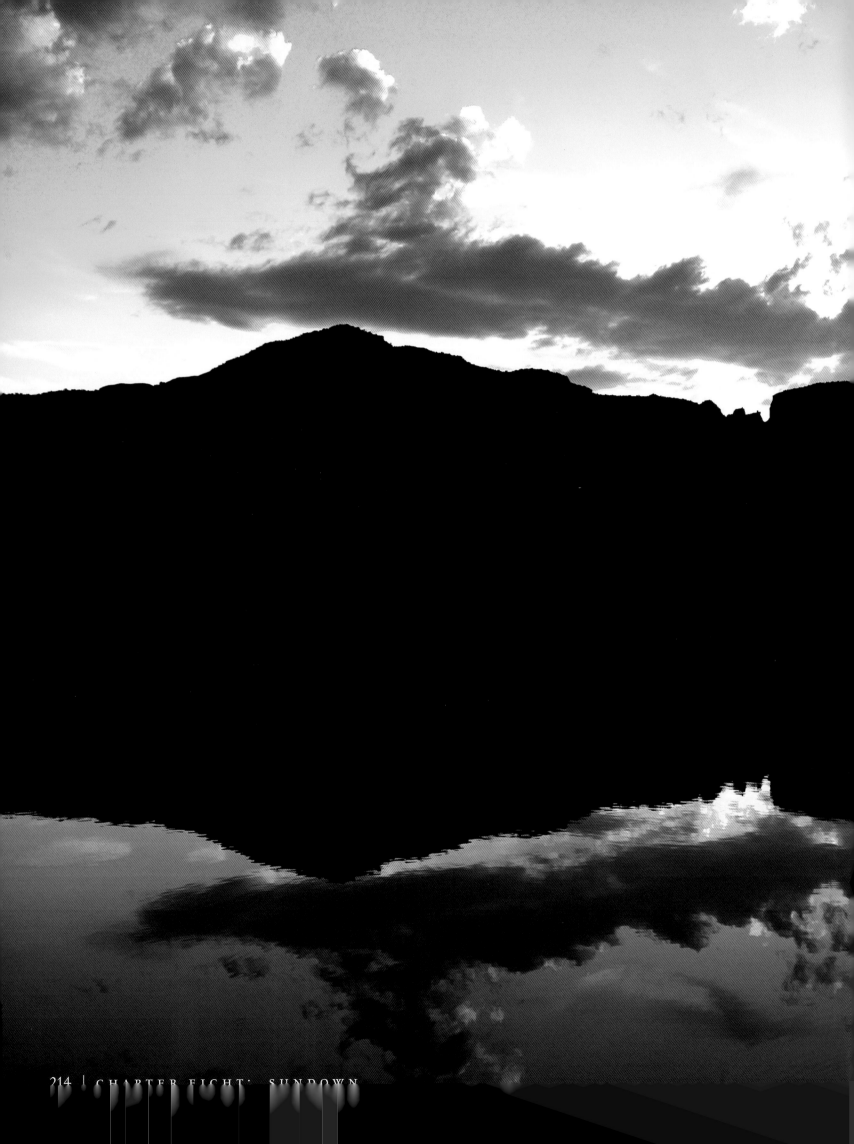

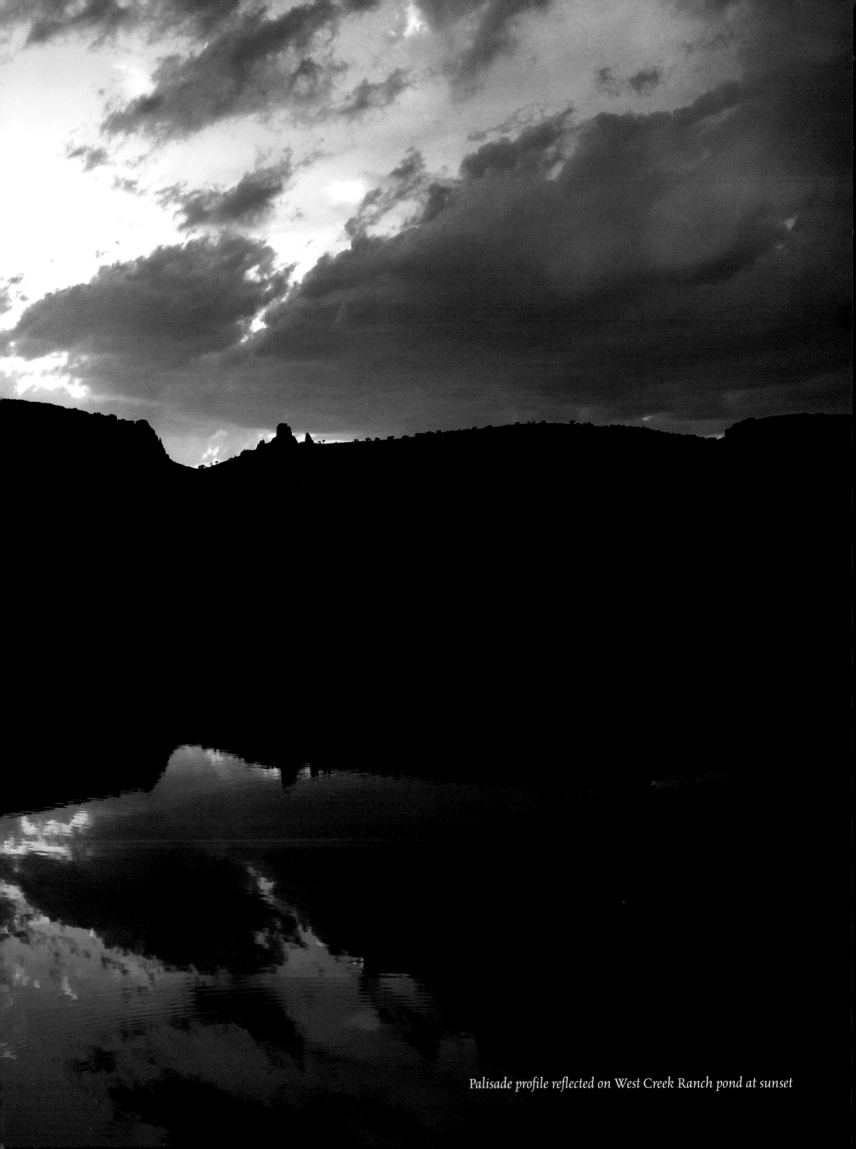

Palisade profile reflected on West Creek Ranch pond at sunset

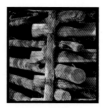

ACKNOWLEDGEMENTS
by
John Hendricks

If you have read my Preface, you know that I need to acknowledge my late father, John Gilbert Hendricks, who first told me about this visually stunning part of the world. Without knowing it, he served as the prime mover for this book of images about a place he could never forget. Next to thank is my wonderfully spirited wife, Maureen, who readily embraced the call of the West with me and who is today working to make the canyons of Gateway a retreat destination for fabric artists. Years ago in their youth, our daughter, Elizabeth, and son, Andrew, gave their often absent father nothing but encouragement as he disappeared to western Colorado to find that calming light of sunset. Elizabeth and Andrew inspire and motivate me to this day.

"You just have to put these photos in a book," was the constant demand of my very good friend and colleague, Nancy Stover, who persuaded me at every turn over the last two years to make this project happen. An inspiring leader, Nancy is also a lover of these parts and she is giving life to the new Experius Academy which will be based at Gateway Canyons.

My great partner at Discovery Communications is the immensely capable David Zaslav, whose remarkable leadership of the organization is so complete and professional that it often permits me to escape to the landscape riches of western Colorado. I am so grateful for David's kind and generous words on the back of the book cover.

I've had the good fortune to collaborate with the very talented Mary Judd who brought both her artist's eye and writer's mind to the canyon country of western Colorado. It has been a treat to explore the land with her. Mary's insights and her joy of discovery have enriched this book.

The splendid graphic design of *The Canyons of Gateway* has been the work of Carrie Hurlburt whose sensitive judgment is reflected throughout these pages. In past years, Carrie brought her considerable skills to the award-winning design department at Discovery. Today, we are fortunate to have her on the Experius team.

For advice on photography and publishing projects such as this, I have none other than the famed photographer, Michael Furman, to call upon for expert advice which he always generously provides. Michael's close collaborator, Bob Tursack, Jr., Master Printer and Founder of Brilliant Studio, completed the expert team on this project with his steadfast devotion to printing excellence.

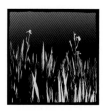

BIBLIOGRAPHY

Chronic, Halka, and Felicie Williams. (2002). *Roadside Geology of Colorado*. Missoula, Montana: Mountain Press Publishing Co.

Collins, Donna Bishop. (1985). *Scenic Trips into Colorado Geology: Uncompahgre Plateau--Montrose, Ridgway, Norwood, Naturita, Uravan, Gateway, Delta*. Colorado Geological Survey Special Publication 27.

Green, Stewart M. (1994). *Colorado Scenic Drives*. Helena, Montana: Falcon Press.

Keener, James, and Christine Bebee Keener. (1988). *Colorado Highway 141 Unaweep to Uravan*. Grand Junction, Colorado: Grand River.

Moores, Jean, and James E. Massey. (2000). *Gateway/Unaweep Canyon At Some Point In Time*. Decorah, Iowa: The Anundsen Publishing Co.

Parker, Kathleen. (1999). *The Colorado Plateau: The Land and the Indians*. Los Alamos, New Mexico: Thunder Mesa Publishing.